Punctuation

Punctuation:

ART, POLITICS, AND PLAY

Jennifer DeVere Brody

DUKE UNIVERSITY PRESS

Durham & London

2008

© 2008 Duke University Press
All rights reserved
Printed in the United States of
America on acid-free paper ∞
Designed by Amy Ruth Buchanan
Typeset in Carter & Cone Galliard by
Tseng Information Systems, Inc.
Library of Congress Cataloging-in-
Publication Data appear on the last
printed page of this book.

Punctuation. Four stops, two marks of movement, and a stroke, or expression of the indefinite or fragmentary.

—SAMUEL TAYLOR COLERIDGE, notebook draft of an essay on punctuation, reproduced in *The Complete Poems*

She would take on their punctuation. . . . Theirs. Punctuation.

—THERESA HAK KYUNG CHA, *Dictee*

Contents

Acknowledgments

This project had its genesis at the University of California, Riverside, where frequently I shared lunch with my friend and colleague Carole-Anne Tyler. During lunch one day, she suggested that I write a book about punctuation since I was working on essays about hyphens and quotations. As a result, she deserves credit for initiating this work. I take credit for any mistakes in the pages that follow. Numerous other colleagues in the Riverside community helped me to conceptualize the project, among them Alicia Arrizón, Piya Chatterjee, Emory Elliott, Bob Essick, Percival Everett, John Ganim, George Haggerty, Amelia Jones, Katherine Kinney, Kathleen McHugh, Ethan Nasreddin-Longo, Sally Ness, Eric Reck, Nancy Rettig, Parama Roy, Paul Simon, and Traise Yamamoto. A very special thank-you goes to the late Phillip Brett as well as Sue-Ellen Case and Susan Foster who published an early version of what is now chapter 3.

Colleagues at George Washington University and in the D.C. area also lent their enthusiasm and knowledge to this work. I thank my writing group—Stacy Wolf, Kerric Harvey, and Rosemarie Garland-Thompson, as well as Chris Sten, Faye Moscowitz, Gayle Wald, Bob McRuer, Jim Miller, Nicole King, Kim Hall, and Jeri Zulli. Upon moving to Chicago, I had the good fortune to work with another group of generous colleagues. Here, I acknowledge the input of Michael Anania, Mark Canuel, Lisa Freeman, Jamie Daniel, Lansiné Kaba, Charles Mills, Jim Hall, Mildred McGinnis, and Dwight McBride. David Lloyd and George Lipsitz made excellent suggestions on a preliminary draft of the manuscript and I thank them for their critiques and encouragement.

I thank the librarians at Northwestern, the British Library, the Newberry Library, and most especially the St. Bridewell Printing Library where Nigel Roche and Denise Roughan assisted me greatly. Roman

Stansberry of Northwestern's art slide library was an invaluable resource. Annette Carlozzi and Kay Tasian of the University of Texas at Austin's Blanton Museum of Art helped me with the Kusama material.

I am thankful as well for the ongoing support of Hazel Carby, Joseph Roach, Hortense Spillers, Ronald Judy, Jonathan Arac, Peter Stallybrass, Emory Elliott, Cathy Davidson, George Lipsitz, Robyn Wiegman, Inderpal Grewal, David Román, and Jill Dolan. I thank Harryette Mullen who generously shared her then unpublished work with me. I thank Joshua Dale for putting me up in Tokyo and talking through ideas. At Northwestern, I thank all my colleagues who have offered help, and am grateful to Kevin Bell, Kathy Daniels, Tracy Davis, Tasha Dennison, Jillana Enteen, Betsy Errkila, Marsha Figaro, Reg Gibbons, John Keene, Jules Law, Susan Manning, Jeff Masten, Nathan Mead, Sandra Richards, Wendy Wall, Alex Weheliye, and Harvey Young—many of whom read and/or gave me suggestions on my work. I thank Dean Dan Linzer for granting me leave and supporting my research.

A postdoctoral fellowship from the Ford Foundation, an award for independent research against homophobia from the Monette-Horwitz Foundation, and research money from the Weinberg College Board of Visitors Research and Teaching Professorship made this project possible. Many students have assisted me with the project, including Rachel Reynolds, Katy Chiles, Katie Zien, John McGlothlin, Stacy Lawrence, and especially Jenn Tyburczy. Various audience members and colleagues across the nation contributed wonderful responses to my talks on this material. I want to thank audiences at UCLA, Duke, NYU, UC Santa Cruz, Cornell, UT Austin, Brown, and Yale. Many individuals at these institutions provided useful suggestions, including Stan Abe, Ann Cvectovich, Michelle and Harry Elam, Jody Greene, Gretchen Phillips, Wahneema Lubiano, Kara Keeling, Srinivas Aravamudan, Judith Halberstam, José Muñoz, and Rachel Lee. My Women and Theatre Program community of scholars includes Rebecca Schneider and Jane Desmond, who served as readers on this project, as well as Ann Pellegrini, Kate Davy, Elin Diamond, Janelle Reinelt, and Lisa Merrill. I thank all the scholars from the Black Performance Theory group for their work, especially Tommy DeFrantz, John Jackson, Wendy Walters, Richard Green, and Anna Scott. Michael Main deserves extra special mention for his many contributions to this project.

I cannot thank Duke University Press enough for their commitment to this book. Chief among those at the Press is Ken Wissoker, to whom

I shall always be indebted. Also, Courtney Berger, Amy Ruth Buchanan, Justin Faerber, and others at the Press aided me in the completion of this book. Martin L. White completed the index.

Richard Artschwager proved to be a wonderful interlocutor and this book owes much to his singular vision. Similarly, I thank Bill T. Jones, Yayoi Kusama, and Miranda July for permission to cite their inspirational work. E. Patrick Johnson has been a friend and colleague: I thank him for reading drafts of several chapters; I benefited from his encouragement and generosity.

I acknowledge the contributions of Nathan and Erness Brody, Alan, Melinda, Aidan, and Piper Brody, Judith and David Sensibar, Elizabeth Alexander, Ficre Gheybreysus, Gene Willis, John Simmons, Carolyn and Clifford Crowder, the Beyer-Campbell Family, Carol and Gerry Neuman, Sarah Shelton, Dana Gingell, and Anne Cubilié. In closing, I thank Sharon Patricia Holland who has shared so many moments of joy with me and who has done so much to make this work, and our life together, not only possible but also meaningful. I am grateful for her interest in the swung dash, Oxford commas, and other arcane subjects.

For(e)thought:
Pre/Script: gesturestyluspunctum

"I grew up with a lot of punctuation myself, so I can understand your nostalgia for parentheses," the dashing Sister Kâ exclaimed to her dingbat friend across the periodic table.
—Harryette Mullen, *Sleeping with the Dictionary*

History has left its residue in punctuation marks, and it is history, far more than meaning or grammatical function, that looks out at us, rigidified and trembling slightly, from every mark of punctuation.
—Theodor Adorno, "Punctuation Marks"

Nostalgia. History. Punctuation? Yes. Punctuation—ubiquitous, understudied, unconscious, undone, present, presentational, peripatetic, imported, important. Repeated, albeit differently, in the epigraphs above, is the issue of what is lost (in punctuation), which is to say, what is found there. The dynamics of this discursive as well as cursive and recursive formation give us pause in both senses of the term. How do these marks function and how do we come to know them even before we understand them? Whatever their value or number (are there nine marks? eleven?), we cannot refute their (im)material existence.

Dear reader, you should know right away, here, upfront and in the very beginning, that I do not count myself among those punctuationists for whom prescriptivist rules rule (go Truss yourself should you wish to be bound by convention!); rather, this study errs with the errant—tolerating and even encouraging circulation among artistic representations of punctuation marks in a mode closer to those linguists who call themselves descriptivists (and even this may be inaccurate given my distrust

of concepts such as found or natural language, not to mention the pre-scriptivist/descriptivist binary).[1] Unlike most punctuationists, I eschew a punctilious approach to punctuation. As a result, this book, rather than arguing a point, argues and plays with points—specifically points made about punctuation. The previous statement can be read as a tautological phrase given that previously and elsewhere—namely in the early modern period in Great Britain—punctuation marks were known as points. The readings that follow rely upon the work of experimental artists—poets, painters, dancers—many of whom can be seen as championing the "visual" or "spatial" turn in cultural studies. Concerned less with "logos (the word)" than with "logo (the icon)"—such artists struggle with predominately visual rather than strictly grammatical understandings of punctuation.[2] Thus, this book focuses on punctuation marks as visual (re)marks.

Disagreeing with the speaker in e.e. cummings's poem "since feeling is first," who asserts that "life's not a paragraph/And death i think is no parenthesis," this book argues that punctuation can indeed be thought of as (a) matter of life and death as well as embodiment. Certainly, I believe that punctuation pertains to an "archive of feelings"—we need only recall the nostalgia cited above—for punctuation marks historically have provided much of the affect of Western print culture since the Enlightenment. We may be tempted to ask: Who invented punctuation and why? We cannot answer such an impossible question and yet we know that "it wasn't there before us so we must have invented it, like we invented Yes and No."[3] The advent of punctuation remains and shall remain unwritten. Nevertheless, some of its origin stories will be replayed, obliquely, in and on the pages that follow. Let us begin with one origin story composed for this occasion.

A Handmaid's Tale

Allegory can be an ally. Let's hear from Mr. Herd (himself herded among a series of quotations selected by Mr. Eric Partridge, to whom any good punctuationist must pay homage, for it was he, Partridge, who understood that we are altogether too much guided in the matter of punctuation). As Mr. Herd (as quoted by Partridge) states: "When punctuation was first employed, it was in the role of the handmaid of prose; later the handmaid was transformed by the pedants into a harsh-faced chaperone, pervertedly ingenious in the contriving of stiff regulations and starched

rules of decorum; now, happily, she is content to act as an auxiliary to the writer and as a guide to the reader."[4] By what alchemy or agency was punctuation "first employed" as a handmaid? When, how, and why was it transformed from chaperone to auxiliary and guide? There is little doubt that, when first employed, punctuation was handmade. Tracing its trajectory from maid to chaperone and ultimately to guide mimics shifts not only in time, type (of work), or demeanor, but also shifts in gender, sexuality, age, nationality, class, and ethnicity. The often-feminized punctuation becomes not only con*tent*, but also *con*tent. The representation of Herd's quotation marks a shift from anonymous prose to that of a mediator between a dyad known as the writer and the reader. This "handmaid's tale" traces a teleological trajectory that transmogrifies the handmaid into an auxiliary (old) maid. Such, perhaps, has been the way of the wor(l)d.

Punctuation's Aspirations

Punctuation's aspirations are problematic. Punctuation is not a proper object: it is neither speech nor writing; art nor craft; sound nor silence. It may be neither here nor there and yet somehow it is everywhere. As such, punctuation performs as a type of (im)material event or, perhaps, as a supplement.[5] Relatively unexamined and certainly undertheorized, punctuation proves to be an unwieldy subject of inquiry. Pedants and language mavens alike have worried about and over (not to mention with) punctuation's properties—What is its proper placement? How does it affect meaning? In their ongoing efforts to pinpoint punctuation's ambiguous movements and to rein in punctuation's tendency toward excess, countless guides to punctuation caution against its misuse, which most frequently is characterized by the trope of overuse or excess. In such treatises, punctuation's proliferation often leads to the devaluation of the prose that employs it. Attempting to reduce punctuation to a system, such tomes codify the marks rather than think of them as art (or at least think of them artfully, as subject to poetic license). Numerous other texts historicize punctuation's appearances—schematizing its presence and absence in and for different eras and areas. There are those who argue that excess punctuation is an effect of style (rather than merely an effete defect or evidence of an overly affected style). Still others see too much punctuation as a mark of "bad" writing and "poor" literary style where "literary style [may be] the power to move freely in length and breadth of linguistic thinking without slipping into banality."[6] According to most manuals,

excessive use of punctuation produces writing that is banal rather than original; illiterate rather than literate; crude rather than erudite.

On the matter of literary value and literacy, I follow those who advocate for an expanded view of writing: one that cannot demarcate the ends of speech and the beginning of writing, and where it is impossible to have a text without a "con" or context. It is precisely punctuation's ambiguous excessive *tendencies* that attract me.[7] Here, we should remember that the invention of punctuation is a belated addition in all histories of writing. As the title of this section reveals, *scriptio continua* was the norm in earlier periods (before the period). Although there is no origin(al) of writing, historical scripts describe punctuation as an after/effect of writing and ascribe to it literally and figuratively a secondary position, akin to certain versions of the story of Eve. To recall Adorno's words in the epigraph, such is the residue of history retained, and contained, in a personification, in every mark of punctuation. As mentioned previously, with some frequency punctuation performs a feminized, ephemeral, nonessential (and yet fundamental) role to the construction of meaning. A belated, belittled, nonessential substance (to understanding), punctuation is thought to serve as a mere assistant to authors and other supposed authorities. In truth, there are no authors of punctuation although authorities on the subject abound.

The number of tracts about punctuation is far too vast to analyze in this monograph. My goal is to encourage readers to be attuned to punctuation's contradictory performances. This book moves consciously but not teleologically among handwriting, print graphics, performative painting, digital art, dancing texts, and more. It does so because despite the fact that some histories see these technologies as "progressive"—where each new innovation supplants the previous one—in practice, the progress proves to be jagged, uneven, and overlapping. Despite "being digital" we have not yet surpassed the era of the pen and paper—not yet is the entire world wired.

Punctuation marks are thought to have little literary value, in part because there is a question about who authors punctuation and how it is authorized—this despite the fact that since at least the eighteenth century, authorities on the proper use of punctuation have increased. By remembering the uncredited role that copyeditors and compositors play and have played in (re)placing punctuation marks we may understand how these workers (not artists) served as mere "mechanical" assistants

to "authors" who were given authority over what were in fact complex collaborations.[8] In such settings, punctuation marks function as shadow figures that both compose and haunt writing's substance. The problem of who "authors" punctuation appears in a stylebook that queries: "Has any critic or reviewer ever praised an author for being a master [note gender] of punctuation, a virtuoso of commas? Has anyone ever won a Pulitzer prize, much less a Nobel, for elegant distinctions between dash and colon, semicolon and comma?"[9] In fact, there have been studies of a single author's use of particular punctuation marks. Moreover, writers themselves often have articulated interesting ideas about punctuation. As Truman Capote says: "I think of myself as a stylist and stylists can become notoriously obsessed with the placing of a comma, the weight of a semi-colon."[10] Gertrude Stein, James Joyce, John Steinbeck, and Nadine Gordimer, to name only a very few, are among the writers who believe that quotation marks in dialogue intrude on the printed page and therefore refuse to use them.

How, then, can we approach the "subject" (of) punctuation? Is it possible to breathe (new) life into this matter? In this study I argue that punctuation's paradoxical performances produce excessive meaning, and that such performances are part and parcel of both the politics and poetics of punctuation. I look at how punctuation marks mediate, express, (re)present, and perform—the interactions between the stage of the page and the work of the mind. Because I concur with Gertrude Stein's statement that "some punctuation is interesting and some is not," I have organized the book around different "points" that I have found interesting. The book's chapters are performative "think pieces" designed to take readers on a peripatetic intellectual journey. The chapters move creatively among different kinds of textual material. This strategy has allowed me to limit the scope of the project that touches upon so many research areas— the history of technology, the physiology of reading, the psychology of perception, and the philosophical investigations into the linguistics of writing, to name only a few. I have aimed to engage readers in thinking about and with punctuation marks—to see punctuation proliferate and take on different guises. While I at times discuss specific sociohistorical and geopolitical contexts for the artistic texts I analyze, it is the structural uncertainties, paradoxical figures, and theoretical conundrums that provide the jagged through line to this study.

How do these performed gestures work and what kind of work do

they do? Are they affect or effect? By thinking of (and with) punctuation marks as "material" events, in this study I explore how and why punctuation is matter that performs affect effectively and vice versa. Moreover, by examining punctuation's (inter)actions as cultural performances, I argue that punctuation plays a key role in our quotidian movements and missteps by stopping, staying, and delaying the incessant flows of information to which we are subject. In this book I read dots, ellipses, hyphens, quotation marks, semicolons, colons, and exclamation points through the trans and/or interdisciplinary lens of performance studies (which includes cultural and visual studies). I query punctuation's engagements with issues of life, death, art, and (identity) politics. Riffing on the famous collaboration by William Strunk and his student E. B. White, I look at the ways in which selected punctuation marks perform as forms of style as well as the ways in which they style form. As suggested by Kobena Mercer, among others (including unwittingly if wittily Strunk and White), aesthetic style is deeply political.[11]

This book shows how punctuation simultaneously comprises, composes, and compromises thought through its gestures. Punctuation marks matter in both senses of the term. The discussion above that conceptualized punctuation as the "handmaiden" and "helpmeet" to speech reveals the gendered as well as raced, classed, and sexualized discourse through which we have come to understand punctuation. Indeed, the discursive production of punctuation depends upon the repeated (and I would add nostalgic, especially in our posthuman era) reproduction of anthropomorphic terms. It is easy to personify punctuation. This may be a result of the fact that one of punctuation's many functions is to endow print with affect and emotion. Punctuation marks can serve as both sense and sensibility—as the most human element in certain sentences.

Let's call this element affect. Human "being" leaps off the page when we see a question mark, a period, or exclamation mark. We react viscerally to punctuation. Here, punctuation is performative. Punctuation's figurations are read, discussed, represented, and felt in bodily terms, and by turns talk of punctuation returns us to elements of the body as both tenor and vehicle of communication. In a recent advertisement by the communications conglomerate Comcast, the smiley face icon was replaced in a horizontal diptych by a photographed human smile—bringing such linguistic circuits full circle.

In certain Roman texts interpuncts were not carved but added in

paint by scribes. Such inscriptions/handwriting may be understood literally and figuratively as strokes of humanism. One of the originary myths about punctuation is that the Romans invented it to help senate orators remember their political speeches and to deliver them with dramatic effect.[12] Cicero's concepts of the *sermo corporis* and the *eloquentia corporis* referred to "the entire delivery of a speech, both the voice (as an emanation of the body) and the gesticulation accompanying it."[13] Punctuation serves as a form of non-verbal communication. As with kinesics, there is a correspondence between punctuation marks and other kinds of bodily discourse. As such, punctuation's performances are vital forms of interaction. "The difference between a face-to-face encounter and a telephone conversation is a reminder of the extent to which facial expression and bodily movements can amplify, modify, confirm, or subvert verbal utterance," in short, can "act" like punctuation and vice versa.[14]

Punctuation appears in/as writing as a means of inscribing bodily affect and presence imagined to be lost in translation. Punctuation's performances situate and suture the indivisible doubled relation captured in and by the phrase "embodied text." We must remember, however, that, as Jonathan Goldberg argues, "the hand moves in language, and its movement retraces the 'being' of the individual inscribed within simulative social practices that are lived as ordinary experience . . . Touching and seeing are not immediate but mediated through the letter-blocks [or punctuation], sensitizing the hand and eye to a world of inscription re-inscribed in the practice of writing . . . such that we recognize the ways in which being (human, material) is scripted."[15]

This project proposes to remove punctuation from the province of linguistics, semantics, and grammar, and place it in what Mary Louise Pratt calls the "global contact zone" where literary, visual, and performance studies meet. The book should be read as participating in a much larger scholarly project that shifts its focus away from master narrative/subjects to "other" constituencies. While there may not be spoken-language equivalents of punctuation, except perhaps performatively, I want to expand the definition delimited previously by claiming that beyond intonation—what we might call the trace of the sound of punctuation—punctuation may be read in bodily inscription as and through gesture. The title of this opening chapter recalls this connection. Gesture, as defined by the *Concise Oxford Dictionary*, is a "significant movement of limb or body; use of such movements as expression of feeling or rhetorical device." This

book eschews a systematized study of punctuation in favor of elaborating upon the ludic, lewd, and lived if not always live performances of specific punctuation marks.

In a sense "silent" by design, one wonders that if punctuation marks could speak then what would they say and how would they say it? Avital Ronell writes that "punctuation hails our sonic gaze."[16] The oral/aural optic and sound vision through and by which Ronell understands and underscores the undecidability of punctuation informs my own project, which similarly seeks to mute and obscure the priority given to either side of the false binary between speech and writing. The use of such a paradox seems (seams) apt. For punctuation cuts "up and across," which is to say into imagined depths and across fictive surfaces.[17] As it lifts itself from the page, like a lifting belly, punctuation moves from the "flat" two-dimensional surface to become a three-dimensional frame. Writing cuts into the page and moves out from it as if it were embossed—as if it were simultaneously concave and convex. "Graphesis and incision are etymologically one."[18] Cross-stitch, cross-hatch, hatchet.

Phenomenologically it is difficult if not impossible to hear the voice of punctuation marks and to be with punctuation. In the comedic parodic performances of Victor Borge, however, we have heard the sound of punctuation marks voiced.[19] In Borge's routine, a question mark is sounded out as a "yip" while a period is heard as a "bip." Marjorie Garber also mentions the performances by Victor Borge in which he translates different punctuation marks into aural/oral cues such that two commas would be rendered as "squeaky pop, squeaky pop."[20] Punctuation marks can be marked by corresponding sounds—by the act of translation, which necessarily transforms transcription. They allow us to enter a disorienting circuit among voice, thought, body, writing, and graphicity as a number of educational videos that use actors to perform as punctuation marks help to underscore.

In sign language (is there any other kind?), punctuation marks are represented by an arched brow or other bodily movements. By contrast, as Della Pollock theorizes in her important essay on metonymic performative writing, such writing "tends [to] displace itself, to unwrite itself at the very moment of composition, opening language to what it is not and can never be. Writing performed *in extremis* [in extremeties?] becomes unwriting. It un/does itself. Even this phrase—'un/does itself'—is a minor metonymy. It marks the materiality of the sign with the use of a practically unspeakable, non- or counter-presentational element of punc-

tuation, an element intelligible only by reference to visual grammatical codes by which a slash or '/' is distinguishable from a '!' or ';', that in its particular use here to divide and double a word—to make the word mean at least two things at once and so to refuse identification with a unitary system of meaning—locates language itself within the medium of print-play."[21] My project extends Pollock's ideas about writing in an extreme manner by thinking of punctuation as extremities, as phantom limbs. This is another way of understanding punctuation's performative excess and bodily play. Punctuation points out the problem, the (k)not of con-nection that ties together binary terms such as orality and literacy, as well as mind and body. Punctuation stages an intervention between utterance and inscription, speech and writing, activism/activity and apathy, body and gesture. It is seen and unspoken, sounded and unseen.

According to the authorities Strunk and White (who are discussed in chapter 3), innovative uses of punctuation often come from the area of advertising. Indeed, we can learn something of punctuation's value when placing an ad in a newspaper. For example, the guidelines for one paper state that the inclusion of "punctuation does not affect the word count." In other words, it will not cost you to use it, unless you hyphenate a word or delete spaces. This is but one example of the value of punctua-tion. "The 'exact value' of the individual points is arbitrary: there can be no single exact value, for every point varies in syntactical importance and in elocutionary duration according to the almost infinite potential variations of the contexts. But the relative importance, whether syntacti-cal and logical, or elocutionary and rhetorical, is not arbitrary."[22]

The poet Samuel Taylor Coleridge drafted an essay on punctuation in which he conceptualizes, in a very performative manner, his own theory of punctuation. The essay begins:

Punctuation. Four stops, two marks of movement, and a stroke, or expression of the indefinite or fragmentary—
Comma , Semicolon ; Colon : Period . Mark Interrogation ? Note of Admiration ! Stroke – .

He then writes:

It appears next to self-evident, that the first four or five characters can never be made to represent all the modes and subtle distinctions of connection, accumulation, disjunction, and completion of sense—it would be quite as absurd as to imagine that the ? and ! should des-

ignate all the moods of passion, that we convey by interrogation or wonder—as the simple question for information—the ironical—the impetuous—the ratiocinative &c—No! this must be left to the understanding of the Reader or Hearer. What then is their use?[23]

Coleridge is hardly the first writer to question the purpose of these marks. What he decides in the course of his musings on the subject is that they correspond to a speaker's breath. Coleridge considers "each stop separately" before offering his main thesis that punctuation is, relatively speaking, more rhetorical than syntactical, although he too understands that these are not binary oppositions. I quote Coleridge at length because his poetic prose complements my own ideas about "connection, accumulation and disjunction" as these actions can be attributed to punctuation. For example, he outlines my understanding of punctuation as political and performative. In explicating Coleridge's text, we should not overlook the significance of his example for demonstrating punctuation's function. By taking slavery as his example his treatise becomes part of abolitionist discourse. Historically, then, punctuation has had a role to play in the era's circum-Atlantic debates about literacy, slavery, and freedom.[24] By explicitly invoking the slave trade in his essay, Coleridge betrays his abolitionist sympathies. Unlike the thinkers who characterized the trade in purely logical terms (attending to its economic aspects), Coleridge, working from his Romantic stance, weds passion with intellect.[25] In humanist discourse, punctuation marks can be personified (we do not, for example, think about punctuation's animalistic qualities). What then do we make of the figure of the slave—the chattel personal? Can it be seen as a close relation if not another example of punctuation? A black mark of affective labor? A supplement to the Human? As I read it, such questions pertain to Coleridge's academic disquisition on the drama of punctuation. He writes:

> I look on the stops not as logical Symbols, but rather as dramatic *directions* representing the process of Thinking and Speaking conjointly—either therefore the regulation of the Breath simply, for in very long periods of exceedingly close reasoning this occurs; or as the movements in the Speaker's Thoughts make him regulate his Breath, pause longer or shorter, & prepare his voice before the pause for the pause—As for instance—[and his example is telling and timely given that Britain ended the slave trade in 1807] "No good man can contem-

plate the African Slave-Trade without horror, who has once read an account of the wars & atrocious kidnapping practised in the procuring of the Slaves, the horrors of the middle passage in the conveyance of them, or the outrage to our common nature in the too frequent and always possible final cruelty in employing & punishing them. Then, too, the fearful effect on the oppressors' own minds, the hardness, pride, proneness to frantic anger, sensuality, and the deadening of the moral sense—respecting the distinctions between Thing & Person will force the thoughts thro' a fresh Channel to the common Bay and Receptacle, in which the mind floats at anchor upon its accumulated Thoughts, deep & with a sure bottom of arguments & grounds, yet wavy with the pas[s]ions of honest Indignation." Now here the later sense is equally the ground of the proposition with the former—; but the former might be, & is gracefully regarded as the whole, at the commencement in the Speaker's view. He pauses—then the activity of the mind, generating upon its generations, starts anew—& the pause is not, for which I am contending, at all *retrospective*, but always prospective—that is, the pause is not affected by what actually follows, but by what anterior to it was foreseen as following. (423–24)

Coleridge's thinking about time here emphasizes the dramatic moment of the pause that anticipates a future via a sense of déjà vu. Like performance theorists' invocation of "twice-restored behavior"—the echo in the pause—Coleridge underscores the convention of expectation—of set lines of communication that (pre)determine interaction. So, too, he shows how punctuation marks both orient and represent Thinking and Speaking (the active gerund forms of thought and speech) conjointly. He amplifies punctuation and reads it in several registers. These ideas will recur in my study along with Coleridge's wonderful concept-metaphor of "generating on generations [that] starts anew" and where "the pause is not retrospective but prospective" thereby showing punctuation's prospects. This may be an appropriately prescient invocation of contemporary conceptions of performance. Coleridge's performance piece characterizes his own métier and medium (that of a writer) in multimedia terms—as "an artist in words" akin to a sculptor or a painter as makers of tangible things. As he concludes:

It is the first and simplest duty of a Writer, i.e. an artist in words, as a Statuary is in Marble, or a Painter in coloured Surfaces—to make

the pauses, which the movements of his Thought require in order to be intelligible, consistent with an easy regulation of the Breath—not that the Stop depends upon the Breath, but that it should prevent the Breath from making a stop from its own necessity . . . Supposing then therefore (& surely, it would be absurd to lay down rules for punctuating what ought not to have been written) I would say, that Punctuation expresses—say, rather—generally *hints* the sorts of pause which the Speaker makes, and the tones accompanying & leading to them from the Speaker's foresight of his own meaning. Punctuation therefore is always prospective: that is, it is not made according to the actual weight & difference or equality of the logical connections, but to the view which the Speaker is supposed to have at the moment, in which he speaks a particular sentence. Therefore I call them not symbols of Logic, but dramatic directions, enabling the reader more easily to place himself in the state of the writer or original Speaker. (424)

Punctuation is the conduit that directs us to creation, the trace of the presence of an embodied act (that Coleridge's manuscript, in its humanist guise, characterizes "the state of the writer or original speaker"). How interesting that it is not the speaker, but rather the state of the speaker or writer—his affect and feeling—that punctuation records/accords. Coleridge's thinking/writing on the subject speaks to oration, sound, thought, flow of ideas, tempo, passion, a kind of artistic license or freedom—or logic (some would see as "illogic") which is imbued inextricably by the subjectivity of the writerly speaker and speakerly writer—an undecidability that cannot be resolved.[26]

The Echo in the Pause

Emphasizing the performative aspects of punctuation, neither purely functional nor merely figurative, helps us to read punctuation as a mediator between speech and writing, performance and gesture. As I have been arguing, punctuation need not be thought of purely in terms of its proper use, but rather may be valued for its expressive, artistic use.[27] This idea runs counter to other definitions of punctuation such as that offered by the *Cambridge Encyclopedia of Language*, which asserts that punctuation marks roughly correspond to "suprasegmentals" but are not technically parts of speech.[28] Further, this encyclopedia notes that such graphemes are understudied and underappreciated, and it claims

that "there is little in speech that corresponds [to punctuation], apart from the occasional prosodic feature: for example, question marks may be expressed by rising intonation; exclamation marks or underlining may increase loudness; and parentheses may lower tempo, loudness and pitch. But the majority of graphic features present a system of contrasts that has no spoken-language equivalent" (179).[29] Throughout this study, I argue that punctuation choreographs and orchestrates thought.

Similarly, Kathryn Sutherland, one of the editors of a revised Cambridge edition of Jane Austen's works, takes note of Austen's experimentation with punctuation by explaining that "a great deal of [representing the voice] relies on a kind of ungrammaticality, on vocal encroachment, and capturing the rhythms of conversation, which are counter-syntactic." She goes on to explain that "restoring expressive punctuation may further new approaches to Austen by reintroducing 'what I would call the noise of her text.'"[30] Sutherland suggests my line of argument about the materiality of punctuation. These are the tenets of "close reading" and good editing in which each mark on the page matters and is the matter of and with writing.

The obscure writer Fran Ross in her riotous and ribald comic novel *Oreo*, published in the 1970s, gives examples of bawdy and brilliant language play. A metacritical moment in the novel employs punctuation as thought-speech: "From time to time, her [Louise's] dialogue will be rendered in ordinary English, which Louise does not speak. To do full justice to her speech would require a ladder of footnotes and glosses, a tic of apostrophes (aphaeresis, hyphaeresis, apocope) and a Louise-ese/ English dictionary of phonetic spellings."[31] Were we to note each punctuation mark in spoken discourse, the ability to focus on the flow of information, the subject, and the main point would be compromised — lost in frequent interdictions, interjections, and interruptions. We could not go on speaking punctuation marks could we [question mark]. What kind of information and meaning would be conveyed were we to do so [question mark]. If one were to persist in speaking punctuation [comma] it would be irritating. In sounding aloud such marks, we might sound like the Homebody of Tony Kushner's play *Homebody/Kabul* (note slash), whose speech is punctuated not by punctuation, but rather by interjections — all the result of having read too many books. Her monologue sounds as if it is writing that should be written and read rather than overheard. The Homebody's monologue is explicated in the prefatory notes to the play

where Kushner explains that "when the Homebody, in Act One, Scene 1, refers to the street on which she found the hat shop, she doesn't mention its name; instead, where the name would fall in the sentence, she makes a wide, sweeping gesture in the air with her right hand, almost as if to say: 'I know the name but I will not tell you.' It is the same gesture each time."[32] In the printed monologue, this movement is rendered "_____ (Gesture)." Is this punctuation? How are we to read such expressivity in the text and on the stage? The very necessity of explaining its expressivity speaks to our need, our desire as different kinds of audiences, to understand such performative gestures. But let me return to my explication of the punctuation mark as a paradoxically unspoken helpmeet to speech acts or, more precisely, to the tension and tempo inherent in written and spoken texts that return us to the roots of writing and perhaps even race, writing, and difference (not to mention to Ronell's synaesthetic sonic gaze).

As the well-known and respected typographer Robert Bringhurst notes: "Typographic ethnocentricity and racism also have thrived in the last hundred years, and much of that narrow-mindedness is institutionalized in the workings of machines. Unregenerate, uneducated fonts and keyboards, defiantly incapable of setting anything beyond the most rudimentary Anglo-American alphabet, are still not difficult to find. . . . Neither typographers nor their tools should labor under the sad misapprehension that no one will ever mention crêpes, flambées, or aïoli, that no one will have a name like Antonín Dvorák or Søren Kierkegaard."[33] I want to note the global circulation of fonts inscribed in the limits of the machine, which tie together Coleridge's ideas with another way of thinking about punctuation's global politics.[34] So too I note here that there is more work to be done on how punctuation marks work in different languages.

Wrangling with what or how punctuation performs as well as represents thought (as well as bodily presence?) is a major focus of this project. How does punctuation convey meaning in different contexts and how do we read its multifarious marks as remarks? The extent to which punctuation speaks is in dispute. Again, Robert Bringhurst believes that "punctuation is cold notation; it is not frustrated speech; it is typographic code."[35] This understanding of punctuation resembles Brent Edwards's reading of Louis Armstrong's excessive punctuation as a kind of "scat aesthetics" in which "graphic accompaniment [graphicity] . . . doesn't

clarify the writing. . . . Instead, it actually makes [it] more daunting, giving too much indexical information, pointing in too many directions at once, invading the spaces between words with a thicket of punctuation that threatens to become impenetrable."[36] Edwards is right to read punctuation as profoundly performative and excessive—as neither a recorded translation of speech or voice nor a mark of idiosyncratic ignorance, but rather as meaningful, effective, and indeed affective excess.[37]

The Chicago Manual of Style suggests that "punctuation should be governed by its function, which is to make the author's meaning clear, to promote ease of reading, and in varying degrees to contribute to the author's style. Although there is inevitably a certain amount of subjectivity in punctuation, there are some principles that the author and editor should know lest the subjective element become so arbitrary as to obscure the sense or make the reader's task difficult or unpleasant."[38] This description of punctuation's functionality echoes other prescriptive style manuals that desire to codify and regulate punctuation's marks. Government printing guides and generations of English teachers have sought to standardize the proper use of these marks, thereby marking national, educational, and class status.

As Michael North writes of the 1920s modernist desire to employ dialect in the context of the increased codification of "standard style"—not coincidently coterminus with Fordist production and film talkies—organizations such as the SPE, or Society for Pure English, founded in 1913 in England by Robert Bridges, and the American Academy of Arts and Letters (founded in 1916), like the Academie Française in France, sought to preserve national pride via regulating language use. In their view, "language becomes the cornerstone of national identity and an index of cultural health. . . . Defense of the language became an indirect and intellectually respectable way of defending the borders."[39] While the debate about proper use is properly debated elsewhere, I mention it in conjunction with my study of punctuation because it points to the larger debate about rhetorical versus grammatical punctuation, between the written and the oral, and between aural and printed forms.

As in Theresa Hak Kyung Cha's text *Dictee* (1982), these different modes of address perform together. In one of the opening pages of the text, the punctuation is written in letters, as transliterated words—first in French, then in English. I represent the words here (having changed the font and italicized the worded punctuation) as follows:

Aller à la ligne C'etait le premier jour *point* Elle venait de loin *point* ce soir au dîner *virgule* les familles demanderaient *virgule ouvre les guillemets* Ca c'est bien passé le premier jour *point d'interrogation ferme les guillemets* au moins *virgule* dire le moins possible *virgule* la résponse serait *virgule ouvre les guillemets* Il n'y a qu'une chose *point ferme les guillemets ouvre les guillemets* Il ya quelqu'une *point* loin *point ferme les guillemets*

Open paragraph It was the first day period She had come from afar period tonight at dinner comma the families would ask comma open quotation marks How was the first day interrogation mark close quotation marks at least to say the least of it possible comma the answer would be open quotation marks there is but one thing period There is someone period From a far period close quotation marks[40]

The repetition of the phrase, "a far period" speaks both to a historical past and place. The first day of interrogation mark (verb) close (similar) quotation—the answers required by interrogation coerced, produced. As rendered in English, reading the punctuation marks as part of the sentence opens up the meaning conveyed. For example, in the line "the answer would be open . . . From a far period close" (time and space) does "far" modify "period close" read as distance rather than as the verb "close"? All possibilities are open to interpretation. Rendering punctuation as words says something different than rendering them as marks. These opening paragraphs are followed with a discussion of the physicality of speech—(leading ultimately to diagrams of the epiglottis). Cha's representation of the struggle for speech, for translation, is documented viscerally. She speaks of the efforts of "mimicking" speaking such . . . "That it might resemble speech. (Anything at all.) Bared noise, groan, bits torn from words. Since she hesitates to measure the accuracy, she resorts to mimicking gestures with the mouth" (3). Cha moves to a discussion of the echo, and the pause as well as the echo in the pause.

She waits inside the pause. Inside her. Now. This very moment. . . . She would take on their punctuation. She waits to service this. Theirs. Punctuation. She would become, herself, demarcations. Absorb it. Spill it. Seize upon the punctuation. Last air. Give her. Her. The relay. Voice. Assign. Hand it. Deliver it. Deliver." (4)

This "taking on" is both a disguise and a takeover—Bhabha's mimicry as menace.[41] Cha alludes to the fact that punctuation is an importa-

tion from the West for many "Eastern" languages, exemplifying a tenet of post*coloni*ality that is the time-space disjunction that aligns the past of the West with the modernity of the rest creating a perpetual time-lag between ideas of a first and third world. Later she makes explicit the idea that there is a connection between ink and blood.

Anne Anlin Cheng, in her eloquent reading of Cha's illustrated text characterizes the style of the text as "concision laced with lyricism."[42] She notes that "*Dictee* raises the challenge that form and aesthetic (specifically, the style of the fragment) poses for the claims of cultural studies" (142). Another way of thinking about the difficulty of the text, then, is to think about how its aesthetic form plays out in its political critique. In short, its very cryptic (in both senses of the term) form bespeaks the history of political conquest undergone by Korea that continues to mark Cha's "personal" and therefore "political" history. Without reading the scene in detail, Cheng notes:

> the first prose section of the book opens with literally a record of a language lesson, where we are given the record of a French dictation in French and then the English translation that follows. What is obviously curious about the English translation is that it . . . spells out both the sentences being dictated *and* the punctuation commands. As critics Shelly Sunn Wong and Lisa Lowe have pointed out, this familiar and mundane scene of a grammar lesson resonates in the colonial context of Korea. The scene calls forth French missionaries' systematic colonization of Korea in the early twentieth century . . . [as well as] the Japanese occupation from 1910 to 1945." (158)

Again, we see how punctuation can partake in subjectivity and the disciplining of the Subject can facilitate corrections.[43]

As the award-winning play *W;T* shows, punctuation has long been the province of English teachers. An anonymous English teacher notes in a 1680 work titled "Treatise of Stops, Points, or Pauses" that "a full stop is a Note of perfect Sense and of perfect Sentence." Interest in punctuation predates the Renaissance, according to M. B. Parkes, who dates its transmission to the sixth century and Isidore de Seville (560–636) who had a preference for silent reading, a technique that changed our relationship to the written word. Parkes reads punctuation purely as a phenomenon of written language. Whereas he sees punctuation's primary function as the resolution of structural uncertainties in a text, I prefer to follow Derrida and close the book in order to open the text.[44] I desire to put a playful

"pun" in punctuation, suspecting that in normative accounts of punctuation there is none.[45]

This book moves punctuation to "center stage," thereby giving it weight and depth—in the manner of the sculptor Richard Artschwager's experiments with three-dimensional punctuation marks that literally occupy space and thus force us to interact with them, to notice them, and to confront them on a grand scale. Artschwager's *Question Mark* (1994) is approximately six feet tall.[46] As such this punctuation mark is a subject in its own write/right, and there is no need for a sentence to support it. Its stem dangles delicately: it is suspended from the ceiling while its accompanying points sit boldly on the floor below.[47] Artschwager desires to solicit viewers' interactions and to challenge their "habits of perception." As Melitta Kliege claims, in Artschwager's art "no content is represented; nor is there any interest in formal relationships of mass and plane. Instead, artistic means are used to set up a dialogue with the viewer. . . . This means, crucially, that the artwork is defined and designed as a situation in which—because it is contradictory—certain elements of vision and perception can become accessible as vital experiences."[48] Moreover, Artschwager, who began his career as a furniture maker, juxtaposes objects such as a household wrench and a question mark, asking, "Too far from?" thereby creating a comparison between the tools with which we work with our habits of mind and visual identification. For him, "Art is not an idea; it is a THING. If it dropped on your foot that would hurt."[49] Artschwager is a tool maker, interested in doing things and in things done.

In his 1982 sketch *Sentence* Artschwager frames drawings of dressers (furniture) with quotation marks, and ellipses float about the page suggesting new ways in which punctuation might qualify understanding. Artschwager once suggested that "you could probably make a system of writing which would include how large and how small the letters were [and] also how close or how far away, a couple more variables to which one could assign a set of meanings."[50] For him, "language itself is a visual sign system and when its function as one kind of communi-

Figure 1. Richard Artschwager, *Question Mark* and *Three Periods*, 1994.
Question Mark: Nylon brush on armature of glass fiber, two parts, 345 × 183 × 73 cm (top), 73 cm globe (bottom). Collection Foundation Cartier pour l'art contemporain, Paris. *Three Periods*: Nylon brush on fiberglass, each globe 73 cm. Collection Foundation Cartier pour l'art contemporain, Paris.

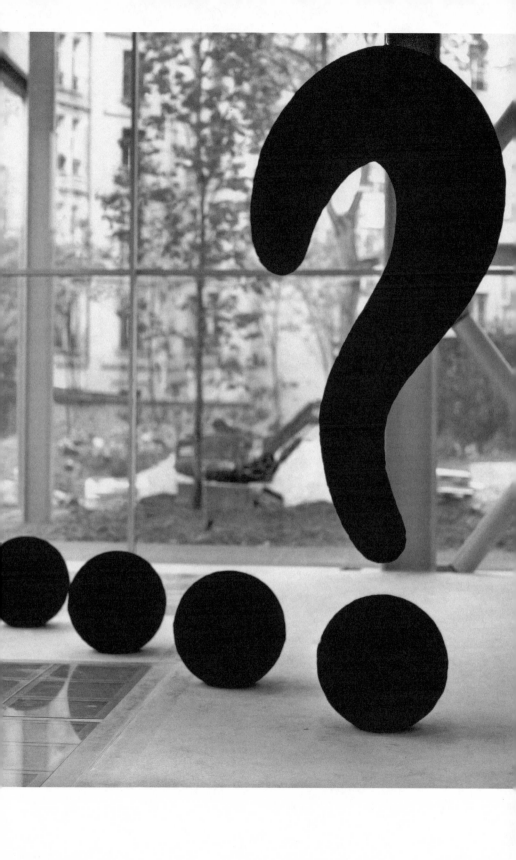

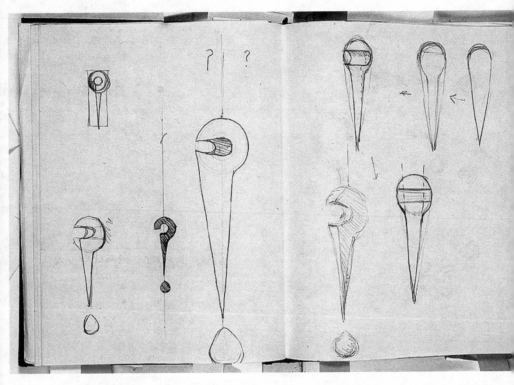

Figure 2. Richard Artschwager, *Notebook Sketch*, not dated. Pencil on paper. Reproduced with permission by the artist.

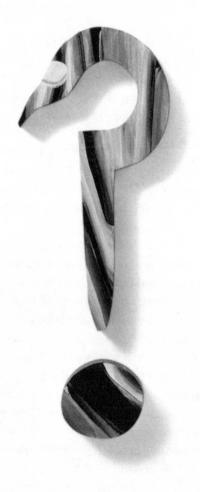

Figure 3. Richard Artschwager, *Pregunta II*, 1983. Painted wood, two parts, 55.8 × 26.8 × 4.4 cm, 14 × 15.2 × 4.7 cm. Brooke Alexander Gallery, New York.

cation device—verbal exchange—is altered, it can be put into service as another communication mechanism—art. To do so is to transform language from a closed system into an open field."[51] His neologism "S-P" defines his sculpture-paintings—the hyphen here denoting the impossibility of resolving the distinction between the two. "Letters and speech often lapse/rise into poetry . . . but the magnet of S-P is always there pulling the words into the service of abridgement."[52] Throughout his work, Artschwager seeks to blur the boundaries not only between sculpture and painting, but also between art and design, and of course art and life. Thus in his notebooks he has written, "I/you place/see it/them";[53] the virgule performs the interactivity and intersubjectivity of making/seeing that is a central tenet of postmodernism, poststructuralism, performance studies, and even psychoanalytic thought. This artistic statement also comments upon priorities of reading: I place it/you see them. It can be read as a series of dyads: I/you place/see it/them. Here, Artschwager connects embodiment and sight, suturing, separating, amplifying, and constructing and environment for interaction.

Punctuation, while related historically to the ear—to the oral/aural nexus, if you will—is also already a visual phenomenon that speaks to the eye via text messages, computer screens, and televisual text—new forms of media for which "the medium is the massage" to quote the title of a famous volume. The abstraction and concretization of punctuation marks mark these new forms. This statement rehearses (do you hear it?) an assertion that Marshall McLuhan makes in his magnum opus *The Gutenberg Galaxy*. While I do not share the anthropological hierarchy made by McLuhan regarding civilized versus primitive cultures that may be understood as either visual or oral, there is something to his thesis. Much of the earlier work on language families is marred by biases: they speak of a hierarchical relationship between primitive dialects and Western languages—of writing as the repository of history. Of the many other signs not addressed here are those found in alchemy, astrology, mathematics, music, metrics, dance notation, Domesday books, and numerous other languages such as Hebrew, Greek, Arabic, Coptic, Sanskrit, Chinese, etc. There are several different alphabetic systems—not all of which include punctuation. It is the Western bias that ranks the phonetic alphabet as superior to hieroglyphics, which were thought to be primitive writing (because they are pictorial rather than abstract, not to mention that they are Egyptian).[54]

Interlude:

COMMAS AND CANARIES

How do you recognize a phenomenon that gives no visible trace? Miners working deep under the earth have long been aware that lethal gases they can neither see nor smell might spell sudden death. Their solution? The hapless canary. For if the caged bird they brought along into the mine succumbed to the silent killer, the miners knew to evacuate immediately. Only by the aftermath—the canary's demise—was the presence of danger established.

Like gases in mines, changes in language are often difficult to document. While the aftermath of language change is less dramatic, language change . . . can profoundly impact how these tools available for human communication and our assumptions about how these tools should be used. What does punctuation have to do with shifting balances between speech and writing in the history of English? Punctuation is the canary.[55]

Punctuation, no less than television, may be seen as a civilian or domestic derivation of military technology. In fact, we can think of punctuation along the following lines: "Writing is a party-line, a grammatology of state."[56] For years scientific researchers in the fields of engineering and psychology have been interested in reading punctuation in conjunction with experiments relating to transcription, encryption, and deciphering codes. All these forms of communication involve aspects of punctuation. Questions of punctuation, broadly conceived, include not only Benedict Anderson's controversial thesis about nationalism and newspapers; but also those equally fundamental issues of military might. As the axiom states, "The standard language is determined by who has the best army." A cultural study of punctuation must at least mention the many aspects such as the practice of reading, its physiology and psychology, the material means by which it is produced, and its cultural value. Much literary criticism, especially that of the new critical variety, for all its attention to close reading of texts has overlooked the value of punctuation by reading print, like its nineteenth-century linguistic parents, as if punctuation were insignificant if not transparent.

For me, researching this project felt like a necessary component of my professional training. I regret that my coursework for the doctorate degree in literature did not require courses on the history of the language,

let alone classes in linguistics, paleography, typography, or printing. I can, retrospectively, trace the genesis of this project to several distinct moments. Growing up in Hartford, Connecticut, my first job as a high school student was as a tour guide at the Brook Farm homes of Harriet Beecher Stowe and her neighbor Mark Twain (Samuel Clemens). I remember telling my tour groups how Clemens became the first American writer to compose a book entirely on a typewriter and how he lost a fortune investing in an early printing machine. Like Nietzsche before him, one wonders about the effect of the new tool on Clemens's writing and therefore his thought.[57] The second moment came while I was preparing to teach a freshman writing seminar. As part of this work I read Strunk and White's *The Elements of Style* "against the grain," noting that their prediction that "the hyphen was destined to disappear" resembled, rhetorically, certain statements made about assimilation and difference in American cultural politics.

The magazine *Adbusters* now regularly features punctuation marks centered in full-page spreads. As one of the art directors, Kalle Lasn, explained to me in an e-mail: "Ever since our s11 issue, we are always looking for ways to melt pic + text into one big narrative . . . telling ever bigger & bigger stories until the whole issue turns into one big story which reads like a comic book flow from cover to cover . . . Full page punctuation is one way to keep the concept & mood flow going, cheers, Kalle." Lasn's description, and the "txted" style in which it is written, give testimony to our changing relationship to graphic images, technology, punctuation, and modes of communication. Not only is the influence of *manga* (Japanese comics) implicated in the circulation of global images, but also in the "wake" of s11 (a much better moniker than 9/11, or should that be 9–11 or perhaps 9.11?) in the concept of connectivity and the increasing constriction of world boundaries. The repetition of the term "flow" (with its decidedly hip-hop flava) is another way of understanding the melding of image and text epitomized by punctuation marks. Lasn's comments, written on the same day as the inauguration of National Punctuation Day, promote a very different agenda. The founder of the new holiday recommended celebrating by scouring newsprint for errors and then writing to editors and authors demanding corrections.

In contrast, this book might ask you to deface the book at your whim and will with your own supplemental punctuation marks. Ultimately, this book leads to what we might call the incursion of punctuation marks into our lived environment. Here, the book thinks of punctuation not

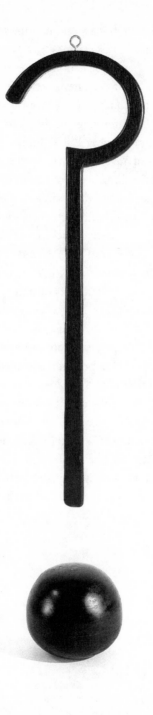

Figure 4. Richard Artschwager, *Pregunta III*, 1983. Wood, 73.7 × 50.8 cm, 22.4 × 2.54 cm. Reproduced with permission by the artist.

merely as engraved matter, but also as grave matter and marks of gravure. As Paul Monette writes in his elegant essay "3275": "Exquisite, that use of 'grave' for 'engrave,' as if the action of the stonecutter and the place itself are one."[58] Like the stonecutter's action, this book moves from an exclusive engagement with print and manuscript culture to address how punctuation functions off the stage of the page, as embodied gesture in the dances of the choreographer Bill T. Jones, the impasto-laden paintings and body shows of Yayoi Kusama, the three-dimensional sculpture of Artschwager, and the filmic work of Miranda July. Such multidimensional performances are discussed throughout the text. Each performance can be seen as part and parcel of punctuation's increasing ability to stand on its own—without a sentence to make sense of it.

This book may be thought of as an extended meditation on punctuation marks as "marginal" as well as excessive subjects. It ends with a discussion of the new meanings and uses of punctuation in txt messaging, and emoticons or "smileys" in e-mail where a semicolon and a parenthesis represent a "wink" ;). Such an inquiry exposes the material effects and affect of punctuation that play such an important if understudied (pun intended) role in our lives. I hope that readers will view this project as an introduction to the varieties and vagaries of punctuation. On the punctuation listserv to which I subscribe, there have been numerous queries about the "origin" of particular punctuation marks. So, too, there are often calls for a "Causabonian" key to punctuation (pace George Eliot's *Middlemarch*). For my colleagues desiring such a tome, I regret that this volume will disappoint—for my aim here is to provide discontinuous readings of different, distinct punctuation marks while emphasizing the significance of (: .?/[-!; . . .

Smutty Daubings

It is customary for books on punctuation to begin with what many per-
ceive to be punctuation's most elemental form: the dot. This chapter,
while starting with the dot, departs rather quickly from traditional prim-
ers and follows the dot as it travels in different directions and dimen-
sions—especially that of dimensional typography. "From early carved
inscriptions to neon signs, numerous experiments in the history of ty-
pography and signage have interpreted letters as physical, spatial enti-
ties. With the advent of motion pictures, animation and movie titles
have explored the temporal possibilities of letters moving through space
and time. By now, the spectacle of the dancing, decorated, and three-
dimensional letterform is common in both print and electronic media."[1]
Here, we will look at some earlier examples of dimensional typography
and other graphic "period" formations.

Discontinuity and disjuncture "structure" this chapter, which pays
homage to a singular yet plural pattern known as the polka dot. While
technically not punctuation marks, polka dots nevertheless can help us
see punctuation marks as extending beyond the stage of the page as they
perform in arenas in which various dimensional properties are expanded.
Polka dots display a resistance to congealing; we cannot hold them readily
as they are held together by empty space that they also delimit. Though
made of circular forms polka dots are not circular; rather, they circulate
like circumlocutions that both cover and expose. We recognize polka dots
ironically as they are both discrete and indiscrete, closed and open, singu-
lar and collective. Polka dots textured nonnarrative, nonnormative, and
inconclusive patterning and their paradoxical representation of deep sur-
faces and still movements complicate simple sentencing. Thus, we might
say that the polka dot resembles yet reassembles the period that has come
to conclude many a thought as well as a sentence.

Polka dots have been characterized as relatively useless and certainly excessive things. We think of them, superficially, as decoration—as belonging to a feminized world of frivolity. For example, lunares (the Spanish word for polka dots related to the moon) festoon flamenco dancers' costumes—appearing on earrings, shoes, and dress flounces. While we may be accustomed to thinking of polka dots (like punctuation) as confined and bound to two-dimensional surfaces, in this chapter I unleash an army of polka dots allowing them to act up, take to the streets, take on bodies both human and celestial, travel the globe, and transform our understanding of their potential power.[2]

Let us open with a few questions. What kind of political move would it be to adorn/obliterate the world with polka dots? The works of the experimental Japanese artist Yayoi Kusama (b.1929) will help us answer this question as we follow her life-long obsession with this motif, which she makes into a motive for her political performance art. While drawing on the work of others, in this chapter I am also concerned with drawing (perhaps more than writing) in a literal sense. As such, I desire to see writing as drawing—as dots on a page that call to if not correspond (both senses of the term) with and to our minds and bodies. I will focus on several visionary experiments that resulted in radical transformations of the dot. How did these experiments give the dot new dimensions? To answer this query, I start with a brief detour through a point in seventeenth-century England, then turn abruptly to the theory of polka dots deployed by Kusama, and finally I take a third turn to Wall Street to make a dot posit computer style. A detour, a theory, a turn . . . three sides of the same point.

✳✴✶●

Juliet Fleming's book on graffiti and the writing arts in the early modern era analyzes inscribed objects (such as pots) *as* literary works. Fleming argues that "writing so displayed has at its disposal a particular set of physical properties, the most obvious of which is its existence in three dimensions."[3] Her discussion of the early modern penchant for penning on such multiple, dimensional surfaces (e.g., cloth, clay, casements, and cornices) allows us to rethink the distinctions between "writing and drawing, utility and art, literacy and knowledge" (136) that came to characterize (through characters) logocentrism in the West. She explains that such writing should be thought of as "forever in the act of vanishing, or re-appearing, around a curve," and she adds that "such writing makes ex-

plicit the role of the materiality of space within the act of understanding" (111). Her remarks about "graffiti" cast it as a substance that "even where accorded special privilege as the speaking writing of the past . . . [it] remains something spectral" (41). Thus her project, pace Jacques Derrida and Jonathan Goldberg, sees writing not as an expression of "consciousness unbound by the text . . . but rather as a space where matter appears to bind thought" (13). Fleming's thinking about the "material supports" (10) for the economy of writing in the period resurfaces in the late-twentieth-century body works (and body of work) produced by the multimedia artist Yayoi Kusama whom I read, à la Fleming, as a type of graffiti artist.[4] What I hope to suggest in this study is that Kusama's visual work—her drawings, paintings, and impromptu danced demonstrations—are akin to writing and especially to graffiti with its visible scrawl, its public display, and its performance of anti-establishment, illicit, and even illegal (if legible) activity.

Attending to the physical properties and multidimensionality of such writing/drawing or drawing/writing, along with the surfaces upon which such (im)material events occur, is a move that has been incorporated in certain forms of body art that reproduce "writing" as such on living surfaces. Kusama works in an expanded field of writing; her hand-painted polka dots appear on a vast array of material supports including canvas, cotton, horse hair, cat fur, bark, clocks, stocks, genitals, concrete, porcelain teapots, the Holy Bible, dollar bills, draft cards, Nixon posters, bread, and human epidermis.[5] Her obsession with body painting and dotting diverse surfaces with her handmade polka dots is another example of the incursion of such points into and onto three-dimensional space. I see Kusama's colorful kinetic conceptual polka dots dancing a dance of deconstruction, taking the previous points made about punctuation at least one step or stop farther . . . beyond a beginning point whose origin is impossible. In this chapter I drive toward the contemplation of text as a template for understanding Kusama's serious play with polka dots while circumventing conventional readings of historical development. Here we will dance with the dots and let them lead us beyond strict teleological parameters that are out of line with our rhizomatic, performative logic that permits us to play—to catch the point with a wide net in an open field. You can see, then, how the end point of the chapter is to connect, temporarily, the temporally and spatially discontinuous dots between earlier periods and Kusama's polka °●∘.•°•○,

Let us now attend to the mark in the accompanying illustration.

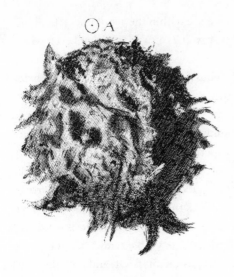

Figure 5. Robert Hooke, "Smutty Daubings" of a full stop in Robert Hooke, *Micrographia* (London, 1665). Reproduced by permission of the Houghton Library, Harvard University.

This is an experiment. You are being put on the spot. What do you see? A blotchy black dot? Is it a spore or a medieval weapon? A blind spot? Perhaps it is a kind of "broken circle"—something whose surface once was as smooth and simple as a perfect point but now appears ruptured, imperfect, displaying a monstrous roughly textured skin. This experiment catches your eye in the ambiguous space of the "so-called size-distance relationship" that necessarily constricts your reading/knowledge.[6] The point of this experiment is to illustrate the illusion of depth (perception) created by a representation made by the pen of Robert Hooke (1635–1703), the English scientist, surveyor, inventor, and member of the famed Royal Society.[7] Hooke, a rival of Sir Isaac Newton and a friend of the famous English printer Joseph Moxon (who wrote the first guide for printers that stressed proper pointing), sketched this dot for his lavishly produced Renaissance text *Micrographia: or some Physiological Descriptions of Minute Bodies made by Magnifying Glasses. With Observations and Inquiries thereupon* (1665).[8] Hooke's text holds value for historians both of science and of the book itself because it was one of the very first volumes on the then new topic of miscroscopy. Although naturally some of its scientific claims proved untenable, the book has been remembered for Hooke's stunning illustrations.[9] Hooke provides us not only with our first punctuation mark, but also with the title of this chapter, "smutty daubing"—a felicitous phrase given that there is more smut to follow when we return, to 1960s New York, to attend to one of Kusama's nude "body festivals."

As the inaugural curator of experiments for the Royal Society, Hooke sought to show the inaccuracies inherent in understanding the natural world. He undertook different experiments with a microscope in order to show the vagaries as well as the vagueness of perception. With the assistance of his magnifier, which made much of seemingly insignificant things, Hooke was able to use "a sincere Hand and a faithful eye" (429) to represent a period such that its "true nature" (428) was revealed to be *not* a precise dot, but rather a "smutty daubing on a matt or uneven floor made with a blunt extinguist brand or stick's end" (431).[10] Hooke's experiment underscores the materiality (in both senses of the term) of punctuation and helps us to see the conjunction or interplay of technology, perception, and punctuation that I discuss in the introduction to (and generally throughout) this study. Writing in the 1990s, the typographer Robert Bringhurst characterized punctuation marks as "microscopic works of art" connecting again the links between punctuation, art, and microscopy.[11] Like Hooke, in this chapter I put a fundamental mark of punctuation, the dot, under the microscope to examine its properties—to reveal the substance and significance of what many perceive as an unimportant mark on a page, a mere speck of dirt rather than a substantive matter and a matter of substance.

Why did Hooke decide to open his text by magnifying a mere spot of ink? Adrian Johns explains that Hooke wanted to imitate "classical conventions, [and therefore] began [the book] as if it were a work of geometry. Instead of a mathematical point, though—the classic starting element of that science—Hooke began with its physical equivalent, the tip of a pin."[12] Hooke's "close-up" of the point transformed a mere speck into a monumental form. Like the close-up in film, or the pixel in digitized works of art, this isolated point interrupted narrative flow and became, for a moment, a whole world unto itself and not just a part of a given world. Hooke created a new context for the point that resulted in the founding of the smutty daubing. "Under [Hooke's] microscope the sharpest of magnified points was revealed to be blunt and pitted, Natural points such as an insect's sting displayed no such imperfections, and Hooke took this to be powerful evidence of a Creator." But Hooke then turned the microscope onto "a *point* commonly so call'd: that is, the mark of *full stop*, or *period*." Through the microscope, any such character, printed or written—and Hooke examined "multitudes" of each—appeared like "*smutty daubings*" or "great splotches of London dirt thanks to a combination of irregularity of type, uneven cloth-based paper, and

the rough use of ink."[13] Hooke's description of the "smutty daubings" or "splotches" conveys, almost as if by onomatopoeia, the impasto made by the unnatural mixture of elements noted above—the combination of India ink, a quill or the nib of a pen, rag paper, and pressure from the palm of a human hand.

The microscope revealed some much-vaunted tiny writing as barely readable without "a good fantsy well preposest to help one through," and in fact a good fancy was needed for all reading. Since the "imaginations" we had of objects were not decided by "the nature of the things themselves" so much as by the "peculiar Organs, by which they are made sensible to the Understanding," different organs would have produced different perceptions.[14] Hooke now points out a still-greater implication of the corporeality of reading practices. His experiment with the microscope revealed the importance of seeing beyond the so-called naked eye.

The point that Hooke and his microscope help us to see is that dots are uneven, multidimensional, indiscrete, and irregular. He shows how even two-dimensional dots can be seen as complex material. "The microscopic observations published during the 1660s and early 1670s are deeply concerned with the issues raised by the corpuscular philosophy and Cartesian-inspired physiology. They also reveal a deep commitment to the experimental method on the part of the investigators. The beginning of the heyday of microscopy in the seventeenth century was therefore the result of a combination of the novel seventeenth century conception of nature with the experimental method."[15] We see now how the dot played an important role in new conceptions of perception. Hooke, hooked neither on phonics nor phonemes but rather on a punctuation mark, proved a point about the physiology and psychology of reading—which is to say the embodied practices that were to become normalized with the spread of literacy. Such insights may founder, as does much writing about writing, on the (im)possibility of moving beyond movable type. This is a point that we should remember as we read the printed pages that follow. The abbreviated discussion of *Micrographia* provides a transitional hook, or perhaps a flashpoint that transports us some three hundred years over and through multiple global representations via circular, "dotological" reasoning—we move from 1660s London to 1960s New York, from one set of dotty experiments to another.

Spotty Evidence ●●●○○

"My love is like mixed media, mixing you and me."
—Yayoi Kusama, "Thoughts on the Mausoleum of Modern Art"

The prolific and multitalented Japanese artist Yayoi Kusama paints, writes poetry, lyrics, and novels, and she was a fashion designer, an installation artist, and a performance artist before the term had any currency (pun intended). Her engagement with both the "feminine" (read excessive, crafty) and the "masculine" (read minimalist, designed) was part of her feminist strategy to both occupy and complicate the rules of "high art." Kusama circulated in the same 1960s downtown New York art circles as her coevals Claes Oldenburg, Andy Warhol, Donald Judd, John Chamberlain, Fluxus, Judson Dancers, Merce Cunningham, John Cage, Agnes Martin, Carolee Schneemann, Lee Bontecou, Roy Lichtenstein, and numerous other avant-garde artists and collectives, many of whom were associated with new forms of interaction such as Happenings, events, and performances that championed improvisation, presence, and being in the moment.[16] Specifically, Kusama spent the years 1957–1973 living and working in New York City. Although she was a regular participant in the downtown scene, she is mentioned only rarely in the overviews of the period. I contend, however, that her art can be read, retrospectively, as a vital element in the period's crucible of happenings, collaborations, and other experimental art works.[17] Sharing a building on East Nineteenth Street with well-known artists such as Donald Judd, among others, Kusama covered the vast majority of her work with various kinds of polka dots. For a time at the height of her fame one New York newspaper named her "Dotty" and another the "Princess of Polka Dots." She dubbed herself "Queen of Love and Polka Dots," and "High Priestess of Polka Dots," when appearing at her Church of Self-Obliteration.

Yayoi Kusama, perhaps no less than Robert Hooke, had a hand to play in the reformation of the dot. Like her coevals, she participated in transforming her everyday environment with her embodied artistic practice of polka dotting virtually everything with which she came into contact or confrontation. Imparting the design (the sign of the polka dot) was part of a larger cultural and artistic transformation in the field of design that encompassed changes in letterforms and fonts. "A range of display fonts produced in the 1960s and 1970s exhibit cartoon-like forms that bear the influence of the Pop appreciation of toys, kitsch, and vernacular

objects. Pop art directly engaged letterforms and numbers as part of its inventory of everyday life. The soft sculptures of Claes Oldenburg, which presented letters and numbers as soft, pillow-like constructions, have directly and indirectly informed the sensibility of 1960's and 1970's novelty lettering."[18] Kusama's polka dots can be read in this context as another formation of novelty lettering with the difference that the polka dots, like graffiti, perform more as litter than letters.

In an interview Kusama explained how "motifs of food and sex were the rage in the New York art scene in the 1960's. By then, [she] had begun to create work using mirrors and plastics. [She] covered the walls of a room with mirrors and planted thousands of machine-sewn white protuberances with red polka dots on the floor." She goes on to explain that in such environments, "there emerged solemn, strange, 'Wilderness of Phalli' where the mirrors infinitely reflected the phalli. Viewers walked on the phalli barefoot. Integrated with the phalli, the viewers experienced the sensation of their bodies and movement becoming part of the sculpture, and in the strange, endless world they became captivated by the imagination of being put right in the middle of [a] magnificent accumulation of sex, with red polka dots symbolizing sexual disease in a humorous way, in broad daylight."[19] This description of one of her installations blurs the distinction between painting and sculpture while offering one interpretation of her polka dots. Elsewhere, Kusama has spoken of the dots as "a symbol of peace, and also of the moon which maintains quiet over the whole world." The sensuous experience and bodily engagement with such sculptural environments expresses Kusama's belief that "soft sculpture is alive, always preferable to hard sculpture" and that touch should be a fundamental aspect or affective part of "viewing" art. She was involved in staging happenings "in which the public were to play leading roles."[20] Her work thus fit squarely within the hip, happening scenes of the period that mixed media and valorized interactive art in the form of viewers' physical "full body" engagements with the art in question.[21]

Kusama's vertiginous polka dots are recurrent features in, of, and on her various works. They can be detachable color forms, sometimes made of paper or of the paint itself. The dots do not rely on a canvas for support. Such dancing dots are out of line: they disrupt (patriarchal) succession in their queer disorderly and unorderly display. Their directionality is undetermined—they are omnipresent, peripheral, proliferating. Indeed, one could argue that polka dots are the marks that became her mark as a kind of signature, with the exception that they were not hers alone as

Figure 6. Yayoi Kusama, *Accumulation of Spaces (No. BT)*, 1963. Mixed media work on paper, 50.2 × 64.8 cm. Courtesy of the Walker Art Center, T. B. Walker Acquisition Fund.

others could and did paint them periodically. Etymologically, polka dots are connected closely to music and dance—to the polka that became a craze in Europe and the United States in the late nineteenth century. Co-incidentally, then, the "polka" ties together femininity, dance, rhythm (which is to say repetition and pattern), music, the moving body, and festivity—all of which figure in if not as the work of Kusama.

Kusama's obsessions, while focused on the dot, also encompassed the dot's structural opposite, the hole or net. Early in her career, she painted what she called "net paintings" composed of open, rather than closed, cir-cular patterns. She came to juxtapose such (w)holes when she would cos-tume herself in fishnet stockings and then arrange herself as an odalisque on a bed of macaroni in front of one of her giant net paintings. To top it all off, in one of the photographs in which she is so displayed, her bare torso is covered with hand-painted polka dots. This photographic image of Kusama as pin-up girl is also a performance of her artistic aesthetic that demonstrates how her own body (as artist/object) is implicated in her work. So, too, this image is reminiscent of later work of "bare" bodies that bear the weight of queer exoticism (and here I am thinking of Keith Haring's experiment with a naked Bill T. Jones as his fleshly canvas).

Kusama wrote that her net paintings "had no composition, no centers. The monotonousness produced by the repetitive patterns bewildered the viewers, and the hypnotism and serenity that the paintings engendered lured them into the dizziness of 'nothingness.' These paintings were a har-binger of 'zero' movement which subsequently became the rage in Europe and of Op Art which subsequently became the dominant type of abstrac-tion in New York."[22] She claims that she has been obsessed not only *with* but also *by* dots. As a child in Japan, Kusama (who returned to her birth country in the early 1970s after her two-decade stay in New York) one day hallucinated that the entire room in which she sat was taken over by a sea of dots. She recalled that this mania developed during the World War II air raids on Japan. She remembers that during the chaos she would focus on counting the white stones in the stream near her family's home in an effort to avoid the terror of the B29 aerial bombers. This repeated and recycled narrative came to exemplify what she called her "depersonaliza-tion"—a term I will discuss momentarily below. Certainly, her art bears out the fact that for her entire career she has been obsessed with "infinite repetition" and questions of (if not a quest for) obliteration.[23]

In an interview circa 1963, Kusama explained that she arrived at her style "after years of experimentation." As a little girl she used to tear

Figure 7. Yayoi Kusama, *Accumulation of Nets (No. 7)*, 1962. Collage of gelatin silver prints, 74 × 62 cm. Courtesy of Agnes Gund, New York.

"clothing, papers, even books into many, many thousand pieces with scissors and razor blades. [She] also liked to shatter windows, mirrors and dishes with stones and hammer."[24] She established a process that reduced wholes to parts—obliterating larger entities by "returning" them to their molecular level and making what was formerly smooth and "coherent" into something disaggregated, broken, and cut. Such action worked as a kind of redoing of Hooke's undoing of the dot. (Perhaps such controlled violence served as a reaction to the splitting of the atom that in turn led to the possibility of dropping the bomb.) As James Snead and others have theorized, the cut is not a break, but rather a figure that allows a repetition of difference—a kind of perforation that marks a (w)hole.[25]

In the early part of her career Kusama exhibited a series of paintings, painstakingly executed, known as "Infinity Nets." For her installations, "Infinity Mirror Room—Phalli's Field" and "Kusama Peep Show," done in the mid-sixties, she created architectural mirrored environments that implicated the viewer in the work at the same time that they distorted and dispersed the viewing subjects. The installation "breaks" viewers into multiple pieces parsing them to the extent that they are seen not as discrete persons but rather personas, personifications, or in Kusama's term "depersonalized"—no longer individual personalities, but rather stylized, repeated patterns. This mirror/stage presented the individual as infinite—neither complete nor unique. In this work, figures of both "accumulation and obliteration" are combined. Dots and nets might be mistaken as structural opposites; however, both make negative space positive or perhaps play on the connection between these two extremes. Kusama's art disorients the viewer, forcing him or her (dare I write you and me or even us?) to interact with its demanding scope and scale as well as to see that the net or dot has texture. One literally must move oneself in closely, must take a second look to "see" the detail, the painting, and the *work*. Most of the artworks display a thick impasto quite different from the slick, mechanized style of Warhol or Lichtenstein, precisely placed Benday dots.

In a fascinating discussion of the properties and scale of texture, Eve Sedgwick writes: "Whatever the scale, one bump on a surface, or even three, won't constitute texture. A repeated pattern like polka dots might, but it depends on how big they are or how close you are: from across the room you might see them as a flat sheet of gray; at a few feet, the dots make a visible texture; through a magnifying glass you'll see an underlying texture of paper or fabric unrelated to the two or three hundred

rounded shapes that make a big design. Texture, in short, comprises an array of perceptual data that includes repetition, but whose degree of organization hovers just below the level of shape or structure."[26] Here, Sedgwick might well be describing one of Kusama's giant white-on-white "net" paintings that were displayed in her first one-woman show at Brata Gallery in 1959. Donald Judd described these net paintings in oxymoronic if apt terms by calling them "massive slabs of solid lace."[27] Such a phrase mixes genders and genres of painting again emphasizing Kusama's feminist critique of art historical hierarchy. In particular, I see resonances between Kusama's work and that of the contemporary artist Linda Besemer, about whom Judith Halberstam has written. Indeed, Halberstam characterizes Besemer's "slab" paint sculptures as "paint no longer anchored to a pliant and absorbent canvas, the paint announces its own artifice, detachability, and even performativity. And by calling attention to the act of painting itself as a gesture that has left the canvas behind, Besemer rescripts the traditionally gendered relationship between figure and ground that locates the canvas as the female body and the brushstroke as a male genius."[28]

In the opening essay to the *Love Forever* catalogue that accompanied the major retrospective of Kusama's work in the mid-1990s, we learn that Kusama arrived in New York City in June 1958 carrying with her a cache of thousands of drawings and paintings. At the Brata Gallery in 1959 she showed five "white-on-white paintings nearly the size of the gallery walls. These were so visually subtle that, on entering the space, 'the initial impression was of no-show,' critic Lucy Lippard later reported, but on close scrutiny a fine mesh of circular patterns was revealed" (12). Meiling Cheng critiques the curators of the *Love Forever* show for downplaying the blatantly anti-racist and feminist irony apparent in Kusama's works. As Cheng notes: "I am somewhat dismayed that 'Love Forever' steers away from the rebellious spirit of its own artist-subject, who never hesitated to assault the world with her politics [and/as her polka dots]. The discourse surrounding the exhibition has missed the opportunity for a frontal engagement with the gender-specific and race-conscious materiality of Kusama's art, which . . . centers around a humorous deconstruction of the phallus myth and a blatant sabotage of Eurocentricism through parody, excessive repetition, and usurpation."[29] A review of Kusama's many communiqués reveals her reliance on parody and her comic sense of play. An example of this is the typewritten press release flyer that served as a pedagogical communiqué for one of her naked events.[30]

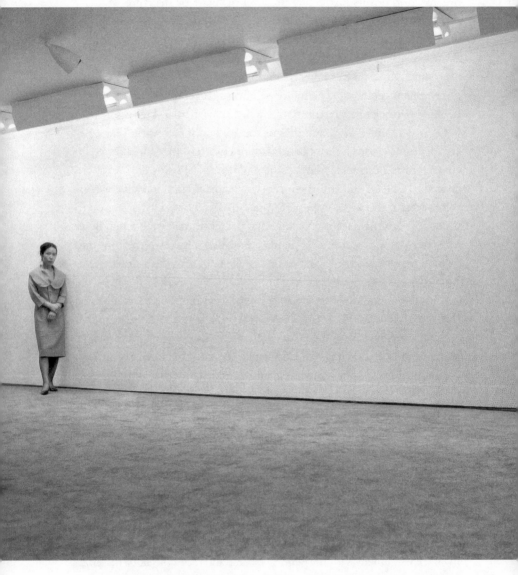

Figure 8. Photograph of Yayoi Kusama in front of her no longer extant painting *Infinity Net* (1961, oil on canvas). Stephen Radich Gallery, New York. Courtesy of the artist.

FOR IMMEDIATE RELEASE
NUDITY IS EDUCATIONAL
We protest the lack of courses in school covering-
—or, even better, uncovering -- the nude.
Educational authorities say children should become habituated
to the nude.
Let children and adolescents grow up with healthy minds.
Let them get us used to the facts of nature!
We say the human body is beautiful, not dirty!
Sex is normal.
Sex is beautiful.
Join us to re-install beauty in the world!
As the world becomes nuder and nuder (miniskirts, bikinis,
Kusama, etc.) the people want to understand why everything stops
short!
Don't stop short of the facts of nature!
Join the irresistible trend toward decent exposure,
the ANATOMIC EXPLOSION!
—Kusama[31]

Here Kusama comprehends and artfully deploys the "rhetoric of the pose" as she does in her staged and choreographed photos—especially those in which she plays her self vs. herself (that Wildean quip that being natural is such a difficult pose to keep up). It is clear from the composition of her various fliers that she thought about their appearance in terms of layout, font, punctuation, and visual effect. An announcement for Kusama's "Electric Circus" tea-dancers exemplifies this as it has giant dots littering the page and four different fonts. This cultivated coy persona differs considerably from the no less performed "voice" of the letters she wrote beginning in 1957 to Georgia O'Keeffe, who sponsored her and her art by introducing her to galleries in the United States.

Purportedly, in 1968 when Kusama made the front page of the *New York Daily Herald* she was more popular than Warhol (she had hundreds of articles published about her in 1968 alone). Part of what propelled her to fame in this propitious year (student uprisings in France, the assassinations of Martin Luther King Jr. and Robert Kennedy, the invasion of Czechoslovakia by the USSR, and the My Lai massacre and the Tet Offensive in Vietnam)[32] was the fact that she began to stage her nude happenings throughout the city. When nudity was permitted in art in New

York City beginning January 1968, Kusama went on a naked spree, not only in her body painting nudes in public to demonstrate her philosophy of polka dots, but also in having people remove their clothes in order to polka dot each other in discotheques and public parks at the statue of Liberty, Wall Street, and the United Nations as well as in her studio. Whereas it had been the tradition of artists' studios to house nude models for the sake of art, Kusama's downtown paint shop invited the public in, for a fee, to decorate her living female and male "canvasses" who also dotted other models. These paint-ins were advertised in local New York papers. Although some of the polka dot sessions were impromptu, others took place at strategic locations throughout the city and were staged for political effect and impact. Such scenes were reported frequently in the local papers.

One of the journals that reported on Kusama's "be-ins" noted that "sometimes things went too far and shocked even such liberal newspapers as the 'Village Voice.' When recently Kusama staged the first homosexual wedding in America, 'marrying two young men who were very much in love with each other,' by polka dotting them in the nude and reading the nuptial ceremony from a New York telephone directory, the 'Village Voice' cried that Kusama . . . [was] suffering from overexposure [no pun intended]."[33] Although Kusama publicized the event widely via posters and proper invitations, "Western Union refused to send telegrams to the press announcing the event because it contained the word homosexual."[34]

Kusama's work foregrounds the process of producing. Evidence of her laboring hand seems always present in the work whether in the nonuniformity of her dots or the variegated shapes of her phalli. Nevertheless, Kusama's experiments, no less than Hooke's, relied upon the use of technology in the form of tools such as paintbrushes, scissors, and sewing machines. In aesthetic terms, Kusama's early work is attuned to questions of figure, ground, vibration, and perception. We might see her work as manifesting a fascination with the absurd, the offbeat, the eccentric, and the queer (the latter both explicitly and implicitly). Kusama noted that "men monopolize all rights to a full life, granting women nothing but an unproductive place in society," a phrase that gives a feminist bent to her preoccupations. She critiqued capitalism in part through her interest in dematerialization and, of course, her puns upon the problem of materiality. Her call was to "obliterate your personality. Become part of your environment." Kusama's art may be said to focus on the loopholes,

on positive and negative, absence and presence—on (im)material events and fugitive possibilities; or, in her terms, "dissolution and accumulation. Proliferation and fragmentation."[35] One of the keywords in her work is "endless," which again eschews or defers indefinitely a final period in favor of a fantasy of forever that the recurring polka dots seem to perform.

Kusama's *Self-Obliteration* (1967) is a twenty-three-minute 16mm film that she produced with Jud Yalkut. The award-winning film, which counted Yoko Ono among its admirers, might be read as a kind of psychedelic, pornographic version of a Busby Berkeley movie from the 1930s.[36] A press release from Jud Yalkut described the film as an "exploration of the work and aesthetic concepts of Yayoi Kusama, painter, sculptor, and environmentalist, conceived in terms of an intense emotional experience." The dots that appear and disappear throughout the work obliterate differences of class, race, gender, sexuality, and even species. The film culminates in a tangle of collective flesh in which vibrating dots overtake the screen.

Self-Obliteration includes close-ups of Kusama's artwork such as clips of her "One Thousand Boats Show" and her early net paintings. The nondiegetic soundtrack of psychedelic music of chants and the occasional bell makes the nonnarrative experimental film all the more strange and hypnotic. Among the many amusing scenes in the opening half is one in which Kusama covers a cat with leaves and then wades into a pond to paint red polka dots whose dissolution or self-obliteration reveals and becomes the current of the rippling water. The centerpiece of the film is a rapid montage of New York landmarks such as the city skyline, the United Nations building, the Empire State building, and the Statue of Liberty—all of which are overcome with polka dots as they also are overlaid with colored scrims. As the film moves indoors to a mirrored disco, we see extreme close-ups of objects such as vegetables and fruit (corn-on-the-cob and bananas). The former are reminiscent of Georgia O'Keeffe's work and provide a segue to more overt sexual images of genitalia. Each object gets the polka dot treatment. There is no dialogue in the film and no plot; rather, the whole is composed only of raw action and disorienting pattern. Precut dots are stuck like buttons on naked bodies (or perhaps punctuation marks without sentences to support them?) while other dots are painted on various body parts by Kusama and her nude cohort. In the latter half of the film, Kusama sports a white-dotted cowboy hat as a form of U.S. masculinist drag, almost as if she is winking at America's "gift" to world cinema—the innovation known as the western. So, too,

perhaps she also performs a kind of (white) masculine drag that signifies on the tradition of the male actor/painter/subject and his passive feminized canvas. The closing shots (there is no conclusion to speak of) disintegrate into a mob of flesh with a brief and disturbing segment of a black male participant who is being tied up like a captured slave. This last act closes the ritualistic simulated vaguely sexual encounters that appeared previously.

The critic Paul Sharits wrote one of the best contemporary "synopses" of *Self-Obliteration*. He summarized it as follows: "The obsessive act of *covering* (destruction of boundaries-identities) gradually becomes equivalent to the ritual of *uncovering* (stripping away of ego); individual self, destroyed in mask/parody/clustering, is transcended. Mandalic (magic circle meditational form used to concentrate attention to a center, zero point) leitmotivs rhythmically recur on multiple levels to create a sense of spiraling in/to a point . . . The technique of superimposition, a mere gimmick in most films, is an apt formal analogue for the dissolution of discreteness, for the meshing-merging of identities. . . . In the last orgiastic section of *SELF-OBLITERATION* we are confronted not with an atomistic collection of figures interacting but one emergent, undulating, Meat-Cloud-Being."[37] This last phrase recalls Carolee Schneemann's infamous "More than Meat Joy" performance that also used nudity.

Like Schneemann, one suspects that Kusama may have felt "that her gender inhibited her consideration as a serious contributor to the art world. Beyond the dance-identified circles of Judson Church, she [may have] felt she had partial status, and [may have been] troubled by the suspicion that she was included only as a 'cunt mascot' in the heavily male cliques of Fluxus and Happenings."[38] Kusama's response to this dilemma, which was complicated by her racial designation and "foreign" status, was to participate clothed with paintbrush (or day-glo spray can) in hand while her Western dancers, male and female, black and white, revealed themselves. This is not to say that she was averse to showing herself as and in her art, but rather to remember that she did so infrequently and almost always in a context where she was shown to be both painter and painted, subject and object, rather than merely the latter.

Robert Nelson of *Canyon Cinema News* gave the following "backhanded" comment about the film: "Yayoi Kusama, a crazy Japanese chick puts dots on the whole world. Dots move into psychodelia which moves into orgy. Smooth transition." Kusama's anti-establishment, countercul-

Figure 9. Yayoi Kusama and Jud Yalkut, 16mm film stills from Kusama's *Self-Obliteration*, 1967. Courtesy of Jud Yalkut.

tural works were taken up by the popular press, specifically by the bevy of small "gentlemen's" magazines (we would term them zines today) that loved to report on her naked happenings and weekly "flesh-ins." Along with articles and notices in the likes of *Playboy*, the *New York Daily Herald*, *Esquire*, and *Vogue*, Kusama's work was publicized in *Mr.*, *Straight Arrow Productions*, *Bachelor*, *Man to Man*, *Ace*, *Rogue*, *TAB*, *Voyeur*, *Debonair*, and *Sir!* These "male only" spaces tended to ridicule Kusama's feminist, anti-racist, anti-imperialist, and anti-war politics while missing their inherent interconnections in her work.

In the years following *Self-Obliteration*, experimental film moved from "realism" to surrealism, from natural settings to the electric disco.[39] As Wheeler Winston Dixon states: "In the 1960's, before the specter of AIDS consciousness closed off the body into a site of dis/ease, American experimental filmmakers were more intent on exploring the limits of their physical/mental existence than on more formalist questions of filmic structure and syntax, which would dominate the American avant-garde in the 1970's and 1980's . . . These filmmakers shared . . . a highly personal and deeply felt vision of a new and anarchic way of looking at film and video, fueled by the inexhaustible romanticism of the era and the fact that film and video were both very 'cheap.'" He surmises further that "these performative films of human sexuality and ritualized body display were a response to the repressive atmosphere of the 1950's and a breaking-down of the then-established rules of gender, sex roles, and social taboos."[40]

Like some of Deborah Richards's recent poems that experiment with composition and layout, Kusama's oeuvre concerns itself with issues of

accumulation that make demands on the reader/viewer who may be en-countering such formats for the first time. As Richards says of her for-mally difficult poems: "To accumulate the parts of work on the same page . . . I like having everything thrown together, yet separate . . . I hope that the reader has the stamina to read the whole work, as each section accumulates toward the end. For instance, as the theme of the work re-peats within the text, there is a kind of déjà vu for the reader. I'm hoping that she or he responds to the connections that appear within each text." Richards goes on to discuss the episodic and the strongly horizontal grid-like forms of her work that read as "discontinuous texts." So, too, she emphasizes her interest in and commitment to reading the "gaps" that are for her reminiscent of "Japanese sumi brush painting that is purposely left incomplete. The viewer [then] has to become an active participant. That's what I would like to happen—my reader reads the gaps as well as the content of the poem."[41] Richards, like Kusama, explicitly compares her poetry to theater and painting (as well as noting the influence on it by dance). As such, her multimedia work follows in a tradition we can read, retroactively, as being akin to Kusama's work as sculptor, fashion designer, performance artist, painter, choreographer, and impresario.

Much of Kusama's work was temporary, performative, and therefore committed to investigating the temporal. In an autobiographical essay written in 1975, entitled "Struggles and Wanderings of My Soul." Kusama claims that "In 1959 I issued a manifesto in which I declared that the white nets that were interlocked by astronomical accumulation of polka dots would obliterate myself, others, and everything in the universe. The white nets enveloped dark, voiceless, black polka dots of death that were underneath them. I painted the nets from morning till night. When the canvas reached 33 foot long, they extended beyond it to cover the whole room, evolved into an 'act' embracing the whole of me."[42] Proliferation produces possibility. This description amplifies Kusama's interest in nets, holes, life, and death, or "being and nothingness" to invoke the title of Sartre's existentialist tome. Kusama dedicated her art to answering ques-tions of "Dissolution and accumulation. Proliferation and fragmentation. The feeling of . . . being obliterated and the reverberation from the in-visible universe" (3).

Kusama's body's form follows her fashions for two or more: in re-sponse to her statement that "clothes ought to bring people together, not separate them," she crafted a literal "orgy dress" to be worn "col-lectively" by more than one person at a time, and which was worn by

Falcon McKendall and John deVries for their Homosexual Wedding in 1968, over which Kusama presided. Kusama's holey ensemble made visible what conventional sociocultural codes made invisible (specifically tabooed body parts). Kusama paints not black holes but rather open nets and dots—cutouts that reveal more than they occlude given that her models are actually naked (they cannot be Nudes, ask Kenneth Clark why!). Kusama's "naked" fashions and shows were part of the 1960s experimentation with more open forms of expression and were cited in the context of naked artwork such as the musical "Hair," Richard Schnecner's "Dionysus in 69," and even the Allman Brothers concerts.[43] As I will discuss momentarily, the point in French is a synonym for "stitch." What I want to knit together here is the various conceptual and formal patterns played out in Kusama's multimedia work.

On many occasions at venues throughout the city Kusama put on demonstrations with her dance troupe.[44] Pace Rebecca Schneider, she employed her "explicit body" in performance.[45] As Kusama's communiqué extolled: "Nudism is the one thing that doesn't cost anything. Clothes cost money. Property costs money. Taxes cost money. Stocks cost money. Only the dollar costs less. Let's protest the dollar by economizing! Let's tighten our belts! Let's throw away our belts! Let the pants fall where they may."[46] Although Kusama's happenings are mentioned infrequently in studies of the avant-garde period, they should be seen as part of the larger context of performance art that flourished in 1960s New York. (The Tate Modern in London lists her as a performance artist in their timeline of modern art.) In one particular event called "The Anatomic Explosion," Kusama's pun replaces atomic with anatomy that is "an" atomic as in against atomic explosions such as those to which the Japanese were subject during World War II. So, too, an atomization would dis-integrate a being to the cellular level—a single circular cell, like a dot, is the building block of pre-genetic/genome scientific thought. Part of the appeal of Kusama's work is that her polka dots are not petrified in a period (style). She continues to use them, albeit differently and on an ever-increasing range of materials.

Kusama's polka dots migrated to her use of fields of soft or flaccid phalli (again, she claims to have inspired Claes Oldenburg's soft sculptures). Her works such as *Dots Obsession* (1997), and *Interminable Net* (1959), and *Nets and Red No. 3* (1958)/c. 1963 recite and resituate this basic element, giving it new iterations across bodies, space, and time. By questioning what should be perceived in her net and dot drawings,

Kusama allows us to think about the differences between . . . closed and open structures—a topic that will return throughout this study. Her early work on the "surround" or the frame produces the centered dot as its by-product (the center is and is not the point) her work opens up questions of framing—directing our gaze to an outside and giving the perimeter priority. Kusama was interested in challenging traditional models of art and standard types of performance. In her installation, "Aggregation: One Thousand Boats Show" (1963), she highlighted these tropes of accumulation and repetition. As such, this work, like so many of her mixed media pieces, is a wonderful example of performance as defined by Joe Roach. Roach writes, "As an aggregation of art and crafts that consume extra time and extra space beyond those required to meet basic human needs, performance encompasses conscious repetition and occasional revision of previous public behaviors."[47] Changes in the dimensionality of type can be rendered using techniques such as **EXTRUSION**, tubing, SHADOWING, *ribboning*, molecular construction, **MODULAR CONSTRUCTION**, and **bloating** to name only a few.[48] Kusama used many of these in her cartoon and staged re-tellings of the story and film of Bonnie and Clyde, and certainly her multiform polka dots increased the dimensionality of the dot.

While staging what she called "naked demonstrations" during the height of the Vietnam War Kusama simultaneously pursued her "symbolic philosophy with polka dots." She urged: "Obliterate your personality with polka dots. Become one with eternity. Become part of your environment. Take off your clothes. Make love. Forget yourself. Self destruction is the only way to peace."[49] Like her contemporaries Yoko Ono and John Lennon, who asked their generation to "make love, not war" in their famous 1969 "Bed In (Bed Peace)," Kusama counted herself among the growing number of antiwar performance artists.[50] We should remember as well that anti-Vietnam rhetoric was integral to some of the early work of the Gay Liberation Front (GLF). Among their slogans were "Soldiers: Make each other, not war" and "Send the troops to bed together."[51]

Kusama and the artist Richard Artschwager, whom I mentioned in the introduction, are coevals. Both were born in the 1920s, were affected by World War II (Artschwager was a naval engineer), started their art careers in the late 1950s, and then came to prominence in the 1960s. Both are alive and have continued to work steadily. Both are conceptual performance artists, who, in my opinion, redo and reformulate works from

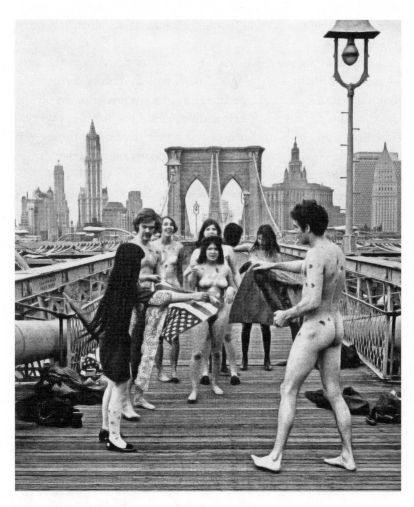

Figure 10. Yayoi Kusama, *Photograph of Naked Happening Orgy and Flag Burning*, Brooklyn Bridge, New York, May 17, 1968. Kusama Studio.

their earlier repertoire (as we do ourselves, everyday). The motifs (of) re-turn, ubiquity, and (re)iteration of the infinite ongoing that nevertheless changes recur throughout the following chapters in this book. Though as readers in and of Western modernity, we have been trained to see the dot as emphatic (the period signals the end) the dots that appear here seem open-ended—their power to stop has been eviscerated. Instead they are repeated and varied—they leap and spread and are capable of appearing on multiple bodies, in many places. Viewers of these multidimensional dots may more readily desire to engage them as visceral objects—to caress their smooth, highly glossed texture or to touch their rough exteriors

(like Braille?) and to try and follow their immediate all encompassing pattern.

In the accompanying illustration, we can perceive from the light source that Richard Artschwager's late-twentieth-century dot exists in three dimensions. The dot's circular, curved form gives this usually flat and two-dimensional figure heft and substance: this is heavy punctuation. Like many of the other dots that appear repeatedly throughout Artschwager's oeuvre, this one possesses physical properties that change our perception of it, which is to say our relationship to it.[52] Artschwager's experimental work enlarges punctuation and positions it so that its materiality can be experienced more fully by those who encounter it. At this point, the viewer of such a three-dimensional work seems to be even more implicated as part of the environment than the reader who may more readily pass over similar dots that appear on pages as printed material. Ultimately, however, here I aim to show that even the printed dots may be seen as three-dimensional matter—in short, as smutty daubings.

In another of Artschwager's works, *Up and Across* (1984–85), he transforms a series of dots into a horizontal row of bulbous black blobs, the last of which appears to have been plopped onto its shelf-like support by the stem of an exclamation point-cum-stylus. Having dripped from the "dropper," the giant, quasi-molten "stops" of what seems to be congealed viscous ink sit side by side as if they were candies on a conveyer belt; they look to have the consistency of hardened taffy or cooled chocolate, though they are made of formica, painted wood, and enamel. The support for *Up and Across* has two steps that encourage interaction as they invite the viewer to step up and into as well as onto the punctuational plane/shelf that is supported by two black brackets. Artschwager says that he makes many such objects "for non-use. By killing off the use part, non-use aspects are allowed living space, breathing space. Things in a still-life painting have monumentality—and I don't think that their monumentality has been lessened because of their edibility." He described some of his early work not as sculpture but rather as "painting pushed into three dimensions . . . multi-picture[s]."[53] As the sculptor Donald Judd, a contemporary of Artschwager, wrote: "The use of three dimensions is an obvious alternative [to the flat relics of European art as two-dimensional, rectangular wall paintings]. It opens to anything . . . Obviously, anything in three dimensions can be any shape, regular or irregular, and can have any relation to the wall, floor, ceiling, room, rooms, or exterior or none at all. Any material can be used. As is or painted."[54] In other words, three-

Figure 11. Richard Artschwager, *Untitled (DOT)*, 1991. Enamel on wood, 31.75 × 6.35 cm. Collection of the artist.

dimensionality deforms the perfect circle or sphere of Platonism or the figure of perfect identity. Such sculpture-paintings want to transform the relations between the viewer and work as well as the work and the museum or gallery space.

Artschwager wrote of his punctuation pieces that "a gymnastic stretching of the context was attempted in some large punctuation pieces (1966) and resolved in the Blp (1968)" (135). Artschwager's term *blp* has been attributed to the dots seen on the screen of a military submarine. They appeared throughout the 1968–69 Whitney show, "Contemporary American Sculpture." Like Kusama's polka dots, Artschwager's blps (which now appear as massive white or black graffiti on buildings) were part of a dispersed installation work called, "100 Locations." The piece placed one hundred blps all throughout the Whitney building—"in the exhibition galleries, on the stairs, in the lifts, museum offices. Sometimes stenciled, but also often fabricated in wood, hair, and plastic, the blps had gained in size . . . their placing served to attract attention to their context" (144). Artschwager repeated this performance of the blps in Utrecht, where he placed them in a horse paddock, flower stalls, and fences among other places in a move akin to Kusama's placement of her polka dots. Peter Noever's claim that the point of Artschwager's art is "to demystify perception which in turn helps to free perception from the limitations of

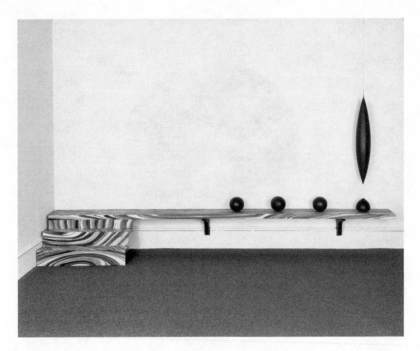

Figure 12. Richard Artschwager, *Up and Across*, 1984–1985. Acrylic on wood, 162.5 × 365.7 × 88.9 cm. Los Angeles County Museum of Art.

pre-conceived notions of usefulness . . . [and] inspires and encourages a kind of productive disrespect and openness that allows access to that place wherein the intellect can celebrate its freedom to the utmost" could be applied to Kusama's work as well.[55] While such a comment may be sanguine and celebratory, it is nevertheless the case that these artists experimented with the known world and became sculptors of the environment.

Points of Contention

Foreground and background are crutches for the mind which painting should put in question.
—T. J. Clark

The nineteenth-century French painter Georges Seurat made an impression as the "father" of "pointillism."[56] A century later, in the mid-twentieth century, Yayoi Kusama made a huge leap from Seurat's late-

nineteenth-century masterpiece *La Grande Jatte* to perform her own series of ongoing texts in her signature use of polka dots. Kusama's artistic techniques contrast with Seurat's "pointillist" technique where in the latter's works dots are used to make an image appear and cohere. Kusama uses dots to obliterate appearances and to produce incoherent vibrations. If the point of pointillism were to produce verisimilitude by formalist means, Kusama's polka dots pointedly were aimed against patriarchy and toward the proliferation of feminist (freedom of) expression. The darting horizontal and vertical gestures Seurat used to apply paint to the canvas may be juxtaposed with Kusama's circular brushstrokes that created subtle, almost invisible, loops. (Should we wonder here that in the musical *Sunday in the Park with George*, the fictional female lead, played by Bernadette Peters, was named DOT?) In Seurat's *La Grande Jatte* "the uncanny rigidity of the strollers . . . points to something profoundly wrong in their world—they cannot move with grace . . . they *should* be experiencing the freedom of their bodies and the pleasures of improvised, untrammeled movements as though the industrial society to which they belong, the rhythms set by the factory and the office had been internalized in to a perpetual prison-house." In New York Kusama says that she found herself "in a uniform environment, one which is strangely mechanized and standardized," and that she felt this "strongly in highly civilized America and particularly so in New York."[57] As a result, Kusama's nonfigurative brushstrokes abstract and make concrete irregular freely expressed "bodies" of paint and her human canvases are painted bodies of freedom. In contradistinction to Seurat, and even to twentieth-century artists such as Roy Lichtenstein with his uniform Benday dots and Chuck Close with his pixelated dots, Kusama's work eschews mechanization.

In contrast to Kusama's brush strokes that anyone could perform as an act of free expression, "Seurat sees . . . freedom as thoroughly inhabited by mechanical control: even his brushwork with its renunciation of any kind of self-expressiveness, enacts the triumph of the mechanical in its repeated dots that mime the technology of the late century's mass-produced imagery."[58] It is helpful here to point out that like Artschwager, Kusama has been misread as a Pop artist when, in fact, her work and his do not conform to key aspects of the predominant Pop art aesthetic—particularly in their disdain for mass production—even when their work employs mass-produced materials such as Formica (Artschwager) and airmail stamps (Kusama). Their work comparatively is more textured

than the slick uniformity associated with Pop art. Thus, Artschwager used "grained" formica to look like faux wood, and in Kusama's airmail collages the hand-placed stamps invariably veer out of line and overlap.

In an interview, Kusama stated that she "painted boredom which is much more important than the sunlight the impressionists painted."[59] The substitution of "boredom" for "sunlight" suggests some important philosophical and phenomenological differences. For example, whereas sunlight emanates from an external natural source and is a product (or is it process—that one can nevertheless engage or feel) of Nature, boredom is a psychological state that comes from (internal) emotive affect. One requires a removal "en plein air" whereas the other does not necessarily react to such external sense data. In French the verb *ennuyer* (to be bored) is self-reflexive, so that more literally one bores oneself, as in fails to find stimulation. But what might we make of Kusama's boredom? I tend to think of those loopy loops as loopholes of retreat (pace Linda Brent in *Incidents in the Life of a Slave Girl*) where Kusama performs a focused action painting as women's work that keeps her occupied in both senses of the term. She eschews Enlightenment masculine mastery in favor of feminine, feminist, focused work that has the quality of "massive slabs of lace." Indeed, Kusama wields power with her brush strokes. It is for these details that I have used the word "texture" to talk about the fashion designer Kusama's work.

Even in her many installations in which quotidian objects are covered with soft-sculpted or sewn phallic-like forms, a profusion of proliferating polka dots appear. The word "polka" is Czech for the feminine form of Polakiem or Polák referring to a Polish man. The dance and music form of the polka refer to, according to the *OED*, "a vivacious couple dance of Bohemian origin in duple time with basic pattern of hop-step-close-step." The polka dot entered discourse at the end of the nineteenth century, according to the *American Heritage Dictionary*, and it is defined as "a dot in a pattern of regularly distributed dots in textile design." The term *polka* was a promiscuous prefix that was affixed to an array of products (including fabric) not necessarily of Polish origin. Kusama notes that "Polka Dots can't stay alone: like the communicative life of people two or three or more polka dots become movement." Her "holey" holy war included her decision to put polka dots on her own boundary, to use her body as a canvas that confounded distinctions between art and life, performance and nature. As with Mira Schor and so many other feminist, and perhaps even many "minority" or shall we say peripheral artists, Ka-

suma performed her personal life politically and made politics personal, as in her love letter to Richard Nixon that in part reads like a "private" epistle but in fact was circulated publicly.[60] Kusama staged a number of photographs with her protesting dancers where they adorned not only Nixon masks but also those depicting Wallace and Humphrey.

Kusama produced her love letter to Nixon on November 11, 1968. It is here that she posits the polka dot not merely as an aesthetic object, but as an ethical idea and ideal.

Open LETTER TO MY HERO, RICHARD NIXON.

Our earth is like one little polka dot, among millions of other celestial bodies, one orb full of hatred and strife amid the peaceful, silent spheres. Let's you and I change all of that and make this world a new Garden of Eden.

Let's forget ourselves, dearest Richard, and become one with the Absolute, all together in the altogether. As we soar through the heavens, we'll paint each other with polka dots, lose our egos in timeless eternity, and finally discover the naked truth:

You can't eradicate violence by using more violence. This truth is written in spheres with which I will lovingly, soothingly, adorn your hard, masculine body. Gently! Gently! Dear Richard. Calm your manly fighting spirit![61]

The letter is a romantic, feminist take on the spoils of war. So, too, it highlights gender differences in order to claim softness, stereotypically for feminine anti-war wiles. Specifically, Kusama wishes to soften Nixon's hard masculine body with feminized polka dots that will calm his manly fighting spirit. The letter draws Nixon close while pushing the world into the background. Taking a truly global, indeed, planetary view, Kusama shifts the terms of discourse—addressing the president personally, intimately. She makes an analogy between the dots of their bodies and celestial bodies—planets like the 1990s feminist rap group Digable Planets whose members imagine themselves as orbs traveling through space.[62]

Similarly, in the wonderful word/image production made of the poet Elizabeth Alexander's response to a painting by Agnes Martin titled *Islands Number Four to Islands No. 4* the reading of dotted forms highlights how we understand shapes as ideograms and ideologies.[63] Alexander's exacting eye perceives the irregular strokes of Martin's seemingly symmetrical, striped ovals on a grid noting that "what appears/To be perfect

is handmade, disturbed." As with Kusama's handiwork, what appears is "Clean form from a distance, up close, her hand." Thus, "What looks to be perfect is not perfect." Alexander notes the connection to a history of coerced labor—namely, slavery—in the graphic forms produced by Martin's art. Moreover, like all of the artists I have discussed heretofore, she sees how the poetics and politics of "pure forms" are linked, or more precisely how formal purity is an impossibility. As Toni Morrison reminds us, the ink itself bears and bares the trace of black deeds, not to mention black bodies.[64] Here we return to Hooke's experiments with both microscope and telescope with micro and macro scales and to changing views of perceived phenomena.

It is no accident that one of the targets in Kusama's ongoing war against capitalism was Wall Street. I am aware of what it means to write such a line after what is now known as 9/11 or 9–11 (the slash may differ from the dash or the dots of 9.11). If read from the perspective of the terrorists who may have understood the precedent put down and putdown produced by the rap group Public Enemy in their track "911 Is a Joke," which retroactively laid the groundwork for the event at "Ground Zero" space has been converted to time and memory such that the events in Pennsylvania and at the Pentagon have been elided. Kusama staged several "Happenings" near Wall Street that serves as a metonym for global capitalism. In her performance piece "The Anatomic Explosion" she and her multicultural, mixed (in terms of sex, gender, sexuality, and race) troupe of dancers and actors protested directly in front of the Stock Exchange. In this specific Wall Street naked demonstration, Kusama called to "obliterate Wall Street men with polka dots." The press release for the event read:

STOCK IS FRAUD!
STOCK MEANS NOTHING TO THE WORKING MAN.
STOCK IS A LOT OF CAPITALIST BULLSHIT.
We want [to] stop this game. The money made with this stock is enabling the war to continue.[65]

The punctuation in the typewritten flyer resembles L/A/N/G/U/A/G/E poetry. Moreover, it demonstrates Kusama's media savvy and penchant for protest.

Kusama's polka dots connote collective movement, as they can never appear "alone." Their singularity must be constituted as a series or a set: they *must* appear together for singly they [are a] stop. Period. (This period

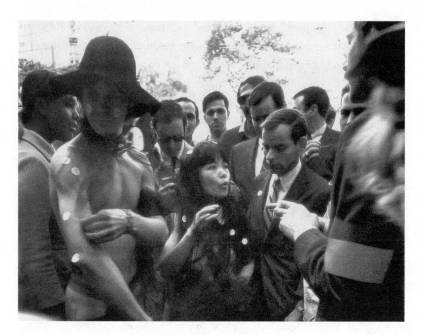

Figure 13. Yayoi Kusama, *Naked Demonstration at Wall Street*, 1968. Kusama Studio.

that "makes each of us a period . . . is, in a sense, our life sentence.")[66] Lest it be lonely, the dot appears with other marks, morphing into new punctuation such as the semicolon, the colon, the question mark, and the exclamation point. Trying to decipher the dots on the page, not to mention the figure/ground confusion marked in and by the profusion of unstable, dauby dots that appear as Kusama's paintings and her life work, will keep us dizzy and busy for some time to come.

Entering a New Period

In 1998 a reporter writing for the *Press-Enterprise* noted that "the punctuation world is entering a new period."[67] The reference here is both literal and figurative in that the new period entered is both temporal (it refers to an era) and aesthetic (a new style). Interviewing "advertisers ranging from Bergdorf Goodman to the American Association of Railroads," the author of the article learned that "traditional telephony punctuation was shifting from the hyphen to the dot." Companies attributed their decision to replace the hyphen with the dot to a desire for a new, updated style. The interviewees exclaimed, "Dots are a little cooler, a little classier, a

little more computery." Locating the punctuational shift in a teleological trajectory, both customers and designers explained that the "ubiquity of the dot in cyberspace made its migration to phone and fax inevitable." In addition to this deterministic model of historical change that hinges on specious connections between "ubiquity" and "inevitability," those quoted in the article provide more complex rationales for preferring dots to hyphens.

For example, the article suggests first that entering a dot is an easier key stroke for secretaries (which to my mind comments on the limits of the body and to labor); second, that the dot is easier for computers to decipher because it eliminates the problem of misreading hyphens as minus signs (this rationale relates to the limits of the machine); and, finally, that the dot provides an overall "cleaner" graphic environment (signifying the limits of visual and psychological perception). Each of the three rationales listed above helps to explain the preference for the dot over the hyphen. Each explanation anatomizes the preference for the dot in a mixture of aesthetic, economic, and political discourses. The condensation evident in the dot is reminiscent of accretions credited to other facets of globalization such as David Harvey's "time-space compression,"[68] or the rise of global English credited to the Internet and the "loosening hyphen between nation and state" as Spivak would say.[69] In our age of abbreviation, where time-space compression is part of our lived reality (the page is as much a stage for such revisions as is the screen and the built environment), it is expedient to be economic in our use of abbreviations. Now we have KFC as a substitute for the multisyllabic Kentucky Fried Chicken, whose full title is as cumbersome and old-fashioned as Colonel Sanders himself. The abbreviation is economic in the sense that the initials are (literally, letterally) a sign like a slogan seen from afar, an identity easily read and consumed—think of new forms of (il)literacy here—and remembered, not to mention quickly spoken in the sound bite.

The *Press-Enterprise* article exemplifies the ways in which punctuation performs a nodal point in a nexus/matrix among culture, politics, and style and makes us wonder, "What kind of political and cultural work does the dot do and is done through the dot?" Clearly a case of a doing and a thing done—the performative dimensions of the dot dot our mindscape, compelling us to respond to its call. Although in its conclusion the article minimizes the significance of thinking about punctuation by stating, "most clients aren't concerned with such level of minutiae," it is the contention of this chapter and indeed this book that such marginal-

Figure 14. Guy Williams, *Rhizome*, c. 1996. Digital image, *Dimensional Typography*. Princeton Architecture Press. Courtesy of Emigre Fonts.

ized minor, minute, or minoritized marks SHOULD concern clients and consumers as well as cultural critics. Such minutiae express the potential for explosion. Indeed, my goal in this book is to give readers a sense of the breadth and import of punctuation when read "against the grain," as elements of thought as well as style—as figural markers that defy traditional, "Enlightenment" binary oppositions between seeing and saying, imaging and speaking, pictures and propositions.

Now that we have entered the new period of graphic design and multimedia, the dot may be seen as even less discrete than it was imagined to be for a period of time in the nineteenth century. Consider the accompanying illustration: what you see may be a virtual copy of Hooke's smutty daubing; it is, in fact, another example of "dimensional typography." Produced nearly four hundred years after Hooke's experiment, it nonetheless resembles it. Like our earlier examples, this dot (it is the top of the letter J seen from above), "adds a spatial and temporal concern to the traditionally 'flat' and static province" of writing.[70] This dot returns us to the opening questions of this chapter that focused on perception, reading, and graphic forms. As Miller explains: "Presumably, concern for the SPATIAL aspect of *navigation* and concern for the SCULPTURAL aspect of *individual forms* will converge in a new approach to typography . . . Both directions suggest an expanded field for design. Readers and viewers are increasingly able and willing to navigate texts and nego-

tiate challenging textual and visual environments, whether they are the physical spaces of exhibitions or the virtual environments of new media. Designers accustomed to dealing with the flat, pictorial paradigms of print are now dealing with the architectural, ergonomic, and cinematic paradigms of environmental, immersive media" (2). In the epilogue to this book, we will think more about how we are continuing to interpret such multimedia. For now, however, we must be content that we have almost come full circle from the point where we began (with points made by Fleming and Hooke).

o

It was a civilizing urge—
to bring closure, to come full circle,
to worship time by divvying it out
into portions, increments, sentences.

All things must end, mustn't they?
Breath, as well as mortgages, as well
as prison terms, marriage vows, etc.
It was a civilizing urge—to end.

one thought and begin another,
to pardon a slight, borrow a rake,
castle the future, crib the past,
count each day, siphon the moment.

But what about before this era,
when the currents of time flowed on
eternally through our veins through
our minds our souls our lives when

all bodies were charged by turning stars
by the bisons' migrations the gazelles'
leaping the clouds' turmoil the ants'
gyrations—the whole heaving universe

endlessly dancing? A civilized urge.
Necessary. No doubt. The way. Modern
minds. Work. Bidding the forbidden. To
halt. What else could we do? Period.
—Maurya Simon, "The Era of the Period"

Maurya Simon's poem serves as the epigraph for this epilogue. The poem imagines the period after and before "the era of the period." The poem's title, "The Era of the Period" invokes temporality by focusing on periodicity.[71] For those of us trained in literary history and/or art history, periods still matter even though we know they are not fixed points: that they are subject to revision. Simon's poem implicates the period in master narratives of periodization. The poem posits that we have an urge, an innate inclination to end. Endings are part and parcel of the civilizing mission of the West that has been so invested in marking and maintaining boundaries. Rather than discuss the "civilizing mission," Simon mentions the civilizing "urge" as if to suggest, as did Coleridge, that the rational and irrational merge into an instinct. Law and order, civilization and its discontents and continents can be traced to a mere mark on a map, a legal sentence, an official seal on a bureaucratic document that determines one's fate as a fait accompli. "Whether spatially or temporally perceived, a structure appears "closed" when it is experienced as integral: coherent, complete, and stable."[72] If we believe that closure is a human conceit,[73] how do we determine who has the right to end?[74] Simon's poem reiterates the concept that to end is an authoritative act: that to periodize is to speak with specific endpoints in mind. Thus, to declare the end is a mark of power.

PERIOD·

Belaboring the Point • • •

There is reason to fear that, like ellipsis, the fragment—the "I say practically nothing and take it back right away"—makes mastery over all that goes unsaid possible, arranging in advance for all the continuities and supplements to come.
—Jacques Derrida, quoted in Maurice Blanchot, *The Literature of Disaster*

Pick up any play script and you are bound to engage with its typographical elements. The dialogue that composes and comprises the script calls upon us—critics, readers, actors, dramaturges, and directors—to interpret not only the words presented but also the inevitably present blank spaces, parentheses, colons, fonts, typefaces, italics, ellipses, etc.[1] Though an "author" may wish to guide us in our reading (as does Tony Kushner in the introduction to *Homebody/Kabul* where he notes "a sentence ending with a '. . .' indicates that the speaker has trailed off . . . [and] a sentence ending with a '—' indicates that the speaker is interrupted by someone or something"),[2] in practice we are free to imagine and even produce our own supplements to the printed matter in/of the text. What I wish to emphasize here is the ambivalence of such marks that are perpetually open to interpretation and improvisation. Exactly how long is a beat? How does one translate the pitch of boldface? How does one sense and interpret an italicized word? Can we think of such notations as notes—as both shorthand and music? How does typography cue us to action and vice versa? Here my questions are informed in part by the following quotation from Marshall McLuhan's controversial and typographically innovative production, *The Medium Is the Massage*, which reads: "*Reminders*—(relics of the past)—in a world of the PRINTED word—efforts to **introduce** an AUDITORY dimension onto the visual organization of the **PAGE**: all effect *information*, **RHYTHM**, inflection, pauses. Until *recent* years, these EFFECTS were quite **elaborate**—they allowed for all

sorts of **CHANGES** of type faces. The NEWSPAPER layout provides more variety for **AUDITORY** effects from typography than the **ordinary book page** does."[3] Despite the dubious priority accorded to types of print in this passage, it helps us to re-cognize the role typography plays in our perception of things and concepts. In highlighting typography, I want to remember that writing has been a tool of colonization and power.[4]

So, too, this inquiry is complicated by Ed Bullins's play *The Theme Is Blackness* (1966), which reads in its entirety:

> SPEAKER: The theme of our drama tonight will be Blackness. Within Blackness One may discover all the self-illuminating universes in creation. And now *BLACKNESS*—
> (*Lights go out for twenty minutes. Lights up.*)
> SPEAKER: Will Blackness please step out and take a curtain call? (Lights Out.)
> BLACKNESS[5]

Bullins's drama, appearing more than a decade after the publication of Ellison's *Invisible Man* (1952), replays one of its retroactively produced antecedent themes (and here the term should be thought of in its most musical guise). In this drama, as in *Invisible Man*, there is an unnamed "speaker"; the concept-metaphor of blackness is played out against an idea of illumination; blackness is repeated with a difference; the action is "circular," it appears between parentheses—bracketed as if in a black hole, the blackness of blackness is performed viscerally for an audience, and the blackness of blackness is "determined in the encountering time of a caesura," according to Fred Moten.[6] As such, Bullins's play surprisingly shares much with Ellison's earlier text. This genealogy goes against a more popular version of literary history in which members of the 1960s Black Arts movement, such as Bullins, presented a radical break with the purportedly more assimilationist and conservative artists such as Ellison who wrote during the 1940s and 1950s. In my reading, however, both texts are exemplars of experimental (black) performative conditions. In both Bullins's play and Ellison's novel, as I read them here, blackness is simultaneously visceral and elusive, enveloping and intangible, material and conceptual. Both texts let us see in the dark, hear in the silence, feel in an empty arena the blackness of blackness.

The embodied experience is played out against a series of always already inscribed notions of what blackness "is" and "ain't" and of our ex-

pectations of its overdetermined view. That blackness is in/visible—is tied to the ocular—is the premise that Ellison's famous novel at once seeks to acknowledge and undo through its complicated rendering of scenes that stage and restage formative moments of "blackness" in American culture. In this chapter, I think about the role that typography plays in eliciting and soliciting (black) sensations and sensations of blackness—in moving us to respond to the "calls" (as in hailing) of black ink.[7] More specifically, I offer a reading of a scene from Ellison's *Invisible Man*. The larger goal of this endeavor is to press the issue of the link (or leak) between black ink and embodied forms of blackness.[8]

The amount of published material on Ellison and jazz/blues is daunting by any estimation.[9] Nevertheless, for all their detailed attention to the THEMATIC of jazz, many of these critiques have downplayed the significance of Ellison's typographical composition by relegating it to a lower frequency whose relative invisibility seems not to speak at all. For all the reams of paper devoted to explicating Ellison's work in musical terms, little has been said about how the white background of the *mise-en-page* mediates and materially produces the black-and-blue marks of "invisible music." In musical notation, specific symbols such as rests, notes, and the like provide a blueprint for performance. Analogously (we still work with this technology even in this era of the digital), we might argue that other typographic devices (boldface, punctuation, italics, spacing, etc.) serve as the dramatic guidelines for the written word. There are multiple ways to construct a genealogy of such experimentation—but suffice it here to state that whatever their source, such typographic elements can be read as an important resource for reading *Invisible Man*. Virtually every page of *Invisible Man* can be read as a "psychovisualauditory" event. For example, chapter 9 (what a DVD might label the Peter Wheatstraw episode) employs the convention of *scriptio continua* inwhichwordsarewrittenwithoutspace.

Even more specifically, however, I am interested in seeing how various marks on the stage of Ellison's page come to signify the "blackness of blackness" that "is . . . and ain't" sighted sound. With this last remark, I gesture toward the way in which characteristics of the ellipsis work as analogues to the character Invisible Man. Both "characters" are ambivalent, singular yet multiple, "heard" but not seen, black but blank. Before offering an explication of these contentious points, I want to say something more about how we might temporarily join discussions that have previously occurred separately. Yayoi Kusama's work on the white-

ness of whiteness echoes Ralph Ellison's on the blackness of blackness that I discuss in this chapter. Ellison's reliance upon the ellipsis to signify doubly what is there as the not-there echoes Kusama's use of polka dots that simultaneously (un)cover material forms. Such taut tautological or perhaps "dotological" formations perform the concept of repetition and difference that we can now see the polka dots performing. They both veil and expose surfaces and spaces. So, too, their repetition in space makes them differ from "themselves"—as dots they become the ellipsis. Both Ellison's ellipsis and Kusama's polka dots are collective marks that cannot appear alone; for example, where during Invisible Man's battle against Monopolated Light and Power the narrator says "to be aware of one's form is to live a death." The narrator continues this thought, adding that he "did not become alive until [he] discovered [his] invisibility."[10] Similarly, Kusama has spoken of an insistent dream of obliteration as a means of liberation. Both artists, then, relied upon abstract concepts embodied in such material marks to convey their specific historical, philosophical, political, and aesthetic ideas.

As Ellison famously wrote, "history is like a boomerang"; which is to say that it is not teleological but rather replayed through the return—an event that elapses time and space. This idea recalls Rebecca Schneider's reading of "the archive and the repertoire" (pace Diana Taylor) that argues the "idea that theater does not disappear . . . but rather it reverberates, . . . it enters or begins again and again . . . via itself as a repetition—like a copy or perhaps more like ritual—as an echo in the ears of a confidence, an audience member, a *witness*."[11] The fact that this description mixes sight and sound—includes the echo and the witness—suggests that sensory perception, like memory and history, is both multifaceted and entangled. In a brilliant reading of the "interwoven visual and aural contours" of four jazz poems, Meta Jones argues that "'typographical techniques'" are not merely orthographic but also prosodic.[12] Some of the experimental typography that appears in the text includes the following: the use of italics to mark some of the dream sequences and stress important words; the use of boldface and larger fonts to mark the various signs, slogans, and rising intonation; and a lack of spacing and/or insertion of extra spaces. Although typographical experiments may be construed as part of a Western modernist tradition dating back at least to the novelist Laurence Sterne, Ellison's innovation was to put these black marks into the service of black subjectivity. Thus, in my reading, the blackness of blackness signifies and signifies upon a certain excess associated with black performance. In this

I follow Marcellus Blount who notes: "While the term *performance* can be applied variously to a range of cultural and literary phenomena, I use it to designate verbal performance viewed as a cultural event. . . . The term *vernacular* [is associated] with the modern concept of folklore as an intricate interaction between performer and audience that relies on linguistic, paralinguistic, kinesic, and thoroughly contextual codes and conventions. . . . In written texts that draw on the aesthetics of vernacular performance, the relations of orality and literacy are continuous."[13]

In her essay on Ellison and visual art, Elizabeth Yukins argues that "as an artist, [Ellison] had to transfigure his conceptions and his sense of rhythm and form into the specific and sometimes restrictive medium of writing."[14] While her analysis is confined to his posthumously published novel *Juneteenth*, one can see and hear elements of this technique in *Invisible Man* as well. I extend Yukins's insights about Ellison's use of "cubist" and "collagist" techniques (again suggesting multiple dimensions) by allowing us to see and hear how a graphic element figures in such renditions. Let us note here that Yukins argues for the role of the visual in Ellison's work, whereas other scholars seek to play up the role of music in the text such that they argue that "Ellison plays with language as he would a trumpet, taking lyrical flight in improvisational passages that stylistically emulate his artistic ancestor, 'Satchmo' Armstrong . . . *Invisible Man* is a musician's novel, a book meant to be heard as much as read."[15]

In a letter to his longtime correspondent Albert Murray documenting the completion of the "you-know-what" that was to become *Invisible Man*, Ellison wrote, "Is it a rock around my neck; a dream, a nasty compulsive dream which I no longer write but now am acting out (in an early section the guy is obsessed by gadgets and music, now I'm playing with cameras and have recently completed two high-fidelity amplifiers and installed a sound system for a friend); a ritual of regression which makes me dream of childhood every night (as a child I was a radio bug, you know, and take it from me after getting around with the camera bugs and the high-fi bugs and the model train bugs, you'll have no doubts as to the regressive nature of this gadget culture); or is it a kind of death a dying?"[16] This rich quotation hints at a practice that Ellison would take up in composing his text. Although he began writing by hand, having his wife Fanny work as his typist, he typed as well as orally recorded his novels. Fanny remembers hearing him talking out loud to and as the characters in his work, a technique practiced by the audio artist and filmmaker Miranda July, whom I discuss in the epilogue. Fanny Ellison claimed that

when her "husband couldn't find the words at the typewriter, he [went] upstairs and play[ed] the trumpet."[17] The relationship between Ellison's "bio" and his "graphy," like that between his fiction and his criticism, has been intertwined repeatedly. My contribution to this axiomatic way of entering Ellison scholarship is to read a scene that was aired in a television documentary in 2002.[18]

Toward the end of the 2002 PBS documentary about the life and work of Ellison, the audience sees the writer in his home office, composing the beginning of his second novel, posthumously published as *Juneteenth*.[19] The camera zooms in on a large tape recorder perched precariously on the edge of Ellison's paper-cluttered desk. The clear plastic reels of the recorder spin black tape at high speed as the camera pans upward to reveal Ellison, microphone in hand, simultaneously reading typescript and speaking aloud. His voice becomes invisibly inscribed—in a medium shot we hear the voiceprint played back in reel/real time. Ellison smiles and laughs, nods his head acknowledging the "joy in repetition" (to quote the artist formerly and again known as Prince). Such a scene reveals much more than the writer's process or even the long-standing practice of writers presenting dramatic readings of their work (here I am thinking of those popularized by Dickens, among other nineteenth-century professional writers); indeed, the entire sequence suggests, as Ellison himself wrote in a letter to Murray, that he often *acted out* his narratives. The film returns us to this scene again, showing us that Ellison has rewound the tape and during playback his affect changes; he shakes his head with satisfaction at the sound of his recorded, deferred, and differently technologized voice. In voicing his text, Ellison relies on the technology of the voice, as well as the recording machine. This kind of temporal disjunction appears again and again in Ellison's novel. In other words, Ellison's use of the recording device points out the simultaneity of what is too often taken to be a binary opposition between orality (spoken speech) and textuality (written word). In contrast, I want to think of orality and textuality as co-conspirators—simultaneous mechanical actors that maintain and produce movement.

In Ellison's introduction to the 1981 edition of *Invisible Man*, he records one of several different origin stories about how he came to write his novel. He remembers that: "Shortly before the spokesman for invisibility intruded, [he] had seen, in a nearby Vermont village, a poster announcing the performance of a 'Tom Show,' that forgotten term for blackface minstrel versions of Mrs. Stowe's *Uncle Tom's Cabin*. [He] had thought such

entertainment a thing of the past, but there in a quiet Northern village it was alive and kicking, with Eliza, frantically slipping and sliding on the ice, still trying—and that during World War II!—to escape the slavering hounds . . ." (xvi). The passage records two annunciations: the intrusion of the voice of an invisible man and the advertisement of a blackface minstrel show. The theatrical underpinnings evident in these stereotypes of black performance retroactively provide a previously overlooked origin for the genesis of one of the twentieth century's most celebrated American novels, namely *Invisible Man*. Encountering these "strangers in the village" (pace James Baldwin) provides the writer Ellison with an opportunity to recognize the endurance of black popular forms in American culture. More specifically, Ellison's vivid re-reading of the still active and kicking, still running theatrical event from the nineteenth century serves, in its re-presentation, to keep the image in circulation. Far from having outlived its entertainment value, the "world's greatest hit"[20]—replete with its live translations from page to stage of the most prurient scenes of melodrama and violence—trades on and in a nostalgia for a past that, as its recurrence attests, has not passed. "Forgotten but not gone," to use Joe Roach's phrase, the Tom show is a (North) American staple.

The narrator of Ellison's novel-to-be is characterized as an intruder as well as a "spokesman for invisibility." He is a voice without a visage although he has vision and story to tell. Ellison has seen "a poster announcing the performance of a 'Tom Show,' that forgotten term for blackface minstrel versions of Mrs. Stowe's *Uncle Tom's Cabin.*" Although Ellison directs our attention to the ubiquitous black-and-white image of Eliza on the ice, such theatrical posters include writing—or more specifically, typography. As noted earlier, numerous critics have commented and elegantly analyzed the jazz language of Ellison's magnum opus, but few have seen the actual typeface and typography of the text as an element performing in the service of such jazz aesthetic politics. Taking Nathaniel Mackey's rendition of Hurston's formative work, we can see not only nouns singing and swinging in Ellison's text but also punctuation marks and especially the poster as a peculiarly modern intertext for the novel itself.[21] In short, I want to notice the notices that appear in the text as signposts and signals that provide viewers with opportunities to scrutinize sheets of sighted sound (and commodity culture)—those printed quotidian documents that help to compose the blackness of blackness in very graphic ways.

If doubleness is constitutive of black performance, then we must learn to see the suprasegmentals and analphabetic symbols that appear throughout the text as complicated material in their own right/write. Where earlier modernists experimented with the form of the novel—adding and deleting punctuation for effect and affect—Ellison's experiments also help to mediate and imprint call-and-response and other modes of black vernacular theory.

Ellison claimed that after typing the first sentence of the novel, "I am an invisible man," that he ripped the page from the typewriter and wanted to destroy the paper. He pondered the "origin" of such a sentence and then "the words began to sound with a familiar timbre of voice." He recalls: "And suddenly I could hear in my head a blackface comedian bragging on the stage of Harlem's Apollo Theatre to the effect that each generation of his family was becoming so progressively black of complexion that no one, not even its own mother, had ever been able to see the two-year-old baby. The audience had roared with laughter, and I recognized something of the same joking, in-group Negro American irony sounding from my rumpled page."[22] Such a phenotypical phenomenon can be seen in the black folk humor that produced the nickname "blue" for Negroes so black they were "blue." The blackface humor of the text is integral to explicating the blackness of blackness as an inescapable "ethnic notion." In *Invisible Man*, theatrical posters, placards, and other printed signs appear to break up the otherwise uniform print. Given these insights into Ellison's practices, we should not be surprised by the fact that the printed *Invisible Man* begins with two epigraphs that "record" dialogue, the first from a scene in Melville's novella *Benito Cereno*, and the latter from the playscript *Family Reunion* (1939) by T. S. Eliot. There are also moments in *Invisible Man* where Ellison employs different forms of typographical excess to overscore, underscore, and represent important shifts in the narrative. For example, the use of italics in the dream sequences, parenthetical asides, lack of spacing, capitalization, line breaks, etc. Indeed, retrospectively, the book reads as if it were a Beat poem. For all of Amiri Baraka's and other black nationalist poets' denouncing of Ellison as an Uncle Tom and an apolitical writer, they nevertheless seem indebted to his formal experimentation with the *mise-en-page*. Even the very use of the term "blackness" as a signifier for the new movement might be indebted to its appearance in the novel that deployed the term in contradistinction to Ellison's contemporaneous citation of the term "Negro."

The first edition begins with an "I" that is printed in font so bold that it is without benefit of seraph. The first fragmented sentence in bold reads I AM AN invisible man. The phrase "I am a man" serves as a political catchphrase for black masculinity. The dancer Bill T. Jones, whom I discuss in chapter 4, utters the phrase in his performances. The use of capitalization makes a fragment that is reminiscent of Ellison's stutter with its near rhyme between AM and AN (missing in a near rhyme making a Man). Could we hear Ellison, with the stutter he famously tried to stop, recording "I am Man—(sotto voce) invisible Man."

Although in classical rhetoric the ellipsis has been understood as a "scheme" rather than a trope, more current scholarship, according to the *Cambridge Encyclopedia of Language*, notes that classical rhetoric increasingly is read in figurative terms.[23] I argue that the proleptic, proliferating, and perforating figure of the ellipsis performs in Ellison's text (as it does here) as a point of contention. More importantly, however, I am interested here in explicating a key moment in *Invisible Man* that dramatizes typography as a form of experimental (and perhaps even experiential) blackness, "foregrounding" the unusual use of typography as a means of expressing the blackness of blackness. This is a playful if deadly serious endeavor that seeks to understand such a tautological phrase as inscribing blackness as a nonessential character. I ask you to look askance at the ellipsis and to listen to them/it—as if in a hallucination. Now we occupy an imaginative place of play where lucidity loses it appeal. Like Ellison's fictional character, we enter a layered cave in an impossible time-space continuum—the passage is by turns violent and pleasurable. Significantly, however, it calls upon us as readers to witness the existential angst of the character. In analyzing the fragmentation of accounts of those survivors of state terror (such as the Holocaust and the disappeared in Argentina) that Anne Cubilié has analyzed. Cubilié argues that "the complexity of issues raised by this dialogic and temporal confusion . . . the narrative collage style in which the book is written works against strong reader identification with a single authorial voice . . . [instead] the text works to create an engaged and critical reader . . . While one can read the book as a distanced spectator, eliding the gaps and reading only the basic narrative structure, the form of the text encourages a performative, engaged, witnessing relationship with the reader."[24]

Invisible Man can also be read as a text that sutures the sound/image binary. Remember, Ellison read out the entire text even as the priority of

speaking/writing/reading cannot be ascertained. The point here/hear is to recognize the simultaneity and untranslatability of this ritual practice and to re-member the "interanimation . . . of vision and sound" recorded through the recoding in Ellison's work.[25] Then, it is up to the audience (in multiple senses of the term) to "fall for your affectation or flail you for requesting their attention."[26] We can imagine Ellison, like so many other writers whose "work is a collaboration of voices [in which one] takes the role of director, producer, and editor."[27] Like the poet Deborah Richards, the book makes a case for the active role of the witness/participant that accords with Ellison's well-documented ideas about call-and-response and the potential of art to transform action. She describes her style as being "like watching a play from the wings. If I continue the analogy, I would say that with my work you get a closer look at the strings holding the puppet up. Perhaps you even see the puppeteer working the limbs"[28] (and here we might think of the scene in *Invisible Man* with the minstrel doll). Such techniques are at play in Ellison's text—especially in the figure of the ellipsis that appears throughout.

The ellipsis appears to de-compose the page and speech: as such, it labors to contra-dictory ends. It marks a strategic deletion that produces not only deleterious effects (lack), but also, and simultaneously, affective desire (excess). Like the strategy of silence that many employed as a form of power and that has been examined by black feminist critics such as Darlene Clark Hine, the ellipsis can be read as "saying something obliquely," or as Linda Brent says, "telling it slant." In speech, the ellipsis runs rampant. It is an everyday occurrence. Here I am concurring with Fred Moten's idea that there is an "intense relationship between experimentalism and the everyday (which includes but is not reducible to what people call 'the vernacular') that animates radical artistic practice in the second half of the twentieth century."[29] Ellison, as a scholar of vernacular culture, a musician, and an interpreter of black forms, employs the ellipsis as both a mark and a strategy in *Invisible Man*. At times in Ellison's text, the ellipsis can be read as a site that invites improvisation: one might even say that the ellipsis as a present figure of absence is paradoxically more meaning-full, rather than meaning-less.[30] By this I mean to point out that rather than seeing the ellipsis as "empty"—not doing or "acting" on the page—it could be rethought as an active agent that sutures the call and response of Ellison's dialogue and in other spaces, as the mark that hails the reader as a participant, inviting the audience into imaginative engage-

ment with the text. The mandate to "keep this nigger boy running" can be read typographically in the repetition (always with difference) of the ellipsis throughout the entire novel.

The ongoing black blues tradition of the changing same has been documented and replayed by many who subscribe to the aesthetic and theoretical idea that it is "in the break" that the music and movement of invisibility and improvisation take place.[31] This notion of the "break" or "change" is constitutive of a modern black tradition reaching back, if you will, to an (African) past that can only ever be reconstructed by remembering the radical break—known euphemistically as the middle passage—in the transition. In the following reading, the ellipsis is read as revealing, evoking, and performing as Ellison's effective and affective strategy of racialized performance.

Let us think about *Invisible Man* in terms of the elisions and embodied excesses performed in a pinpointed part of its prologue which itself is performed explicitly for an audience/viewer as signaled by its use of first-person direct address. Here we witness the warped texture or the weave of space, time, temperament, and tempo of the text. The situation in the text is a reefer-induced hallucination in which Invisible Man "slips into a break" that is like a spatio-temporal warp . . . like the "beam of lyrical sound" bent by Louis Armstrong's "military instrument" (8). He seems to be caught in limbo between time spent/spending time, past-passed and present.

beneath the swiftness of the hot tempo there was a slower tempo and a cave and I entered it [cave or tempo or both?] and looked around and heard an old woman singing a spiritual as full of Weltschmerz as flamenco, and beneath that lay a still lower level on which I saw a beautiful girl the color of ivory pleading in a voice like my mother's as she stood before a group of slave-owners who bid for her naked body, and below that I found a lower level and a more rapid tempo and I heard someone shout:

"Brothers and sisters, my text this morning is the 'Blackness of Blackness.'"

And a congregation of voices answered: "That blackness is most black, brother, most Black . . ."

"In the beginning . . ."

"At the very start," they cried.

". . . there was blackness . . ."

"Preach it . . ."

". . . and the sun . . ."
"The sun, Lawd . . ."
". . . was bloody red . . ."
"Red . . ."
"Now black is . . ." the preacher shouted.
"Bloody . . ."
"I said black is . . ."
"Preach it, brother . . ."
". . . an' black ain't . . ."
"Red, Lawd, red: He said it's red!" (8–9)

The ellipses here signify a hallucinatory sequence whose spatio-temporality is "preposterous"; like a boomerang, its "end is in the beginning and lies far ahead."[32] Thinking elliptically (with the ellipsis) helps us to understand Ellison's ethical call and response. Ellison's text notes, with and through the ellipsis, a suspended space and space of suspense where "the unheard sounds came through, and each melodic line existed of itself, stood out clearly from all the rest, said its piece, and waited patiently for the other voices to speak. That night, I found myself hearing not only in time, but in space as well" (8). We witness the performative labor the ellipsis does in this famous passage of Ellison's text. It is noteworthy that the passage rendered in italics repeats the word "tempo" three times in its opening paragraph. The swift hot tempo gives way to a slower tempo and ultimately to a more rapid tempo. Each shift in tempo takes the narrator to another level signaling the impossibility of separating time from space—a concept-metaphor substantiated by the ellipses in the passage—back, which is to say, below . . . a passage that "is and ain't." The tempo never stops: rather, like the ellipsis, it is figured relationally—as "more or less" (t)here. It is in this section that a dialogue ensues between the old woman and the Invisible Man about the terms love, hate, and ambivalence, the latter glossed as "a word that doesn't explain it."

As we have begun to map out, the ellipsis is ambivalent, enigmatic, paradoxical—the presence of absence (or vice versa) that like the blackness of blackness both "is and ain't." Isaac Julien praises the passage for having the preacher show that "being black is an open-ended identity."[33] The ellipsis self-referentially points to a variable deictic space in which "the entanglement of subject and object . . . embraces the reader within the narrative as a variable 'you,' who is fully dependent on, *and* constitutive of, its corollary, the 'I.'"[34]

The blackness of blackness is both textual and performative—figured as, in, and by—the ellipsis. Even the previous paragraph illuminates or serves to illustrate and narrate the ellipsis. For when the dream, which is recorded in italic type, enters into the depths (remember we read the book layer by layer—creating the illusion of entering its depths; it also has a prologue and epilogue that take place in the same space) the narrator continues: "*beneath that lay a still lower level on which I saw a beautiful girl the color of ivory pleading in a voice like my mother's as she stood before a group of slaveowners who bid for her naked body, and below that I found a lower level and a more rapid tempo*" (9). The page that forms and frames the ellipses (framed again by quotations) is ivory colored, like the (not)black slave mother, who, it bears repeating, is the condition of possibility for the birth of (the) blackness of the sun/son. Law-d (think logos) over by an overlord in the form of the white master's bidding on her body, it is she who carries the trace of blackness that gives birth to the trauma experienced and expressed in Invisible Man.[35] This is in fact one of the harbingers of the strategy of racial performance that is performed in the novel's engagement with both the "speakerly and preacherly text."[36]

The miscegenative mixture is the trope that animates the text. The spiritual aspects of the text are less metaphysical than temporal and cultural (in the sense of tied to tempo—to the here and now as opposed to some conception of a transcendental eternal space above the line). As Kim Benston explains, "Ellison ironically displaces 'white mythology's' fable of the origin with a story of the beginning-as-blackness. At that beginning, the passage suggests, we find enacted a series of complex differences and dislocations, first imaged here as a 'descending' through cultural realms. . . . [then plunging] toward a site where language, in the crucible of national and family romance, has both the impulse . . . and the power to declare its own absence."[37] I would argue, however, that the ellipsis presented in the second epigraph and throughout the prologue in fact marks the "beginning of blackness" that performs such a vital element and idea. For, if we read the typography of *Invisible Man*, the ellipsis appears as the first (in)co-hear-ent mark in the text—an initializing site/cite of trouble that recurs in the opening stages of the text. (The ellipses are at once distant and near, transparent and opaque. Their beat . . . nicks the page—confounding and connecting senses and sensations simultaneously while gathering into its orbit a host of other binary oppositions so as to move beyond them.)

When Ellison's text records and repeats the word "red" as in the color

of the bloody sun, I see and hear the term, literally, "read." The history, his story and ours, is bloody, red, black, and ivory—but also read, and heard, in black and white.[38] The speech act mixes the sacred and secular, recording, reverentially, a profound profanity. Ellison also asks: "Could this compulsion to put invisibility down in black and white be thus an urge to make music of invisibility?" (13–14). In terms of my desire to read punctuation-typography's aspirations problematically and materially, I think that this is an important question for which ellipses may provide a partial, imprinted answer. Before I elaborate this elaborate point (and these elaborate points . . .), let me complete my reading of Ellison's paragraph. "But I am an orator, a rabble rouser—Am? I *was*, and perhaps shall be again. Who knows? All sickness is not unto death, neither is invisibility" (14). The phrasing here signals the open end of the novel's sentence of blackness that concludes with the repetition of the epistemological query, "Who knows"? As the text asks later: "Who knows but that, on the lower frequencies, I speak for you?" (581). Again, the ellipses open the spatial/temporal gap, mark the break, *are represented in and in fact are the break* between these determined, determining questions. Thus, the ellipsis at once "is and ain't."

The ellipsis in Ellison's text may be read as a means of understanding black performance or, more pointedly, the performance of the blackness of blackness. In such settings (pun intended), these graphic analphabetic symbols function as shadow figures that both compose and haunt writing's sound and substance. We remember that Ellison, with his stutter, vocalized every page of *Invisible Man*—recording and recoding his language in a process that he called acting but that required the use of machinery to "capture" the sound. There is no priority here in the circulation of the "text." Hearing the "unheard" music of *Invisible Man* requires us to respond with ear, eye, and mind. Indeed, those moments in the text, where words break apart, dialect becomes dialogue, spaces appear and disappear, and where punctuation proliferates, perforating the page and our passive "silent" reading—these are the interactive moments of Ellison's work that turn us into audiences—things seen as written and written as seen. Ellison played out his work vocally in the rhythm of a jazz musician. Although he left his musical training behind, he was still a composer of sound and visual rhythm.

As I allude to in the opening of this chapter, the "script" in theater as well as in our daily repertoire is that which allows us to repeat our lines. Typography and punctuation perform as do mouth movements, facial

contortions, and other somatic gestures. Such "excess *outlines* other possibilities not taken, not voiced. There is no transcendence here; all elements (at the very least), all these implications coexist in the performance . . ." (italics added).[39] Indeed, such gestures both frame and exceed the "lines" all subjects are given to perform. The ellipsis can be read as signifyin(g) ". . . as expressive potentiality, articulating a syntax where, in Billie Holiday's phrase, the meaning used to change. Scat works 'the accompaniments of the utterance' in a given medium: in song, the vocal play that liquefies words; in performance, the excessive, oblique physicality, of mugging; *in writing, the overgrowth of punctuation*, self-interruptions, asides, that exceed the purposes of emphasis, intonation, citation. Inarticulacy is telling because the proliferation of index points at—structurally suggests—an expressive syntax that is unavailable but inferred through its 'accompaniments'" (italics added).[40] The ellipsis as I am reading them here form a corollary between the different and yet analogically related experiences of silence and invisibility. They supplement experience and call attention to the scripted-ness and excess ascribed to black performance. Others have called such "notes" grace notes or perhaps we might even think of them as akin to theatrical "stage business." Where previous scholars have tended to read punctuation marks as a "visual supplement rather than aural cue,"[41] I read punctuation marks as figures of speech that cannot resolve the tension between aural/oral and visual as "the surplus gift inherent to Afro-diasporic double consciousness . . . [whose] excess comes in the form of a phonography that rebuffs any separation of the two forces in this compound [speech/writing] whether it rolls up in the sphere of literature or music."[42]

The ellipsis marks both presence and absence. On the page, it is a visible element that signals missing information and it does so in the English language through the repetition of a dot such that it becomes a series.[43] In short, the ellipsis, in its singularity, is not a "single" mark but rather a triple "one" or a "complete multiple."[44] Ellison himself spoke of the significance of "our unity-in-diversity, our oneness-in-manyness."[45] Here, one can extrapolate and read the ellipsis as a figure that is at once singular and collective, denoted by a *series* of dots (a run of ellipses) whose connotations are a con akin to "unspeakable things unspoken," to borrow Toni Morrison's suggestive phrase, or perhaps, to revise her words, unbreakable things unbroken. This (im)possible construction lays and delays the groundwork of sentencing and leaves a final resolution open

to questioning: "Who knows but that, on the lower frequencies, I speak for you?" asks Invisible Man at the conclusion (not end) of his text. The ellipsis tarries with negative space and suggests the not (t)here. Ellipses (un)cover (un)familiar ghosts. These *blank black bullets* bore into our psyches asking us as we read them to project and imagine what might be . . . behind, beyond, and within them. Like empty signifiers, they mark a desire, whose meaning can never be fulfilled but must always be filled. Such comments concur with the tenets of "close reading" in which each mark on the page matters—is the matter of/with writing. Such counter-syntactic cues provide clues to the importance of improvisation in Ellison's sermonic section of text. Typography becomes "song" in its excessive expression.

The ellipsis in particular defies the supposed value of punctuation for prescriptivist punctuationists who subscribe to the view that punctuation can harness speech and/as writing in an enlightened drive for clarity and rationality. What I want to underscore here is the way in which Ellison's gestural use of typography seeks to liberate and "free" such markers from their conformist strictures. They are in fact part and parcel of the novel's improvisational impulse. We might even say that they provide the page with a pulsing visual rhythm. The very word "point" itself is "elliptical for *full* (or *perfect*) *point*; *full* (or *complete*) *pause*; *full stop*."[46] This last point relates to my earlier discussion of the ellipsis as delaying sentencing. We are made aware of that which either goes unsaid, exceeds saying, or cannot be said. The ellipsis can stand for what *need not be said*, for what may be redundant to say as well as for what *cannot be said*, for that which exceeds locution and is therefore impossible.[47]

The ellipses mark the space of difference—where the practically nothing but (im)practically something will be (not) said and (not) written—or, "said in silence." Jason Merchant in *The Syntax of Silence* claims that the primary goal of the discipline of theoretical linguistics "is to develop a theory of the correspondence between sound (or gesture) and meaning. Nowhere does this sound-meaning correspondence break down more spectacularly than in the case of ellipsis. And yet various forms of ellipsis are pervasive in natural language—words and phrases that by rights should be in the linguistic signal go missing. . . . [This] is possible because ellipsis is parasitic on redundancy: . . ."[48] Here, Merchant explicates several key ideas associated with the definition and work of ellipses: namely, redundancy, silence, and omission. Redundancy, silence, and omission

are also figures of blackface performance—those grace notes and synco-pated moments or breaks that mark time and space simultaneously.[49]

In re-reading *Invisible Man*, I was struck by the following line: "The end is in the beginning and lies far ahead" (6). I render this phrase as Elli-son's eloquent elaboration of the ellipsis given that the end and beginning of the ellipsis is recorded in a horizontal train distinguished only by the space in-between that is another black (w)hole. Entering such open-*end-ed*ness confounds our orientation . . . we are disoriented yet present. The use of ellipses by Ellison and other artists punches a hole (Moten would say cuts "in the break") in the illusion of perception, adding dimension by disrupting the seemingly seamless relentlessness of the line—of linear-ity, whether horizontal or vertical—that directs writing. Ellipses function as points of disorientation and perhaps democracy. Like a palindrome, and a palimpsest (or perhaps even the book itself), ellipsis may be read backward or forward and in terms of surface and depth. Their multifac-eted structure of many in one that forms a complex yet unified web may be read as supporting Ellison's radical "democratic" content. Ellison's use of the ellipses helps us to rethink the line along the lines of the artist Paul Klee who conceived of the line as "dots going out for a walk."[50] As the unnamed narrator in Ellison's novel tells us, "the point now is that I found a home—or a hole in the ground" (6). I tend to read this line lit-erarily rather than literally, which is to say that I interpret Ellison's point to be that this home is a "hole in the ground(ing)" of being—if not a becoming that moves even in its apparent stability. The distinction be-tween being and becoming here suggests the home/hole is also a drop in the bucket of opaque whiteness that is destined to disappear in America's will toward whiteness, an idea Joseph Roach suggests when he names "miscegenation, as a strategic tactic of whiteness."[51] *Invisible Man* seeks to re-member the blackness of whiteness that the term American would seek to erase.

Another formative meditation on race and American culture is W. E. B. Du Bois's endlessly repeated pronouncement: "The problem of the Twentieth Century is the problem of the color line."[52] In *After White-ness: Unmaking an American Majority*, Mike Hill justifies employing or rather deploying only an elliptical version of Du Bois's overcited axiom. He justifies his strategic citation of the line, which he never presents in full but only in its "cut" version, explaining: "The epigraph above from Du Bois, which I leave deliberately incomplete, is perhaps one of the most

oft repeated aphorisms ever cited in contemporary scholarship on race. In that sense, to those familiar with such work, the phrase may sound a little worn. But then again, how else can we begin to think about color and categorization, which of course includes thinking about whiteness, than through the extraordinary figure of Du Bois? Even in the simple reluctance to repeat his celebrated phrase yet once more."[53] Du Bois's epigraph evokes a problem about citation (and re-citation) that is the heart of theatrical practice and performance, its twice-restored behavior, and therefore gets one thinking from the "get-go" about repetition and time. This ongoing racial drama was played out similarly in Ellison's ellipses—a sentence he did not want to finish as he remembered standing before the poster of the Tom show about to embark on the composition of *Invisible Man*.

Hill returns to the phrase later in his text when he repeats his reasoning about why Du Bois's line in (t)his historical moment must be elided, emended, elliptical. Hill writes, "Part One of this book began with a certain reluctance to repeat Du Bois's famous maxim that 'the problem of the twentieth century is . . .' *et cetera*. By way of introduction, my intention in leaving out the key term 'color line' was to signal my sense of the overuse of this phrase. There has been no more repeated *line* in race scholarship over the last twenty years than that one, I remarked. The idea in not repeating it once again, or in *almost* not repeating it, was not just an academic language game. I wanted to signal a more substantive political problem having to do with subjective citationality at the beginning of the twenty-first century."[54] Such ideas fit as well with Ellison's interest in warping history—of not succumbing to an idea of history as a linear, progressive time line. To my mind, this is an elaboration of the problematic involved in the performance of "colored contradictions" (to recite the title of a collection of African American plays) especially in Ellison's work.[55] It may be no coincidence that E. Patrick Johnson elaborates this concept in his eloquent redaction of Marlon Riggs's film *Black Is . . . Black Ain't*. For the title, like Riggs's naked black body in the film, recites and resituates as well as signifies on Ellison's ellipsis and on black performance more generally. I concur with Johnson's argument for the simultaneity of being and becoming that "refus[es] to privilege identity as solely performance or solely performative and by demonstrating the dialogic/dialectic relationship of these two tropes housed in and by the body."[56]

As noted above, a quotation from T. S. Eliot's play *Family Reunion* provides a beginning or entry (as well as ending) to *Invisible Man*. It reads:

HARRY: I tell you, it is not me you are looking at,
Not me you are grinning at, not me your confidential looks
Incriminate, but that other person, if person,
You thought I was: let your necrophily
Feed upon that carcasse. . . .

The four dots that provide the open ending of the quotation offer our first encounter with such marks in the text. Eliot's ellipsis here graphically illustrates and performs the repetition of the "not me" that is a central thematic in Ellison's novel. The epigraph points the way toward the profusion of ellipses that appear in the oft-quoted text on the "Blackness of Blackness" in *Invisible Man* (9). Despite the numerous commentaries on this passage of (the) text, to my knowledge none have thought to think about how the ellipses signify and are signifying there. Do the dots function "punctuationally" by marking mere pauses in dialogue? Are they meant to mimic spoken language in an impossible transcription of aurality/orality? Or rather, is the work of the ellipsis more ludic than lucid? I suspect that the ellipses (t)here signify the tempo figured in and by "the Blackness of Blackness." In my reading, ellipses serve as a kind of instantiation of the complex and dynamic (racial) subject that arguably is the main point (pun intended) of the dialogue. They regulate the timing of the call and response, signal a shift in tempo, and invite the reader to enter the dialogue.

In his 1981 introduction to *Invisible Man* Ellison explains that "writing about invisibility had rendered [him] either transparent or opaque" (xi). So, too, in the same introduction he speaks of Invisible Man as "a 'character' . . . in the dual meaning of the term." These statements both allude to the ellipsis: a figure or character, like the performing stereotype, that is neither transparent nor opaque but somehow both simultaneously. Moreover, in his disquisition on democratic fictions, Ellison employs the ellipsis in a key paragraph that reads: "It now appeared that the voice of invisibility issued from deep within our complex American underground. So how crazy-logical that I should finally locate its owner living—and oh, so garrulously—in an abandoned cellar. Of course, the process was far more disjointed than I make it sound, but such was the inner-outer,

subjective-objective process of the developing fiction, its pied rind and surreal heart . . ." (xviii). Ellison suggests that invisibility, erasure, and fluidity—all things figured (out) by the ellipsis—are major themes of the novel as well as its central philosophical concept—which, I contend, is performed in a formal sense by the ellipses. Ellison claimed that the visual arts and early studies of perception influenced his thinking about identity—a fact that allows us to think of the text as a negotiation of the aural/oral matrix.

Perhaps, then, we can imagine the ellipsis set out like bait waiting to be consumed, literally leading us down into the narrator's den as well as into the depths of the text. . . . This would be to recall the first printed ellipses that appear in the epigraph of the text, itself an elliptical redaction of Eliot's text as a (w)hole. The ellipsis is an imaginary figurative and figured space in the analogy between figure and ground that is now punctured and un-done with punctuation. We may read ellipses as figures of history as well as hysteria and haunting—as *Invisible Man*'s quintessential (re)marks. Moreover, to repeat this particular point, the ellipses are contra-dictory figures that are (t)here to mark the (k)not-(t)here of and in the text. Ellipses, we might say, stand in and for the music of invisibility or perhaps more precisely, music's invisible tempo—seen only by the musicians. Here, Ellison riffs on the "music of invisibility" especially when he signifies upon Louis Armstrong's song "What Did I Do to Be So Black and Blue?" The lyrics appear set off from the rest of the text. The perceived opacity of the ellipsis is revealing and has been rendered as the "blankness visible" that is so important to Ellison's experiment with new modes of (black) performance.[57]

Like Ellison, Partridge begins to elaborate the ellipsis's capacity to mark temporality. Partridge claims that the ellipsis can be used to highlight "a pause in the action, a hiatus in the thinking, or a hesitation in the dialogue."[58] This statement is reminiscent of the musical interlude in the blues—that productive gap that is filled in by the audience's expectation, or more precisely its meditation on what has passed and what is to come. Such remarks become a recurrent trope in Ellison's figuration of invisibility, as the following quotation exemplifies: "Invisibility . . . gives one a slightly different sense of time, you're never quite on the beat. Sometimes you're ahead and sometimes behind. *Instead of the swift and imperceptible flowing of time, you are aware of its nodes, those points where time stands still or from which it leaps ahead.* And you slip into the breaks and look around"

(8, italics added). This quotation understands and theorizes time as ellipsis and vice versa. It is this same passage from *Invisible Man* that inspires Fred Moten to ask: "How to activate the noise's transcendence of the ocular frame?" The ellipsis appears to answer Moten's astute and searching query, for they "[put] another metaphysics forward."[59] We return then to the productive performative simultaneity of the aural/oral/visual performance of the ellipsis.

In *Invisible Man* the unnamed narrator thinks that "a hibernation is a covert preparation for a more overt action" (13). Such statements are also part of the narrative's construction of suspense that perhaps not coincidentally is made with suspension points (the British term for the ellipsis). "Multiple dots are equally suitable—many would say unsuitable—for the expression, or at least the intimation, either of suspense, when they are called Points of Suspense, or of reverie."[60] The opacity of the ellipsis is the "blackness visible" that is such an important part of Ellison's experimental performance of blackness. In other words, the ellipsis carries a "negative capability" that can interrupt the flow of time: it can temporarily shift the direction and change speed and tempo. We can think of punctuation as theatrical marks that choreograph thought. Such syncopated "out of sync" sinking sensations are suggested and sustained by the ellipsis in the text. The dots are the nodes, the literal points, where time stands still or from which it leaps ahead. The ellipsis provides us a point of view from which and with which to enter the theatricalized space of time. Indeed, Ellison's wrenching rendering of the wench in the cave exemplifies such defiant gesture—allowing us to enter into the paced space of time. The tempting tempo of the ellipsis leads us into a contretemps. . . .

The ellipsis in *Invisible Man* performs the "figure of a figure," "the blackness of blackness," the "rind and the heart" (21)—not so much an external mark of internal desire, but rather a neither/nor figure whose meaning-content is (re)inscribed, and sounded invisibly, with each review—and therefore is open perpetually to possibility. The form and figure of freedom is rendered with restraint (remember the ellipsis is both contracted and expansive). The ellipsis is the black (w)holes—(and does this *w* stand for whiteness, for writing, the West—all three and more?) of our mutually constituted racialized culture. Anne Cheng argues astutely that some of the characters in *Invisible Man* seem "more stylized than racialized. More to the point, [they expose] the idea that racial*ization* is always a matter of style rather than essence—a performance of type

that can be either self-stereotyping or self-identifying."[61] In this chapter, I have been thinking about the performance of typography as playing a role in such productions. Whereas Cheng perhaps means this abstractly, we might supplement her musing with a concretization of her words, or as Johnson would say, a fleshing out and materialization. The ellipsis seems more stylized than racialized—as a performance of (material) type, although its blackness cannot be elided.[62] I suggest that the ellipsis functions as yet another figuration and materialization for understanding and underscoring Ellison's synaesthetic mix. The Invisible Man drifts off and thinks, if "one could slow down his heartbeats and memory to the tempo of the black drops falling so slowly into the bucket yet reacting so swiftly, it would seem like a sequence in feverish dream . . . I was so deep in reverie that I failed to hear Kimbro approach" (201). He recalls the earlier scene of hallucination, where he finds the founding ancestor—the foremother who comes afterward in the narrative of the text. He tries to temper his temper—to change the tempo . . . but "the rhythm was too hectic. A tom-tom beating like heart-thuds began drowning out the trumpet, filling my ears" (12).[63]

This passage from Ellison's text contrasts with another from the same era that comes from Strunk and White's famous book *The Elements of Style*. In the latter, rule number 21, "Prefer the standard to the offbeat," cautions against the peril of using the crossbred "language of mutilation."[64] Such temptations are carried by sound and rhythm, something emphasized by the use of onomatopoeia: a trope that stresses the commensurability of sound and "word." So too, we might think here of how jazz performs and reforms the standard, or, as James Snead would say, how repetition is a figure of black culture that heralds the cut in contradistinction to the cover up.[65] Indeed, the excessive use of "breaks" and interruptions that mimic emergent patterns of speech and silence might be traced to an African-derived beginning in the letters of Ignatius Sancho, an eighteenth-century black British composer and grocer who corresponded with Laurence Sterne. Sancho was wonderfully innovative in his use of punctuation—as can be seen in his epistles, which are chock full of dashes, exclamation points, and the ellipsis.[66] The performance of the ellipsis in Ellison's text helps us to understand if not apprehend the performativity of the blackness of blackness—that is and ain't—not only on the stage of the page but also in the performance of everyday life.

My Macintosh computer is programmed so that the user no longer

needs to type, in a repetitive keystroke, a period three times to make an ellipsis; rather, the user may simply press the alt/option key simultaneously with the semicolon to produce an ellipsis. Such prefigured programming is problematic—reducing control while saving labor. To make the ellipses, I arrange my digits on the keyboard, making a single gesture, a collective effort: the ellipsis . . .

Hyphen ▬ Nations

No two writers . . . would agree as to the hyphenation of any fifty words taken at random.

—*Philadelphia Sunday Times*, 1894

There are many ways to read the role of the hyphen; however, all those who think critically about this punctuation mark agree that the hyphen *performs*—it is never neutral or natural. Hyphens may link or divide words and/or syllables, but in so doing they always act.[1] By performing the mid-point, hyphens occupy "impossible" positions. The spatio-temporal action of the hyphen makes it a point of controversy. Hyphens can be problematic because they migrate, appearing and disappearing seemingly without fixed rules.

In their most contentious role, hyphens locate intermediate, often invisible, and shifting spaces between what often are supposedly oppositional binary structures. Hyphens cannot stand alone: in fact, they do not "stand" at all; rather, they mark a de-centered if central position that can present readers with a neither-nor proposition. The hyphen is a sign that both compels and repels: it is not a fixed point, but rather a joint—a shifting positionality—a continually collapsing structure. Indeed, as the joint, it is the site of intersection and therefore the weakest link of any construction. The hyphen can be used as a transitive verb that suggests the term's tendency to connote travel. It is in transit, the object of transformation and subject to translation. At other times, the hyphen marks a space of suspension: it performs as a taut tightrope—a trope of perpetual tension.

Although hyphens are central, they are not individual (or indivisible) figures; rather, they are divisive marks in both senses of the term. Later in

this chapter I discuss the noun known as the "hyphenate" as a case study in national discourse. This chapter examines the shifting roles in which postmodern discussions of multiculturalism and American national identity (produced predominantly in the 1990s) cast the hyphen.[2] If the hyphen is the mark that arbitrates the tension between ideas of assimilation and those of exclusion, of sameness and difference, how then can we read its myriad performances? Why do some detest the so-called hyphenated Americans and others embrace hyphenation as a designation and even a destination? Can the hyphen ever dis-solve issues of citizenship, subjectivity, migrancy, and the (re)production of differences to which it has become attached? This narrative presents the hyphen as a merely temporary term whose erasure seems inevitable. This reading of the controversy attached to the hyphen demonstrates the otherwise hidden drama of print culture that, once forgotten, imparts a naturalized normativity. It is just such narratives that this project seeks to disclose and de-familiarize. In doing so, however, we should remember that the hyphen can clarify some ambiguous phrases (e.g., the difference between "twenty-one night-stands" and "twenty one-night stands").

The *Oxford English Dictionary* defines the hyphen as "a short dash or line (-) used to connect two words together as a compound; also, to join the separated syllables of a word, as at the end of a line; or, to divide a word into parts for etymological or other purposes." This definition points to the versatility of the hyphen and reveals its flexibility as a punctuation mark that serves several contradictory purposes. As the verbs in this definition indicate, hyphens can join as well as divide. The "distinct functions: dividing and compounding" compound the problem of reading the hyphen.[3] The hyphen marks the ever-emergent space between two distinct yet linked terms and negotiates a space of (distantly) connected difference (the latter when it appears in a line break).[4]

Among the affects performed by the hyphen are the stammer, the sob, and the gasp. The great British grammarian Eric Partridge calls these actions, collectively, "recalcitrant sound." We should keep these gestures in mind as we read through this chapter that records so much recalcitrant sound—so many hesitations, cries, and shocks along with so much sentiment expressed about and by the hyphen. Indeed, there is no lack of passion when it comes to discussions of the hyphen. The hyphen's hesitant spluttering splits apart syllables and words with its recurrent horizontal cut.[5] Partridge is just one of many who take aesthetic umbrage with the

"ugly-looking arrangement of writing, typing or type" that breaks up an otherwise uniform line.[6] In an intriguing chapter titled "Hyphens and Oddments," Partridge narrates a trend that other language mavens have observed: namely, that hyphens seem destined to disappear. Here, he also posits national differences in how the hyphen is employed by writers of the "English" language on both sides of the Atlantic.

According to Partridge's research, Americans use fewer hyphens than do the British, and this difference has changed over time. He believes that the "tendency [for hyphens to disappear] has accelerated since about 1914: World War I taught many people that superfluities should be treated as such and therefore discarded; World War II increased the tempo, nor have the post-War years done anything to retard it. Americans have gone further than Britons along the lines of 'continuity' or 'solidity'. Some Britons think that Americans have gone too far: yet, ugly as certain American 'continuities' (e.g. *nonresistance*) appear, at first, to British eyes, it must be admitted that Americans have been, are being and will doubtless continue to be chargeable with nothing more reprehensible than 'intelligent anticipation'. This simplification merely accords with the general tenor and tempo of life ever since 1914. 'So why,' ask virtually all Americans and not a few Britons, '—why resist the inevitable?'"[7] Again, it is the "inevitability" of unification or solidity that we should question—as indeed Partridge's locution does even as a rhetorical possibility. Before we discuss "resistance" and, more pointedly, conscientious resistors of inevitability, we should turn to reading some American authors who concur with Partridge's assessment of the American preference for "unity" and "solidity."

Read with other than British eyes (perhaps those of a cultural critic?), we might see in Partridge's explication an allegory of globalization in which the hyphen flattens the thick description of border zones into "thinly linear demarcations of difference," to quote Saskia Sassen. In Sassen's reading of the complex relations between globalization and national spaces, she explains that "these developments signal a transformation in the particular form of the articulation of sovereignty and territory that has marked the recent history of the modern state and interstate system, beginning with World War I and culminating in the Pax Americana period." She goes on to engage the birth of specific "frontier or border zones" that are the result of the "overlapping of global and national orders."[8] Certainly, the hyphen marks such a space of friction—both fic-

tive and f-active. Indeed, I contend that discourse about the hyphen re-
veals it to be the mark par excellence of marked, marketed differences—a
mediated mark and a mark of mediation that is ubiquitous (even when
absent) and significant in such debates.[9] One such serious error involves a
printed enactment of Congress that in substituting a comma for a hyphen
lost thousands of dollars of revenue for the U.S. government by relieving
tariffs on ALL fruit and seeds rather than merely "fruit-seeds."[10]

I turn now to a discussion of the hyphen's performance in debates
about American identity by exploring the etymology of the hyphen in
the context of readings of America's cultural pluralism. The hyphen ap-
pears as an adjectival phrase in American discourse, signaling its import
as a player in cultural politics. Here, I refer to the phrase "hyphenated
American" that Theodore Roosevelt used in a 1915 speech on the dangers
of "such divided Americans." The speech exemplifies the imperialist ide-
ology that aggressively advocates "pure Americanism." Roosevelt pro-
claims that

> there is no room in this country for hyphenated Americanism. When
> I refer to hyphenated Americans, I do not refer to naturalized Ameri-
> cans. Some of the very best Americans I have ever known were natu-
> ralized Americans, Americans born abroad. But a hyphenated Ameri-
> can is not an American at all. This is just as true of the man who puts
> "native" before the hyphen as of the man who puts German or Irish
> or English or French before the hyphen. Americanism is a matter of
> the spirit and of the soul. Our allegiance must be purely to the United
> States. We must unsparingly condemn any man who holds any other
> allegiance.[11]

Roosevelt also mentions that in an era (not unlike our own neo-imperialist
age) when our homeland borders have been infiltrated, such hyphen-
ations must be monitored for our own security: "We cannot afford to
run the risk of having in our time of war men working on our railways
or working in our munitions plants who would in the name of duty to
their own foreign countries bring destruction to us." Thus, he calls for
a secure America that is middle class, masculine, democratic, and most
importantly, *unified*—a term he understands as that which is devoid of
heretical, hysterical hyphenates.

Evolutionary Unions: The Race for One

End bilingualism; end "hyphenated-Americans." Not one federal dime should go to perpetuate bilingualism. We look forward to a day when there are no "hyphenated-Americans," when all are proud to be called, simply, Americans.
—Patrick J. Buchanan, founder of the American Cause and 2000 presidential candidate

Buried somewhere in the rubble of the Sept. 11 attacks is the concept of a hyphenated American.
—Ruben Navarrette Jr. *Albuquerque Journal*, November 17, 2001

Since the turn of the last century, numerous U.S. narratives have continued to cast the hyphen as the tension between assimilation and difference. The classic manual of "proper" American grammar, Strunk and White's *The Elements of Style*, evinces a normative, assimilationist view of hyphenates akin to that articulated by Roosevelt. In their assessment of the hyphen, Strunk and White write that "the steady evolution of the language seems to favor union: two words eventually become one, usually after a period of hyphenation."[12] This statement privileges "evolutionary unions" over merely temporary terms represented by the hyphen. Strunk and White place the hyphen within a linear narrative that strives teleologically toward unity.[13] Their schema values a purportedly closed union over an open period.[14] Like Roosevelt, they value integration and integrity as both an aesthetic and political ideal. Evolution favors unity. I should pause here to mention the cultural capital that has accrued to this little grammar book since its publication circa World War II.

That we have marked history here by referencing wars is no coincidence given that so many language issues are determined by technologies of war, of victory, and military might. Indeed, as Berel Lang observes, there is "a structural analogy between discourse about good writing and discourse on ethical conduct. . . . Like moral precepts expressed in similar form . . . these prescriptions discourage the question 'why'?"[15] Deborah Cameron, in her metacritical reading of the virtues of simplicity, clarity, forthrightness, and the like, also shows how these particular writerly virtues are imbricated with larger democratic ideals such that "since the rise of fascism in Europe in the 1930s a powerful verbal hygiene discourse has developed connecting the manipulation of language with the totalitarian policing of thought."[16] My reading of Strunk and White for the cultural

and political values represented in their discourse—i.e., reading "against the grain"—helped to generate this project on the politics of punctuation. Against their prescriptive penchant for commandants, I question the ideological biases that form the basis of their suggestions for improving one's style. Thus, their comments about the hyphen's disappearance and temporary status, writ large, if you will, say much about certain aspects of a still apparent American obsession with unification.

Yet another example of such a desire for unity appears in an edition of the *United States Government Printing Manual*.[17] Here, the anonymous authors note that

> word forms constantly undergo modification. Two-word forms first acquire the hyphen, later are printed as one word, and not infrequently the transition is *from the two- to the one-word form, bypassing the hyphen stage* . . . The rules laid down cannot be applied inflexibly. Exceptions must necessarily be allowed, so that general good form will not be offended. However, current language trends point definitely to *closing up words* which, through frequent use, have become associated in the reader's mind as units of thought. The tendency to amalgamate words . . . *assures easier continuity*, and is a *natural* progression from the older and less flexible treatment of words. [Italics added][18]

The official (as in "authorized by the national government") authors of this tome, which contains a thirty-page section called "Guide to Compounding," naturalize the process of amalgamation and assimilation. They suggest that proper solidification secures and "assures easier continuity." Older and less flexible terms give way to the "natural progression" of properly amalgamated words. Like American anti-miscegenation laws, this guide seeks to regulate reproduction. The emphasis on "solid compounds" occludes the viscous and asymmetrical workings of power and perhaps sexuality as well. The guide recommends bypassing the hyphen in favor of reducing two to ONE. The closing up of words (and borders) reminds us of the constant contradiction that undergirds if not supports "nativist" American attitudes—especially during times of imperialist expansion in which we may be called upon to follow the phrase, "United we stand."

This drive toward unity has been prominent in a wide range of U.S. discourses—appearing in rhetoric about the Civil War as well as in debates about the melting pot and the global spread of a totalized democracy (to name only a few examples that illustrate Strunk and White's

concept-metaphor that evolution favors union). This line of thinking conceives of hyphenated forms as lacking and/or broken, debasing them with their reverence for whole, wholesome, holy unions. The genuflection toward unbroken forms suggests that power resides only with the pure, the unified, or solidified.[19] Such a concept is upheld even in the rare cases in which hyphenation occurs after the origin. For example, the term "electronic mail," which entered the lexicon circa 1977, became in the early 1980s the now ubiquitous "e-mail"—a clear sign of devolution (or should I write, "de-evolution"?). Compounding mimics dominant strategies of the nation that cover over connections that are complicated. "A continuing bias in favor of directness, immediacy, the apparent absence of mediating tradition, reflects the fact that the United States was the first post-colonial society to develop a national literature, doing so in part by equating tradition with subjugation, viewing it as an impediment to authentic expression."[20] The hyphen reveals, retroactively, a "tradition" that is composed—compounded—con-fused. How one thinks of and with the hyphen says much about how one construes the historical construction of the nation at large. The idea of bringing together supposedly opposite forms (e.g., platonic souls, the biblical one flesh) continues to influence everyday discourse and actions.

Werner Sollors has delineated two main strategies through which the "formal binding together" works in many American cultural narratives. Sollors represents the tension between consent and descent in American discourse as "the opposition between the artificial and the organic, between the organization of one's choice and the organism of one's essence. . . . In America we may *feel* 'filiopietism,' but we pledge 'allegiance' to the country. To say it plainly, American identity is often imagined as volitional consent, as love and marriage, ethnicity as seemingly immutable ancestry and descent."[21] In the United States citizens pledge allegiance—they recite a symbolic oath in order to become naturalized. This tradition of consensual allegiance began in the 1790s and was revamped at the World's Columbia Exhibition in 1893 when the actual pledge was drafted. Pledging one's allegiance has been a regular and regulating practice throughout the history of the nation.[22] Of course, the quest to secure "American" national identity is impossible since "nationalism, like culture, is a moving base . . . of difference, as dangerous as it is powerful, always ahead or deferred by definitions, pro or contra, upon which it relies."[23] Still, many chroniclers of American culture, even or especially those who praise America's ethnic diversity and pluralism, tend to dismiss

issues of power and ignore the historical and political dimensions that created specific subjectivities. Arthur Schlesinger's popular tract *The Disuniting of America*, for example, ends by heralding an America in which "individuals of all nations are melted into a new race of men."[24]

The early focus on distance from England as difference from the English anchored the NEW Englanders in a new generation that excluded both Native Americans and "Africans-becom[ing]-Americans" (to modify a phrase from Hortense Spillers).[25] These racialized others were imagined and treated in the juridical realm as being(s) from a different space and time. In short, some volitional immigrants were permitted to create a new "American" identity; others were forced to adjust and accept identities legislated for them.

Xenophobic critics who see themselves as "solid/solidified" Americans worry that "their" nation is beginning to favor those whom they think were and by definition should remain un-American (people of color, the lower classes, immoral Americans). Americans of different ideological positions register fear about the "browning of America," as *Time* magazine called the phenomenon of America's changing demographic in a 1993 special issue on immigration.[26] The historian Daniel J. Boorstin, author of the Pulitzer Prize–winning trilogy *The Americans* and the nation's only emeritus librarian of Congress, has claimed that "'the notion of a hyphenated American is un-American. I believe there are only *Americans*. Polish-Americans, Italian-Americans or African-Americans are an emphasis that is not fertile.'"[27] Boorstin, like Strunk and White, presents the hyphen as the marker of emergent entities that should evolve by dissolving into a dominant, unified "whole." He asserts that unified formations must forget or rather actively efface their hyphenated origins and complicated histories. As such, Boorstin no doubt wittingly repeats the central thesis of the infamous address made by Theodore Roosevelt quoted earlier.

Boorstin consciously ignores the constantly contested constructing of national character by arguing that evolutionary unions are naturally progressive and that hyphen-nations are unnaturally regressive. He reveals his contempt for hyphenated Americans by stating: "Some of us who have believed the glory of our nation has been our ability to encompass all comers as Americans are shocked to see any of our fellow-citizens demand to be known as *nothing* but hyphenated Americans" (italics added).[28] Boorstin's statement labels the act of qualifying one's "heredity"

heretical. He conceptualizes America as an absorbing and homogenizing nation in which there is no place for marked differences. Boorstin's "one America" thesis was re-cited by an anonymous black woman interviewed on ABC news one year after the events of September 11, 2001. When asked to comment on the significance of the ubiquity of the American flag since the start of the war on terrorism, she said "it [the flag] took away all the hyphenations and it should take away all the hyphenations."[29] This statement echoes Boorstin's conception of American hyphenation. The phrase serves as a kind of moral mandate—*e pluribus unum*—you are with us or . . . against us, you are for hyphenation. The relentless drive toward an imperial one-world democracy was echoed in President George W. Bush's second inaugural speech.

In Boorstin's reading, contestation from hyphenated groups threatens the fertile future of America. If such fracturing continues to be overt and visible, America will become "Balkanized." His focus on mythic and monolithic nationalism elides the fact that the nation has always already been "undone." He cannot conceive of the fundamental impurity of purportedly "pure" identities and thus he misses the fact that pure forms are always already troubled by their own hyphenated/hybrid origins. He overlooks the fact that unity, by its very definition, depends upon division if not plurality. Not only does Boorstin ignore the problem of global capitalism, he disregards the material history of Native Americans (a term he despises, as do some Indians) when he attributes the success of American assimilation to the fact that Americans, unlike Europeans, are "people . . . at a great distance from their old burial grounds, it's harder for them to keep their old name and insist on respect because of their grandfather."[30] Boorstin wants to cover over the process of unification in favor of presenting the product of a discrete, perfectly homogeneous American identity. Moreover, in his narrative the grand*father* appears as the marker of heritage—to be either re-membered or dis-membered in these opposing strategies. Unfortunately, Boorstin fails to discuss the reactionary "grandfather's clause" that privileged white southern voters during Reconstruction by actively excluding freed male slaves who had been recently given the right to vote from exercising this constitutional right.[31] So, too, he never addresses maternal genealogy, and therefore people whose religious and/or racial coding is determined by their mother's social inscription are marginalized—including slaves whose "condition followed that of the mother" and those who could not claim kinship to grandfathers.[32]

Boorstin bemoans the loss of "the word 'Negro,' with a long and re-spectable history," as a label for the now "shocking" African-American.[33] His response presumes that he possesses the power, like the biblical Adam, to name those over whom he has dominion. His argument dis-places those who are explicitly *not* Americans. Again, many people of African descent began as chattel and then became second-class citizens denied rights and equal access. The legacy of de jure and de facto discrimi-nation necessarily constituted and qualified our Americanness. Attention to the historical shifts of power is crucial to understanding national iden-tities. As Joseph Roach explains,

> The marginal condition of life between powerful categories, the con-dition that postmodern ethnographers find so rich . . . renders the per-sons actually trying to live between them extremely vulnerable to the punitive consequences of their undecidability. If they choose not to take the path of "straight-line assimilation" . . . or if they are forbidden this path by some uncorrectable accident of their births, [what Spivak calls an enabling violation] they live . . . in a double-culture, invested in two worlds (at least), yet faced with powerful laws and customs fa-voring unitary identities. . . . American society . . . [has a tendency] to collapse culture into categories of race, and then to enforce those categories as absolutes.[34]

The instability of the hyphen may be a reason that Tiger Woods—the corporate logo sportsman and spokesman of a post-Loving generation,[35] coined the term "Cablasian" to denote his tripartite heritage rather than the precarious Caucasian-black-Asian moniker. Similarly, a particularly problematic discussion of the Illinois senator Barack Obama appeared in the *New York Times* claiming that Obama was "so rare as to be univer-sal."[36] Such issues are vexed. In such situations, as the metaphor goes, all the ingredients in the pot can melt until blended into an uncomplicated "pure" form.[37] Indeed, as E. San Juan notes, "every time the identity of 'the American people' in this continent is celebrated today as a uniquely composite blend of European immigrants who settled in the Atlantic colonies or passed through Ellis Island, a political decision and a histori-cal judgment are being made. A decision is made to represent Others . . . as missing, absent, or supplemental."[38] In the normative narratives discussed previously, the hyphen may move horizontally between two points. The proper role requires the hyphen to merge into the center.

There is also concern about belated hyphenates that emerge from the center. Both readings stage "the American" as the dominant and originary center. This reading contrasts with those who more comfortably straddle the hyphen. Unlike Boorstin's infertile hyphenated Americans that are destined to disappear, hyphenates that incarnate the margin disturb binaries by throwing such straightforward narratives into disarray.[39]

Boorstin's linear narratives of development consistently deny "other," more complicated narratives. The difficulty with Boorstin's perspective is that it ignores people who have not followed his own assimilationist narrative as well as those who have been prevented from doing so even when they desired to achieve the "American Dream." When he argues that "we are in danger of becoming a nation of 'minorities' rather than 'majorities,'"[40] he speaks from an uncritical or assumed position of centrality in which his "we" is not qualified. He casts the hyphen as the breaking point—the point not of passage, but of partition. Rather than read the hyphen as a productive site of contestation that can provide agency to subjects who seek to mark their historical difference from a mythic (white) norm, Boorstin sees fit to mandate American correctness.

More often than not, the hyphenate is destined to become a portmanteau—a carrying-case that folds in the middle of a word that combines two things into one. William Safire, the vigilant grammarian who writes the *New York Times* weekly column "On Language," disdainfully notes the fashion of "portmanteau" names by legally married couples. In one of his columns, he notes that "in olden times, a woman getting married—who did not like the idea of dropping her surname and taking her husband's— would keep her surname in hyphenated form: Charlayne Hunter-Gault of PBS, for example."[41] He observes a new trend, however, in which a couple's merger is figured by the creation of a new name—a combination of the previously different last names (again giving proof to Strunk and White's thesis vis-à-vis unification).[42] Safire dislikes this trend in part because the husband dissolves into the wife's genealogy. The heterosexual couple becomes a model for the proper perpetuation of a unified nation. Much of the discourse about the extension of the civil right to marry to gays and lesbians echoes the fears made explicit in the statements mentioned previously.

The state should not have a stake in legislating sexuality. Nevertheless, in the double bind of the logic of rights discourse, marriage is something that we "cannot not want," to quote Spivak. Moreover, as Elizabeth Free-

man observes in her compelling book *The Wedding Complex: Forms of Belonging in Modern American Culture*, we might look to "disaggregate the wedding so that it becomes metonymic not of the timeless, transcendent nature of marriage but of a history of struggle among various institutions, and between these institutions and the subjects they engender, for control over the forms and meanings of intimate ties."[43] This might be said as well of how we read and understand the hyphen. It is how we render the construction of the joint that should concern us.

Echoes of what constitutes a "just" American appear in recent articles from the religious right. In a lively if illogical screed, Richard Barrett denounces what he called the split "homosexual-American" citizenship implied by the use of the term "gay American." In an essay published on the Web, Barrett writes: "When New-Jersey [*sic*] Governor James E. McGreevey announced that he was a homosexual, he did so in a manner and under circumstances which unwittingly fueled debate over hyphenated Americanism and immeasurably aided the cause of our singular nationality. McGreevey stirred revulsion, beyond resentment of sex-deviates, in general, when he bestowed upon himself the title 'Gay American' suggesting that one could be both a homosexual and an American. Most Americans, who regard their nationality as awesome, lofty, and exclusive do not include sex-perverts, criminals, or lunatics within their ranks, neither do they countenance incompatible minorities or illegal aliens."[44]

Jeffrey McQuain, a guest writer for Safire's column, also chose "portmanteau" as an apropos term for describing such movements in contemporary U.S. culture. McQuain's piece, "Blending In," begins with praise for the rapper-activist Sister Souljah's self-coined moniker "raptivist," which combines rapper and activist and is a "deft double play on *rap* and *rapt*."[45] He quotes David Barnhart, who says that "'blends are a colorful, interesting category, *but not a particularly productive one until recently*. Their numbers in the past have been low and studies suggest that many blends are *infrequent in use or even a single writer's fixation*'" (italics added).[46] These phrases are completely in line with the largely negative history of hyphenated hybrids. McQuain calls the authors Lewis Carroll and James Joyce men "obsessed" with these blends, thereby implying that only a pathological person would be attracted to these miscegenated, grossly hybrid terms that are destined to die out. McQuain concludes by asking, "Will these faddish phrasings last?" and predicts that "heavy–handed blends like *infotainment* . . . probably won't [survive]"

(12). McQuain's emphasis on survival and uncomplicated descent is perfectly in line with the other authors who participate in promoting the race for ONE.

Zero Identity: The Race of None

Echoing the rocker Micky Dolenz, who stated, "I'm a hyphenate, which is the 1990s equivalent of a Renaissance man," the artist Papo Colo presents his hyphenated identity as "the wave of the future." When asked to answer queries about his identity ("Is he black or white? Puerto Rican or American? Colonial or postcolonial? Arab or Greek?"), Colo concludes that he may be none of the above or perhaps all of them. He disowns any notion of a fixed identity, believing that he is the antidote to the essentialism of Leonard Jefferies on the Left and David Duke on the Right. "Where they trumpet racial purity, he advocates miscegenation." He calls himself the man of "Zero Identity."[47] Colo's "Zero Identity" that is everything and nothing, everywhere and nowhere, omnipresent yet unreadable—cancels itself out. His philosophy exposes the fact that the active process of proclaiming one's identity requires (false) separation: one must draw a line between self and other and artificially mark an impossible boundary. Colo adds that "in reality, we are so mixed up, not only Latinos, or blacks, but Russians, Italians, Irish, that to have an identity is like having a fake passport."[48] Technically, he is right; however, it is still the law to carry such identification, even as one strives to deconstruct it by paying attention to the historicity of such "identities."[49]

Barbara Ehrenreich, in her essay "Cultural Baggage," contributes to the debate by stating: "Throughout the 60's and 70's, I watched one group after another—African-Americans, Latinos, Native Americans—stand up and proudly reclaim their roots while I just sank back ever deeper into my seat. All this excitement over ethnicity stemmed, I uneasily sensed, from a past in which *their* ancestors had been trampled upon by *my* ancestors, or at least by people who looked very much like them. In addition, it had begun to seem almost un-American not to have some sort of hyphen at hand, linking one to more venerable times and locales."[50] Ehrenreich's pronouncement about American ethnicity, in which she notes the transference of the un-American (now a white minority) and the American (once hyphenated others) reveals the difficulty inherent in unifying differences under a national sign.[51] She valorizes the other side of the binary

set up by Boorstin. For Ehrenreich, to be un-American is "not to have a hyphen at hand"; but despite this difference, both Boorstin and Ehrenreich choose to leave the binary in place. Ehrenreich's articulation contradicts Boorstin's naming of the un-American; yet each author assumes his or her authority in naming what is and is not American. By declaring herself and her children as proud members of the "race of none" she displays the desire to erase a past already in place. She reproduces those narratives of the nation that in the evolutionary struggle to survive have excised and/or condensed disparate origins and aberrant histories. Perhaps unwittingly, she proves that proper form requires the hyphen to enact its supposed "will-to-self-erasure." While Ehrenreich has "no race," others are "raced." She "e-races" whiteness as a "racial" identity so that it becomes the (un)masked universal. What Ehrenreich misses is her own complicity in keeping the category of her "race of none" discrete. She sets it up in opposition to the other hyphenated categories; indeed, she has the luxury, perhaps, of doing so. Thus, both Ehrenreich and Boorstin present themselves as the only "just" Americans (pun intended). Their rationales reveal that we must "beware the end of American whiteness, which might be nothing more than the fulfillment of its ends."[52]

Other evidence for the increasing trend toward the normative race of none or the "average(d)" American comes from another political location: the global White Power movement. Racist groups such as the KKK, the Christian Identity movement, and the ARM—the Aryan Resistance Movement—also concern themselves with hyphenations. The journalist Kathy Dobie, in her essay "Long Day's Journey into White," states: "If ethnic identity and ethnic suffering are valued now, what's a mongrel white kid to do? (Most of the skins are some hodge-podge of Western European ancestry that ceased to mean anything a long time ago.) What about OUR history? they yell. They don't seem to see themselves as part of the big white backdrop that people of color have charged against for ages, making a mark here and there."[53] This quotation provides a narrative of the belated ceaselessly beating against the pure and solidified original. The statement clearly delineates the "original" members of the nation, whose ancestry no longer carries with it a positive value. They are hodge-podge mongrels who are de-valued in an era in which "ethnic difference" and ethnic suffering are over-valued. They proclaim their own (false) purity and reclaim whiteness as a new endangered racial species.

As one of the most astute theorists of "whiteness," Mike Hill cautions

against both responses by arguing that "the ambivalent prospect of an end to whiteness haunts progressive scholarship on race as much as it haunts the paranoid visions of white-collar racists on the other side of the ethnographic looking glass." In his ethical call to re-imagine democratic action, he suggests that "whiteness studies might better be dubbed *after*-whiteness studies, thus keeping the temporal irony of its absent presence at the forefront and in play."[54] This statement works well with Dobie's article in which she represents her interviewees by saying: "They're just blanks. Because of their white skin they've escaped hyphenation. They're just American kids; not African-American or Asian-American or Mexican-American. These youth, who are part of various pro-Aryan movements, feel rootless. They want an identity, a flag to defend." I question her choice of verb here. Can one "escape" hyphenation? Those who have escaped roots via escape routes such as the Pilgrim ships, the western trail, and the suburb seem indeed to have disappeared in America.

Strunk and White here again prove useful interrogatories. They warn that "the hyphen can play tricks on the unwary. . . . Obviously, we ask too much of a hyphen when we ask it to cast its spell over words it does not adjoin."[55] But what words are "impossible to adjoin?" This statement alludes to the unbreachable chasms and uncrossable divides. It might refer to race in America where African Americans and many others must perform perpetually a "permanent" hyphenated identity.[56] As Toni Morrison argues: "To identify someone as South African is to say very little; we need the adjective 'white' or 'black' or 'colored' to make our meaning clear. In this country it is quite the reverse. American means white, and Africanist people struggle to make the term applicable to themselves with ethnicity and hyphen after hyphen after hyphen."[57] The African here is not merely political but (world) historical—referencing a spatio-temporal location. The columnist Julianne Malveaux editorializes the situation as follows:

> To be sure, the color line is fuzzier than it has ever been. Our airwaves frequently broadcast the lifestyles of the black and beautiful—the Oprah Winfreys, Michael Jordans, Condoleezza Rices and Colin Powells of the world . . . At the other end, one in four African Americans, and forty percent of African American children live in poverty . . . Until our textbooks spill over with stories of the slaves who built our nation's capital, the African American patriots who fought and died for our country, and the African American scientists whose in-

ventions have shaped our lives, I will gleefully commemorate African American History Month . . . African American history is American history! We hyphenated Americans are merely celebrating the hyphen that history handed us.

What would it mean NOT to keep the hyphen at hand? What of championing blackness? Such a desire for unity signifies as well in Gwendolyn Brooks's poem from the black power era, "I Am A Black," which reads:

> According to my Teachers,
> I am now an African-American.
>
> They call me out of my name.
>
> BLACK is an open umbrella.
> I am Black and A Black forever.
>
> I am one of The Blacks . . .
>
> I am other than Hyphenation.[58]

Danzy Senna's semi-autobiographical, neo-migration novel *Caucasia* (1998) tells the story of the "biracial" Lee sisters, Cole and Birdie. The girls share the same parents and ancestral roots but are torn asunder by the racial divisiveness of Boston in the 1970s. Cole, who has darker skin and curly hair, seems to "belong" with the girls' black father and remains with him; whereas Birdie goes off with the girls' white mother since she is capable of white flight by "virtue" of her light skin and straight hair. In short, one sister passes for white, the other passes for black.[59] The novel is an allegory of American race relations in black and white along the lines of Ralph Ellison's *Invisible Man*. Senna's book is beautifully written with evocative subheadings such as "casts and die," "same difference," "disintegration of funk," "the color of underneath," "soundtrack to a pass," and "golliwog's revenge." This stunning debut novel opens with a moving memory:

> A long time ago I disappeared. . . . One day I was playing schoolgirl games with my sister and our friends in a Roxbury playground. The next I was nobody, just a body without a name or a history, sitting beside my mother in the front seat of our car, moving forward on the highway, not stopping. (And when I stopped being nobody, I would become white. . . .)

I disappeared into America, the easiest place to get lost. Dropped off, without a name, without a record. With only the body I traveled in. And a memory of something lost.[60]

This eloquent opening passage speaks to the idea of a quintessential American identity that seeks to escape roots via escape routes. The routes that provided escape included the ocean, the western trail, the highway, and the sprawling suburb. Most Americans—whether they were pilgrims, slaves, servants, refugees—arrived in boats; others were already "here," such as Native peoples and Mexicans. Some traveled above board, some below, some journeyed from the geographical east also known as the West, many came from southern lands across the globe, and still others from the East, which depending upon one's point of origin is also beyond the West. Many European immigrants and some "light-skinned" nobodies like Birdie, once they stopped and settled, also "became white."

Caucasia relates the quintessential American story of "becoming white" from the perspective of someone who cannot remember to forget the black roots/routes of newly found or invented whiteness. It must be read as telling a peculiarly American story of those Africans who become not only African but also "American" when they are "dropped off without a name, without a record, [with] only the bod[ies] they traveled in [and a] memory of something lost." By contrast, for some others losing one's past selves was not only desirable, but also possible. For these people, the vast blanket of blankness that was their America offered up the possibility of metamorphoses in which the previously poor and only ethnically marked might be transformed. Such identity (re)formations were not, however, the road to happiness for all. That memory of something lost, of what Toni Morrison calls "the thunderous theoretical presence," is the (un)forgettable black racial trace that colors all of American culture. Such racialized absent presences and disappearing traces have been the focus of many recently published books, both popular and academic. Each text speaks to the significance of racial tropes and memories in the formation of American culture.[61]

Repeating the conjunction of African and American with a difference, John Mowitt proclaims that "the trap set becomes a site for thinking the hyphenation of identities, almost as though the hyphen itself were to be read as a graphic inscription of the drum skin stretched between Africa and the Americas."[62] While this may make sense as a cultural designation, others prefer to erase the hyphen entirely and write "African

American," keeping a space open and working to not "conflate the two nouns into one substantive through the hyphen, displacing the ideological stakes in the construct."[63] Seemingly, the hyphen is (un)marked—the spectral absent membrane—it remains as a memory even when it appears to have disappeared. So, too, we must remember that each side of the construction is a catachresis. The African here too often serves as a synonym for "black," which in turn makes the American "white" and vice versa. Ethnicity, race, modification, and modifiers are mixed in such monikers.

In the United States, African Americans too often function as the most "othered" coloreds—sometimes at the expense of other embattled races, classes, ethnicities, and other minorities. Constructed as the anchoring side of a continually repeated black-white binary, African-Americans can be seen as the impossible adjoin, the unassimilable "other" precisely because, to paraphrase Fanon, "the Negro is comparison."[64] The phrase "hyphenated American," rendered always already in the past tense as if it has been "handed" by another, differs from the more active "hyphenating" Americans. "To hyphenate or not to hyphenate?" that is the question many "othered" Americans have asked themselves. Perpetually confronted by the hyphen that simultaneously joins and separates us, we are staged as the limit text that no alchemy of rights can erase. We make ourselves and are made distinct with hyphen, after hyphen, after hyphen. . . .

Holding on-to the Hyphen

In addition to envisioning resurgent tribalisms . . . , and solidarity for tribal Native American peoples; some Native Americans envision the possibility and hope of repentance, retribalization, and solidarity for some hyphenated-American and hybrid peoples. Native American visions of an alternative future are visions of both Native American and hyphenated-American peoples in a genuinely post modern world where righteous tribal values and rightly tribal religions are embraced in creative new ways.

—Theodore Walker Jr., *Social Science and Social Ethics for the 21st Century*

Self-proclaimed postmodern hyphenated Americans include people of color, immigrants, and "queer" sexual minorities, all of whom threaten to disrupt normative American identities. Many such resistant, "othered" Americans seek to play on the hyphenated divide rather than into

it, to paraphrase the lesbian theorist Sue-Ellen Case. In her influential article "Toward a Butch-Femme Aesthetic," Case provides an example of counter-hegemonic hyphenation. She reads the butch-femme couple "not [as] split subjects, suffering the torments of dominant ideology. . . . [but as] coupled ones that do not impale themselves on the poles of sexual difference or metaphysical values, but constantly seduce the sign system . . . replacing the Lacanian slash with a lesbian bar."[65] Case's paradoxical "coupled ones," who exhibit a "terror of wedding," work against the evolutionary unions posited previously in this chapter.[66]

Maurya Simon, in her poem "A Hyphenated Rondo," imagines a postmodern joining that slyly employs the hyphen as both a literal and figurative link.

> Let's join hands, you and I-
> my id married to your ego,
> your bipolar mood swings latched
> onto my subequatorial desires-
>
> let's dance around the edge
> of our *fin-de-siecle* blues-
> shake-rattle-and-rolling our eyes
> in high-energy, all-natural joy
>
> oh, let's (presto-*voila*!) fly
> in our full-sized v-neck T-shirts
> into the air-conditioned night
> like top-of-the-line paper kites-
>
> let's boogie until the stars un-
> do themselves like cut outs from
> this zillion-year-old universe-
> let's join our custom-fit mouths
>
> together (be old-fashioned!) and
> ride each other's merry-go-round
> until our mortis-and-tendon joints
> crack-yes, let's hyphenate our-
>
> selves so that we're ever joined
> at hip-and-rib-and-back-and-neck,
> a wondrous Pushmi-Pullyu-
> a tandem Jekyll-and-Hyde duet.[67]

Rendering her rondo without using specifically gendered pronouns, this romantic rendition of the hyphen illustrates the possibility of hyphenating as a means of being "ever joined." So, too, the poem includes the full range of hyphenation—it is used to break syllables, end lines, connect words into singular phrases, and modify nouns with adjectives. The words it joins together as phrases include: "*fin-de-siecle*," "shake-rattle-and rolling," "top-of-the-line," "zillion-year-old," "merry-go-round," and "hip-and-rib-and-back-and-neck." The "couples" in the poem include "high-energy," "all-natural," "custom-fit," and "our-selves"—a sly pun that mimetically produces the split between one and the Other. Nouns such as "Pushmi-Pullyu" and "Jekyll-and-Hyde" replicate such "coupled ones" while referencing popular late-nineteenth-century British imperial texts.

Diane Gifford-Gonzalez, an anthropologist at the University of California, Santa Cruz, whose hyphenated last name follows "the archaic Spanish usage [that combines] patronymic and matronymic," presents another resistant reading of hyphenization. When reviewers of Gifford-Gonzalez's latest book translated her last name literally, thereby implying that she had "undergone some mitotic division," and other reviewers assumed that she had co-authored the book, she retorted with a letter published in *American Anthropologist*. She criticizes the "postmodern tendency toward deconstruction and ironical collage" as well as the "Anglo-American misperception of the Hispanic binomial" that has questioned her "integrity [as a] hyphenated individual."[68] She ends her polemic by paradoxically urging "reviewers and editors to respect the integrity of hyphenated individuals, regardless of their origins." Gifford-Gonzalez thus shifts the debate to respect for differences and, like Case, makes a case for the importance of resisting the pull toward normative integration. In so doing, she retains a hyphen as a mark of cultural distinction.

The link between nation formation and its corollary, the regulation of citizen-subjects, becomes clear when we notice the increasing trend to employ the hyphen as a mark of difference(s). For example, on July 25, 1993, the *New York Times* ran a front-page story entitled "Immigrants Forgoing Citizenship While Pursuing the American Dream." The article chronicles "new" refugees who refuse to become full-fledged citizens of the United States. The article notes that these immigrants are "not healthy for democracy" because they choose to live in their own "subculture" and are content to have taxation without representation.[69] Roosevelt's rhetoric returns to haunt such statements. These immigrants represent a new

class of trans- or inter-nationals who live in a liminal state as resident aliens. They are reluctant to embrace "America" fully, and often they are dissuaded from assimilating into the land of asylum.

A decade later, after the 2000 census, another article in the *Times* proclaimed: "Census Reveals Fewer Hyphenated Americans."[70] Based on findings from the census, it appears that the American "melting pot" tradition remains alive and well. Data from the census "long form," a more detailed questionnaire that is distributed to approximately one in six households, reveals that more and more Americans prefer to describe themselves simply as "Americans" rather than to identify their ethnic or national heritage. Not surprisingly, this trend is most prevalent among older immigrant groups, especially among Americans of European origin. Compared with the 1990 census, in 2000 some nine million fewer Americans identified themselves as being of German descent, and some five million fewer Americans described themselves as being of English or Irish descent.

By contrast, the number of Americans claiming West Indian, Latin American, and sub-Saharan African descent increased dramatically. Although much of this is attributable to a straightforward increase in the numbers of immigrants from these areas of the world, it is also due, at least in part, to changing trends in ethnic identification. For example, more Americans today identify themselves as African-American than in 1990, and that may explain some of the increase in Americans claiming their origins in sub-Saharan Africa. The question of ethnic identification is even more complicated when it comes to Americans from Central and South America and the Spanish-speaking Caribbean. Observers have noted that the more-established groups from this part of the world—such as Puerto Ricans, Dominicans, and Cubans—have forged political alliances in certain instances. Americans from these areas are often reluctant to identify themselves with newer "Hispanic" immigrant groups, such as those from Mexico and Ecuador.

For those who are uncomfortable with marking difference, such findings offer hope that new immigrants may also eventually consider themselves primarily as "Americans." This is not to say that any American's cultural origins are anything to be ashamed of. To the contrary, true cultural "diversity" makes for a much more interesting American culture. But all too often in recent times the idea of "diversity" has come to mean interest group politics in which one group of Americans is pitted against another group, and in which certain groups sometimes claim victim status in an

effort to gain political advantage. The "events" that fall under the sign of September 11, 2001, were said to have bound the nation together—people were thought to believe that "we" had more to gain from national unity than from cultural fragmentation. The Lebanese-American feminist performer Leila Farah, in her one-woman show against the War(s) in Iraq, writes eloquently about the inequities, particularly after 9/11, of inhabiting a hyphenated identity.[71] A passage in her script states: "You think about the land you sometimes call home, where this places you on the hyphen this time . . . where does this experience fit in the schema of alien-nations . . . of hyphen-nations . . . of 'one nation under God, indivisible, with liberty and justice for all.' [During this last line, I stand mimicking a performance of the Pledge of Allegiance]."

Bharati Mukherjee, in her 1989 novel *Jasmine*, compares the eponymous heroine Jasmine (formerly Jyoti), an émigré from India, with her adopted son Du, who has immigrated to the United States from Vietnam. Jasmine notes that her "transformation has been genetic; Du's was hyphenated. We were so full of wonder at how fast he [Du] became American, but he's a hybrid, like the fantasy appliances he wants to build. His high-school paper did a story on him titled: "Du (Yogi) Ripplemeyer, a Vietnamese-American."[72] The difference between Jasmine and Du is the difference between assimilation and hyphenation.[73] Du, "a resistant" hyphenate, retains his hyphenation. In contrast, Jasmine struggles to ignore her past, renaming and reclassifying herself as the novel "progresses." Jasmine admits that she "was afraid to test the delicate thread of [Du's] hyphenization. Vietnamese-American: don't question either half too hard" (200). Du's refusal to repudiate his Vietnamese "heritage" makes him both more and less American. His both-and positing relies on the hyphen to reconstruct his identity. Like many "marginalized" people, Du proves that it is possible (and perhaps desirable) to maintain one's hyphenations—to resist the pull toward the vanishing point. Gayatri Spivak has called this phenomenon "riding the hyphen."[74]

David Palumbo-Liu inserts a solidus (or "slash") when writing about Asian Americans. By doing so, he seeks to signal "those instances in which a liaison between 'Asian' and 'American,' a *sliding over* between two seemingly separate terms, is constituted. As in the construction 'and/or,' where the solidus at once instantiates a choice between two terms, their simultaneous and equal status, and an element of indecidability, that is, as it at once implies both exclusion and inclusion, 'Asian/American' marks

both the distinction installed between 'Asian' and 'American' *and* a dynamic, unsettled, and inclusive movement."[75] Palumbo-Liu also gestures toward the performative nature of such terms that are both imposed and embraced.

These readers reverse and revise the debate about hyphens by insisting upon respect for difference(s). They seek to foster hyphenation in order to resist forms of integration that are read as ahistorical and are always already complete as well as a priori priorities. As such, they imagine the hyphen as an ever-present entity that acts to de-essentialize and re-member histories. As Homi Bhabha notes in his discussion of the performance artist Guillermo Gomez-Peña:

> Hybrid hyphenations emphasize the incommensurable elements—the stubborn chunks—as the basis of cultural identifications. What is at issue is the performative nature of differential identities: the regulation and negotiation of those spaces that are continually, contingently, "opening out," remaking the boundaries, exposing the limits of any claim to a singular or autonomous sign of difference—be it class, gender or race. Such assignations of social differences—where difference is neither One nor the Other but *something else besides, in-between*—find their agency in a form of the "future" where the past is not originary, where the present is not simply transitory. It is . . . an interstitial future, that emerges *in-between* the claims of the past and the needs of the present.[76]

The question remains: How are we to evaluate the eruption of ever-emergent hyphenates? Is this shifting space actually libratory? Can it function as a site of resistance, as many claim? The difficulty with determining the efficacy of the suspended hyphen lies in the subject who reads. Although the hyphen attempts to mark more accurately the discontinuity of specific subjects, it too is reductive. Here, we might remember that "identities continue across and exceed the political and discursive boundaries of sexual preference, racial markings, age, physical abilities, economic class, and so on. It serves certain interests, however, to insist that selves are distinguishable from others."[77] In this chapter, however, my interest has been in how certain "marginalized" figures cling to the hyphen as a means of resisting dominant strategies of erasure and marginalization, as well as in questions about how American-ness depends upon the hyphen for its (dis)articulation.

66 Queer 99 Quotation Marks

There is a limit to the information language can convey without introducing such devices as quotation marks that differentiate between what logicians call "language" and "metalanguage."
—E. H. Gombrich, *Art and Illusion*

Camp sees everything in quotation marks.
—Susan Sontag, "Notes on 'Camp'"

Quotation stands at the intersection of iconography and intertextuality . . .
—Mieke Bal, *Quoting Caravaggio*

Quotation marks are as queer as they are quotidian. While appearing to bend themselves to the theatrical, the "meta," and the excessive, in practice they are part and parcel of habitual, pedestrian behaviors. Their paradoxical presence, even when unscripted, questions the status of that which passes for the naturalized and the normal. Quotation marks, as gestures both written and embodied, are queer to the extent that they revive and instantiate "prior" performances across space and time, giving these performances priority—what is present, first, *and* previous—all at once. Quotation marks signal an eccentric turn (of phrase—including the dance) that haunts and invades, even as it seems to authenticate and origi-nate. "Besides denoting 'authority,' the word *auctoritas* could mean 'a quo-tation or extract from the work of an *auctor*.' These extracts—these com-monplaces—from *auctore* were typically flagged with a single or double quotation mark in the margin. Such marks said to the reader 'Use me as your own.' By the late seventeenth century and the eighteenth, the winds had shifted. Quotation marks came to indicate not common property but the utterance of others, for which proper attribution was required. What

changed, of course, was not the type of passages being used but the way in which they were viewed."[1] As with punctuation marks generally, the "same" marks had different meanings dependent upon how they were read and interpreted.

Among the queer acts that quotation marks perform is the simultaneous suturing and separating of text(s). Indeed, as the epigraphs to this chapter suggest, quotation marks are devices that can supplement, subvert, amplify, or queer what is taken to be normative. My point here, however, is that in poststructuralist discourse, all language is "meta": such is Derrida's critique of J. L. Austin who thought of the theater as a special rather than a "quotidian" case/space.

In this chapter I peruse a sampling of the queer, quotidian performances of quotation in works by the contemporary dancer/choreographer Bill T. Jones.[2] Specifically, I am interested in how Jones (re)cites and (re)plays standards through the use of queer quotation in two pieces: his little-discussed, repeated "solo" improvisation known as "21" and his collaborative digital work "Ghostcatching." I read Jones's postmodern performances as "queer uses of time and space [that take place] according to other logics of location, movement, and identification."[3] These locations, movements, and identifications trouble progressive narratives of development as they privilege instead concepts such as simultaneity, simulation, and citation. For some, it may seem odd or queer (not to mention illegal or unethical given the copyright laws that have made up the discourse of quotation since the nineteenth century) to treat others' icons, phrases, and even gestures as fungible material. And yet, we know that every writing, like every performance, is a re-writing—an instance of *différance*—a deferral and repetition. This is among the major tenets of "performance studies" for which originality is a by-product of the copy, and we should no longer be surprised by this queer conundrum. Such questions complicate the use and invention of resources such as *Bartlett's Book of Famous Quotations* that first appeared in the mid-nineteenth century (1855), to which many a politician's speech writer and wedding guest have turned as a source of authority—a repository of pre-vetted proven prestige. Quotations erect an apparatus that reframes/unhinges taken-for-granted seens/scenes that call to attention (by calling us to attention—hailing and interpellating us as readers/thinkers/witnesses) the illusion of originality as well as origin. In our age of copyright infringement and plagiarism we must be resourceful in acknowledging other people's property.

Who pays for such borrowing and how is such license (poetic or not) authorized, if at all? This question becomes more acute later in this chapter when I discuss the now passé proposition proposed in the turn-of-the-twentieth-century poet William Butler Yeats's poem "Among School Children," which concludes with the line: "How can we know the dancer from the dance?" This question has been transformed in the present era of "motion-capture technology" that separates or more aptly un-sutures an earlier technology of the body such that the ongoing movements of bodies exist "independently" of the "live" presence of a performer.[4]

The art of quotation triggers and produces our understanding of mnemonic traces—a double discourse that moves in two directions at once. Writing as property impinges on originality—when words are not one's own. Or, as Edward Said has said, "Quotation is a reminder that writing is a form of displacement."[5] The re-circulation and recycling that is a hallmark of the discourse of quotation links it to a performance of memory or, to use Toni Morrison's more active term, "rememory."[6] Indeed, as Joe Roach explains, "memory operates as both quotation and invention."[7] This chapter therefore also explores the "queer" interactions among performance, memory, the quotidian, and the quotation.

Richard Artschwager, in his installation *Untitled (Quotation Marks)* (2002), notes that "the quotes make an aura like other kinds of punctuation, but then they do something else, which is that they enclose space on a wall—some actual footage, so they get physical. Their left to right push is very strong."[8] What intrigues me about Artschwager's comment is the clearly performative aspect he sees in quotation marks: like dance, they are physical, in motion, and a force in/on the environment in which they appear. They seem to kick with their metaphorical feet, keeping the enclosed in a delineated playing field. Like old-time "Negro delineators," their appearance marked a moment of simultaneous contraction and expansion, containment and freedom, danger and pleasure, performance and performativity. Such reproductions marked the delineators as "untitled" (Quotation Marks). Unearthing the barely buried life of blackface minstrelsy in Artschwager's work gives another context for his use of naturalistic synthetic material: wood-grained formica/"wood" and green Astroturf/"grass" or white minstrels/"black" performers. Artschwager's quotation marks are made of Astroturf that reads as a kind of hair. They appear as if in a first-position demi-plié with one's legs bent in the shape of the parenthesis—embracing air, these quotation marks demarcate space.

Looking like a cross between Astroturf and grass, the bristly bright-green fibers play with the concept of quotation and (un)naturalness. These marks, free-floating in their untitled (pun intended) space quote no-thing(ness)—just open/closed space.

In contrast, Artschwager's installation *Janus III (Elevator)* has British-style single quotations quoting a door that, when opened, allows one to step into an "elevator" outfitted with buttons that sound when pressed, but the "room," having no shaft, does not move. It has the illusion of, or rather allows one the freedom to imagine, movement from a static station. The added dimension of sound supplements the reality effect. Or is it that the memory of having ridden in an "actual" operational elevator can be triggered by stepping into the enclosure and pushing the button—thus playing on the spectator's expectation? And yet, surely, spectators have been prepared for a different experience by the quotations around the door that itself is not one that (stereo)typically encloses elevators. Finally, the very title of the installation, *Janus III*, provides a clue to its reconfiguration of the notion of "elevator." The entire installation invites engagement even as its own movement is stalled. The interplay between movement and stasis structures Jones's dance as well.

Jones's choreography is both indebted to and recalls work done by other experimental choreographers such as Yvonne Rainer, Sara Rudner, and the early work of Twyla Tharp. As such, Jones's work is part of other "queerings" of linear time and phrasing that might be deemed "minoritarian versions of world-making" to use José Muñoz's phrase.[9] Specifically, Jones's piece "21" recalls some of the versions of Trisha Brown's "Accumulation" (1971) in which the dancer/choreographer played with repetitious movement, performing in silence as well as talking metacritically about the dance being done. Brown's dances have been described as "cool, obsessive, intelligent investigations of attention and perception, systematically presenting the human body as both subject and object of research . . . There is a sensuality in the various Accumulation Pieces, an erotic suggestion that comes more from insistent rhythm of the sequence and the methodical articulation of the body from any specific symbolic or literal reference."[10]

The late Susan Sontag, in her much quoted and often anthologized essay "Notes on 'Camp,'" argues that "camp sees everything in quotation marks. It is not a lamp, but a 'lamp'; not a woman, but a 'woman.'"[11] In

Figure 15. Richard Artschwager, *Janus III (Elevator)*, 1983, MAK, Vienna 2000.
Formica, plastic, aluminum, and audio equipment, 244 × 244 × 244 cm.
Courtesy Gagosian Gallery, New York.

her example, the quotation performs as a style of reading, marked by in-
tonation that Walter Benjamin might call "against the grain" and Dick
Hebdige would classify as "subcultural."[12] To "see" nouns in quotation
marks is to question their straightforward, direct meaning—to highlight
through a specific ironic staging a queer multiplicity or polymorphous
perversity. The quotation as a queer sign and a sign of queering. As Son-
tag elaborates, "To perceive Camp in objects and persons is to understand
Being-as-Playing-a-Role. It is the farthest extension, in sensibility, of the
metaphor of life as theater."[13] Leaving aside the debate about Sontag's
reading of camp, which is documented in Fabio Cleto's introduction to
his reader *Camp: Queer Aesthetics and the Performing Subject*, it may be
useful here to remember the European origins of the term "camp," spe-
cifically the French and the Italian, both of which relate to "posing." In-

deed, "*se camper* [means] to posture boldly, . . . and *campeggiare* [can be seen] in its theatrical/visual sense of 'standing out.'"[14] Here, the theatrical roots/routes of the term are on display—its visible spacing serves as an ostentatious act. Although I use Bill T. Jones as an exemplar of queer quotation in this chapter, I am cognizant of the fact that such performances are by no means limited to performers such as Jones. Mae West, Sarah Jones, my grandmother, and numerous others—including lamps—have performed according to various "camp" aesthetics with different political stakes.[15]

Some of my thinking about quotation marks and queerness is indebted to Sontag's seeing the quotation mark in the purview of camp, which at one time was also a synonym for the queer. Camp is not the only site of citationality. Indeed, the other discourse that "has the reputation . . . of treating things obliquely, indirectly, with quotation marks" is deconstruction. To generalize, we might say that in the wake of the long-heralded demise (for some) of deconstruction (which predates the death of Jacques Derrida in 2004), the discredited discourse of Camp now labors to belong to the province of the queer. As Derrida questions in his essay "Typewriter Ribbon: Limited Ink (2) ('within such limits')": "How do we understand the word 'materiality' IN QUOTATIONS. To underscore the generalization of quotation marks . . . no longer means one is citing an ulterior author or text; rather, one is citing quite to the contrary, that one is performatively instituting a new concept and a new contract with the word. One is thus inaugurating another word, in sum, a homonym that must be put forward cautiously between quotation marks. Another word-concept is thus staged whose event one causes to come about."[16]

Whereas Sontag concerns herself with how quotation marks make camp, or camp the quotidian, Marjorie Garber, in her essay " " " (Quotation Marks)," highlights authenticity as a central problematic for quotation. Garber notes that "paradoxically . . . quotation marks, when either written or spoken, can convey both absolute authenticity and veracity, on the one hand, and suspected inauthenticity, irony or doubt, on the other."[17] Her concern throughout this essay is with the ways in which the act of quotation conveys information as both writing and speech. Following Said's reading of writing as displacement in his study *Beginnings: Intention and Method*, Garber focuses on the gesture of quotation, one of the few gestures seemingly specific to academic culture—these days still conventional at conventions—in which the "two-finger flex has become

conventional rather than strictly mimetic, a sign of quoting rather than a quote-sign" (657). Properly footnoted quotations are used to create a record of one's epistemological community. And what of those moves that come from coincidence—those circulating gestures that are surrogates?

Garber uses an infamous scene in the Hollywood film *Ghost* (1990) to illustrate the "ways quotation is a kind of cultural ventriloquism, a throwing of the voice that is also an appropriation of authority" (663). *Ghost* tells the story of a white man who is murdered and comes back to life in the form of a (black female) ghost, played by Whoopi Goldberg. In retrospect, it may be seen as part of the growing fascination with the (un)dead in American popular culture as registered in the publication of Toni Morrison's *Beloved* and its material black female ghost among numerous other manifestations in popular culture. Rather than relying on the viewer's memory to "see" the actor Patrick Swayze as he kisses his wife (played by Demi Moore) the director, Jerry Zucker, chooses to make the kiss explicit—it is a he, the character Sam, and not a she, the character Oda Mae Brown played by Goldberg, who kisses the widow Molly played by Moore. The queer kiss between two women, black and white, thus happens only in the unseen space of a memory whose queer trace, like the quotation itself, is (in)visible. The ironies here are many. Moreover, we might think of this kiss as non-reproductive in the "heterosexual" sense, even as it produces queerness in the mind of the spectator. That Garber's discussion of quotation and recitation, substitution or surrogation, to use Joe Roach's term, touches on the white (male) cover-up of a black (female) body should not surprise us if we know anything about American narratives, which so often replay the dyad of the black woman and white man as the specter of miscegenation.[18] This race and gender drag is replayed by both Goldberg and Jones in other performances. Goldberg passes as a white man in the wonderful film *The Associate* and Bill T. Jones takes on white masculinity (among other identities) in his performance of "21."[19]

Here, again, quotation queers issues of authority, authenticity, space, and time.[20] I say this because quotations, as they manifest themselves through textual bodies must reference OTHER resources from different times, contexts, and places. As such, quotation marks bespeak the purported postmodern penchant for pastiche and recyling. The assertive insertion of such intertextual material mimics the act of interjection—an in-

terdiction of con/sequence. At the most elemental level, when we quote something we both de- and re-familiarize it. We make it our own, or at least borrow it as an act of bricolage. This is what makes quotations communal, historical, and complicated as well as queer. As Amelia Jones reminds us, "there is no possibility of an unmediated relationship to any kind of cultural product . . . While the live situation may enable the phenomenological exchange of flesh-to-flesh engagement, the documentary exchange (viewer/reader <—> document) is equally intersubjective."[21] Indeed, Jones's body, especially in the opening sequence of "21," like quotation "stands at the intersection of iconography and intertextuality," as Mieke Bal suggests. Bal then elaborates by noting, "[Preposterous history] is a vision that integrates an epistemological view, a concept of representation, and an aesthetic, all three of which are anchored in the inseparability of mind and body, form and matter, line and color, image and discourse."[22]

Opening Sequences

There is no direction in art.
—Bill T. Jones

There's joy in repetition.
—The Artist Formerly (and yet again) Known as Prince

Do you remember the time when we first met?
—Michael Jackson lyric

This is my memory. My memory is not my enemy. My memory *is* my enemy.
—Bill T. Jones, *Last Night on Earth*

What one does not remember holds the key to who one is in the toilet and in the bedroom.
—James Baldwin, *The Evidence of Things Not Seen*

In the *Oxford English Dictionary* the word "sequel" precedes "sequence"; as a consequence, we can see that one organizational principle, alphabetization, suggests another arbitrary, anti-progressive, or rather strategic (ergo political) organization: time and space. Although both sequel and sequence address spatio-temporal dimensions, one usually thinks of the former—sequel—as a more temporal term than the latter—sequence—

which is more spatial, relatively speaking.[23] In an effort to rethink these categories, or more accurately the boundaries between them, I take up the term "opening sequences" as a way to think about not only temporal openings but also spatial beginnings. As the anthropologist Jonathan Boyarin reminds us, "the very notion of 'progress,' of stepping forward in time, exemplifies how the metaphorical structures of our language betray that bifurcation [between time and space] displaying in particular a tendency to borrow terms connoting spatial relations in our references to change over time. We have a notion of 'progress' that metaphorically discusses temporal sequence in terms of spatial distancing and vice versa: we speak of distant times . . . we think of long-ago places, if not in so many words."[24]

The space-time binary Boyarin tries to dissolve here/now/above/before is reproduced with each performance of Bill T. Jones's danced memoir solo "21." Not to be confused with the duet "21 Supported Positions" that Jones choreographed with Arnie Zane, the solo piece "21" stages significant moments from and migrations in the dancer's life such as the first time Jones had sex with a man, his first trip to Europe, and his brother Boots's imprisonment. Jones claims that he first danced the piece in the early 1980s (time) in his bedroom (space) for a sleeping audience of one (Jones's lover and choreographic collaborator Zane). The text of "21" alternatively as well as simultaneously danced and spoken is told in two registers at once—via sound and movement. As such, it troubles and/or queers the differences between these performative modes.

The solo "21" is reminiscent of Trisha Brown's "accumulation structure" of dance, or even of Gertrude Stein's story "Orta or One Dancing": "She could be dancing. She was remembering then everything of being one who could be dancing. She was dancing then. . . . believing in not needing remembering that some meaning has been existing, believing in moving in any direction, feeling in thinking in meaning being existing, feeling in believing in thinking being existing. . . . She was remembering this thing. She was dancing. She was asking any one who had been one expressing that meaning is existing to be one assisting dancing to be existing. She was dancing. Any one was then assisting that dancing be existing. . . ."[25] Indeed, this complicated and queer narrative structure that moves back and forth—between beyond among through space time being desire—patterns Jones's movements, which themselves are contradictory as well as complementary: the space where the preceding mean-

ing bends and extends—stretching meaning. As Susan Foster notes, "In addition to aleatory procedures, contemporary choreographers have experimented widely with two related *paratactic* procedures in their dances: they convert mathematical equations and game structures into templates for dance sequence."[26] This is very much what Jones does in "21" and it has implications for his later work "Ghostcatching," which also "converts mathematical equations and game structures" in its computerized capture of Jones's movement.

Jones's variations on his theme(s) are literally lyrical—made of spoken and fluid movement, his poetic topic through the entire performance bespeaks many subjects at once. Throughout the piece, Jones varies his tempo and direction, trying to "make use of 360 degrees" as he slips in and out of his set . . . sequence again, enacting wandering and return, movement and stasis, past and present, then and now, here and there, one life and another. He begins by stating "my story begins in Florida, about 1948." Though he invokes the first person here, he is in fact telling his brother Boots's story, which becomes entwined with his own and in some sense provides a queer commentary on black masculinity—where the latter becomes the themed subject and object of the performance. Jones punctuates his spoken text with embodied gestures and repeated poses that compose "21." As he moves and speaks, we learn that at the age of fifteen Boots impregnates his twenty-six-year-old girlfriend and, against his/their mother's wishes, heads north with the woman, declaring "Mama, I'm a Man." There is a lyrically danced interlude before Jones moves to another time and space. Like the dated chapter titles in Toni Morrison's novel *Sula*, Jones states: "1971 and Jones desiring to leave his/their mother to go to Amsterdam with his lover, Arnie Zane." In Amsterdam, Jones overhears on a radio about the uprising at the Attica penitentiary in upstate New York. He states: "Governor Rockefeller has put down a rebel uprising." His brother has been at Attica for four years for having robbed someone of a mere $32. Like Angela Davis hearing about the riots and the escalating violence of the 1960s while studying in Germany, Jones tells Arnie that it is time to return to the United States.

In the opening sequence of "21" Jones dances apparently seamlessly and then "breaks down," cuts apart, queers and interrupts the sequence—so that a pattern appears and the spaces in between the "movements" are seen in the seam and now show through. He moves into specific gestures that are labeled (by spoken text) numerically, in sequence, from "one"

through "twenty-one." My transcription from Jones's February 1996 performance at the University of California, Riverside, includes the following:

1. Contrapposto, Italian Renaissance, Michelangelo's *David*
2. Arnold Schwarzenegger
3. Muhammad Ali, "I am the greatest"
4. Ward Off
5. Pregnant Housewife
6. Antiquity
7. Waiting
8. Male beefcake, tits to the sky
9. Pele, before . . .
10. . . . and after
11. to the groin
12. Nineteenth-century melodrama, "Eek! A mouse!"
13. Ingmar Bergman, "Oh my God!"
14. Nudist
15. Art Deco
16. Pittsburgh Steelers
17. New York Yankees, the wind up
18. Apollo Belvedere
19. Adam, before the fall . . .
20. . . . and after [this pose later signifies Michael Jackson]
21. Gonna go to Heaven

Next, Jones repeats the series of gestures, which are like vogue poses, giving each a linguistic noun-label rather than a numerical "tag." Pose number one is re-presented and labeled (still by spoken text) as "Contrapposto, Italian Renaissance, Michelangelo's David." The accompanying move has Jones, recalling the statue by shifting his weight to his back leg—the figure of idealized male beauty even if rendered in black. The stance suggests movement: it captures a moment where the body is about to shift. This is followed by twenty other poses—each with a cultural tag. For example, his serialized quotations cite gestures from T'ai Chi (the move translated as "Ward Off," styles such as Art Deco, canonical and pop cultural icons including the boxer Muhammad Ali, "I am the greatest," the Apollo Belvedere, Arnold Schwarzenegger, the biblical Adam, a pregnant housewife, and pantomime postures such as "Eek! A mouse!" from nineteenth-century melodrama. This latter pose has Jones in second

position, one leg extended, one hand under his chin, head in profile. Once the audience has been familiarized with the gestures, Jones defamiliarizes them, thereby forcing his audiences to read the gestures in a different way. Rather like learning to recognize letters of a language, the audience must learn to recognize the letter "A" as the same as but different from the letter/mark "a." The dance makes clear that meaning is multiple—that the gestures suggest more than one thing at the same time. In mixing postmodern pastiche Jones performs his life story like a history by perpetually "[engaging] in a restaging of the disappeared."[27] In our postmodern age, "one aesthetic collides with the next, and hyperrealism will compete and collude with high abstraction, which will supplement and contrast with the return of narrative and a new experimentalism. This overlap of styles signifies not cultural confusion but an immense array of strategies deployed to make sense of and resist capitalism . . . What constitutes alternative now is, as Jameson predicted, a technotopic vision of space and flesh in a process of mutual mutation. But while for Jameson, hyperspace was always corporate space, for some postmodern artists [Jones, for example], the creation of new bodies in an aesthetic realm offers a way to begin adapting to life after the death of the subject."[28]

We can understand Jones's performance via Elin Diamond's reading of Adrienne Kennedy's performative autobiography *People Who Led to My Plays*—as an event that "*temporalize*[s] perception, producing new means of imbricating the psychic and the historical. . . . deploying the auratic [body] in order to destroy its uniqueness."[29] Jones's queerly embodied performance is presented in the third person, thus making it incoherent and disorienting. It is important to remember that Jones's body itself is always subject to such interpretation given his status as a black HIV-positive gay male dancer. This is another aspect of Jones's participation in queer temporalities discussed recently by Sara Ahmed and Judith Halberstam.[30] Interpenetration might be the keyword as well as the method of this text. It is, as mentioned previously, at once a reading of two spatio-temporally disjunct physical penetrations—Jones's own and his brother's. Both Bill and Boots tell narratives of demonization, exoticization, and racisms as their masculinity seems to be "thrust into quotations."[31]

Jones's "danced argument" (to use Susan Foster's term), demonstrates that identities "are not to be distinguished by their falsity/genuineness, but by the style in which they are imagined" (and I would add contextualized and performed).[32] So, too, the fact that several tags refer to "styles"

(as in art historical styles) and are performed "chronologically" (through the reference to Arabic numerals that are then repeated out of order) is important because it underscores Jones's understanding that time itself is a cultural artifact subject to becoming choreographed. In/during "21" Jones "writes" his life story as a gesture portrait composed according to some version of "history." I argue that Jones's performances seek to queer time by dancing through re-membered spaces and poses that are disembodied/differently bodied. Such ideas about the queer space-time of Jones's danced memoir are the (vanishing) point of this opening sequence.

Fast Forward // Take 21

The opening sequence to a 1996 performance of "21" (in which I participated as a viewing member of the audience who also moved on stage with Jones, and which I have since re-viewed on videotape as well as on DVD) began with repetitions of a word: "memory." Jones repeated the word "memory" (we wonder, how are the quotation marks functioning here?) almost like an incantation—"memory."[33] Speaking slowly Jones, clad in loose drawstring-tied white pants, deliberately moves center stage, facing front to the audience seated on bleachers—his hand swipes his abdomen, next his thigh, he walks forward and then stage right, to rest on his elbows on a baby grand piano, his hands fold, his legs cross, he looks left and then right—then at the audience. He repeats the word memory, and then walks back to what we know now as the starting point to begin the "sequence" again—only this repetition, as with each successive one (there are six altogether), will be slightly different—steps will be added without seriously comprising punctuated parts of the sequence.

During the sixth go around Jones circles back and many in the audience (which is not a monolith but a collective) laugh when one major segment of what has become a dance sequence is left out. Part of the laughter is nervous and stems, one suspects, from the fact that Jones sits on an audience member's lap. Jones smirks, shrugs, and with a throwaway hand gesture decides not to go through the motions now anticipated and expected by the audience, which nevertheless remembers the movement that was (not)there (how else to account for the laughter?). In what becomes the final pass through of the opening sequence, Jones leaves out (or does he?) a segment, assured perhaps that the moves reside in the audience's memory. The impromptu opening sequence suggests

that memory is (re)produced; that it is made differently as something perpetually deferred, a kind of repeated differential—open to, by, and for revision.

Jones's work produces a temporal play between objects and memory. Jones's dancing answers key queries posed by Elin Diamond: "Is it possible to generate this complex temporality in live performance? Can we give the performance 'present' the sense of the historical without invoking teleology (linearity, fulfillment)? And if memory gives us a temporal flexibility, how does *historical* memory 'appear' when we have not only a solo woman performer in view, but a female body that seems once again to claim what performance art in the 1970s and 1980s tried to displace: the performer's 'aura'—Walter Benjamin's term for the esoteric presence and authority of the artwork before technologies of reproduction."[34] It seems to me that Jones's entire dance performs a brilliant answer to such materialist feminist inquiry. First, Jones's body has always already been (re)produced as a historical body—even in its supposed singularity which again is multiple not only in its meaning but also its staging and (re)presentation. He references a body (not) seen as he re-states his memory of an audition in Amsterdam where an onlooker, one of the "beautiful blondes" whom he ventriloquizes, fetishes his dancing black body by stating, "I am surprised that you could not get the combination: I thought that all American blacks could dance. That it was a gift from God." By re-playing that moment in a different yet certainly similar arena, Jones complicates and questions those current/contemporary/present viewers who perform a different yet similar scopophilic, exoticizing look. So, too, having marked "his" body (please note queer quotation) as David (a Renaissance sculpture), as Art Deco (a style, a period), and as Michael Jackson we cannot simply "compute" his body as his alone. He answers the essentialism of the woman with an anti-essentialist, even anti-humanist retort. He worked as an artists' model in Amsterdam, mimicking sculpture. Remember as well that he has remembered his story as being similar yet different—paralleling and departing from that of another black man, namely his brother Boots, who unlike Bill did not receive his walking papers for many years. They share a mother, a sister, lovers, leaving home, imprisonment, penetration, the inescapability of the black body, education, return, and more (as well as less).

Jones's performance disrupts the rhythm of the sequence—this is perhaps why he makes use repeatedly of the pregnant pause. Also, the audience would not have recognized the pattern of the opening sequence

had it not been interrupted. The gestures form a lexicon—becoming the "minimal units of any choreographed movement" that can be isolated and identified as discrete.³⁵ Jones pauses at the piano, Rest, stop, caesura.

Jones oscillates between speaking in the third person and the first person (subject/object), thereby troubling the spectacle. He chooses to represent his first sexual experience with a man. Jones returns to poses from the earlier sequence, radically queering their "original" order with his elliptical movements. He bends his body, somersaults, twisting and toppling meanings with movements and vice versa: "1971 Bill T. Jones has sex [pregnant pause—arm posed like a parenthesis or a comma, rounded in front of his abdomen] with a young man for the first time." As he performs a series of quick gestures with his body, he speaks the following words:

Pele
Male beefcake
Sex like never before
To the groin

These quoted phrases (danced and spoken) are re-membered and enacted impersonations of Jones in previous guises and impersonations of "other Others." I ask myself, "Does Jones tire of repeating himself?" You can see my line of thinking (just look between the quotation marks). Then I recalled that "21" is a dance in which, paradoxically, the rigid structure leads to the most fluid gestures. The dance is by turns pedagogical and presumptuous, referential and reverential, as well as self-reflexive and unconscious. Jones claims that in "21," "levels of memory slip in and out of [his] control . . . [and that] the whole is a matrix under which the fluid, most unconscious dancing should happen—that's the problem, by solving a problem that is what dance is."³⁶ He used a similar strategy in his dance *Still/Here* (time/space) in which he "set up a field of movement material and juxtaposed it to a text, thereby challenging the viewers to process what they are seeing and hearing simultaneously." Jones assumes "that the result is greater than the sum of its parts."³⁷ He uses movements at various levels of abstraction to channel and amplify specific spoken information. In other words, Jones's works choreograph memory, movement, and identity.

The "truth" of Jones's body is questioned in and by his narrative performance. His is a dance of dissemblance and resemblance as well as reassemblage. Bracketing with bravado, Jones's dance epitomizes equiv-

ocation. For example, his pose "Male Beefcake, tits to the sky," when repeated in the sequence about his brother, refers to his brother's girl-friend's "tits." Such titillating juxtapositions and repetitions complicate questions of signifier and signified, of spoken and danced acts. The piece itself is never "fixed" or "stable," since for twenty-one years Jones has been improvising/revising every time the crucial story of his "coming out," which we know is, like housework, never done. The piece emphasizes the fact that one is always in the process of becoming . . . out. So, too, it might be said to demonstrate that queerness is always already about disrupting the reproduction of a "lily white is right" canon and static no-tions of the subject. Here I am pressing for a reading of the term *queer* as a verb more than a noun—for Eve Sedgwick's view of queer as "a con-tinuing moment, movement, motive—recurrent, eddying, *troublant*. . . . multiply transitive. . . . the open mesh of possibilities, gaps, overlaps, dis-sonances and resonances, lapses and excesses of meaning."[38]

But in reading the performance itself, where does one mark queer-ness exactly? When Jones voices the text that discusses the first time he slept with Arnie Zane? When he narrates the story of his brother being "turned out" by the police (i.e., raped) in prison? It may be important as well to remember the dance critic Arlene Croce's approach to queer-ing Jones's work that requires us NOT to view it. In a now infamous re-view in the *New Yorker*, Croce essentially reversed Justice Potter Stewart's axiom about pornography—"we will know it when we see it"—so that we would know queer art when we must not see it.[39] Because Jones's "identity" as a black, gay, HIV-positive dancer "precedes" his appearance, in Croce's cosmos he can only ever produce "victim art." Croce's episte-mology of queerness is problematic and one of which we must be wary.

The supposed tell-tale signs of difference, marked in many ways, ap-pear in the eyes of the reader/spectator who may always read perversely or queerly as does Jones when he performs. Jones's ability to play with the practice of referentiality—to make his gestures gesture toward other things—is an example of the performativity of queer quotation. His sly alterations, iterations, and reiterations of sequences queer what might otherwise be canonical references. His shifting additions, subtractions, and supplements make us think, see, and feel—not to mention remem-ber—things differently. Jones's work compliments Roach's central claim that "repetition is an art of re-creation as well as restoration. Texts may obscure what performance tends to reveal."[40] It is significant, moreover, that Roach's formulation applies specifically to what he terms "circum-

Atlantic culture" with its obscured black traces that he deems "forgotten but not gone." So too, Roach's comments emphasize that the "text" that is not performed is static. Such ideas have implications for writing dance narratives and dancing written language.

The texture and quality of movement that Jones's virtuoso performances yield, like all dancing, is difficult to translate. One resorts to metaphor, symbolic cultural codes that much of Jones's dancing overturns (it may be no accident, as it were, that the somersault is a recurring feature of "21"—a dance that flagrantly flaunts its juxtapositions of high and low).[41] Among the oft-noted hallmarks of Jones's movement (which has to be taught to him after the fact by another) is its fluid transitions. He combines *pas de chat* and popping, upper-body isolations and positions from classical ballet, not to mention the athletic poses from football (U.S. and global) and baseball, T'ai Chi, and boxing. As such, his movement vocabulary, like those of his 1960s predecessors, eschews a hierarchy between everyday action and virtuoso dancing.

Only from a strictly formalist perspective would the specific patterns and sequences in Jones's dance appear to be set and congealed. In fact, the seemingly formulaic opening of "21" is improvisational. Unlike writing or film sequences, live performances are "one time only" events. As Peggy Phelan remarks, "The ontology of performance maps a gateway [opening] across a different order of production and reproduction."[42] By messing with sequences in his improvised performances, Jones queers the imagined stability and logic of sequence, allowing his audiences to participate in seeing arbitrarily arranged, evanescent scenes of/from his life that significantly are imbricated with other lives. The dance "21" is a profound meditation on racisms, on beauty and violence, as well as on black manhood, prodigal sons, and wandering and return.

After the performance I attended, Jones explained that he was "very interested in sequential movement . . . In "21" . . . I try to keep coming back into sequence, remembering where [I] left off . . . letting the accidents happen."[43] Jones's "21" is yet another example of the many experimental happenings of the 1960s that I discussed in chapter 1, where dance became conceptual, quotidian, and pedestrian rather than a form of inaccessible "high art."[44] This eloquent description resonates with Joe Roach's contention that "under the seductive linearity of its influence, memory operates as an alternation between retrospection and anticipation that is itself a work of art."[45] Is this not also akin to the queer art of quotation,

which, within the delimited boundaries of its marks (re)presents material that at once prioritizes the prior and promotes procession or the process of (re)telling what is yet to come? Jones's performances of "21" demonstrate his ongoing interest in queering autobiography and in what Audre Lorde called "biomythography" and others have termed "the chronobiological basis of narrative."[46] In this, his gestures reassemble and complicate ontology—original/copy—signaled also by his use of the third-person-critical mimesis. In opposition to the notion of "speeded up"—which we now know as the time-space compression of globality pace Harvey—here Jones has slowed down his own movements in a queer distortion of time and space. Jones's queerings have implications for standard elaborations. We see them enacted frame by frame, pose by pose. Like stop-action photography (think of Muybridge) Jones re-presents the basic elements, the single letter, the punctuation mark that will serve as the basis for words, sentences, a narrative. He is interested in reversion and perversion as well as the break.[47] So, too, we can see how Jones plays with ideas of pacing and pace (the latter in its prepositional sense that references deference and permission).

Queering Marked Time

We're almost out of time. Are we out of time?
—Bill T. Jones

Jones's casual query "Are we out of time?"—asked in a literal sense toward the end of his question and answer session at the Riverside performance—queers time with space. The gestures he performs are made poignant by the fact that he, we, the terminally ill patients with whom he works—all of us are running out of/in to time. Jones has spoken and written about how time changes when one is aware that death is understood to be imminent, near. One's perception of the semantic distinction between living and dying bodies changes under critical conditions such as the AIDS crisis.[48] In a reading of another of Jones's dances, titled "Untitled," David Gere links Jones's movement with an understanding of the incorporated fetish of gay male mourning gleaned from Michael Moon among others.[49] When Jones worked with "terminally ill" patients for his aptly titled piece *Still/Here*, he incorporated or quoted excerpts from "21." He directed each of the members of his Survival Workshop to cre-

ate a "gesture portrait of themselves."[50] As a form of both pedagogy and performance, Jones asked the group to explicate and supplement gestures with spoken text. He asks his patient/students, *"What does that [gesture] mean? Could you perform the gesture and tell us something you've learned? . . . Could you conceive your life as one smooth line? Where does it begin? And where does it end?"* In other words, he asks his students in what order (temporal and geo-political) do we narrativize text? And to what end? I would answer toward a perpetually open. . . . To quote Boyarin again: "We move 'through time' as much as we move 'through space,' and this motion is not separated into spatial sequences on the one hand and temporal sequences on the other. However, this does not mean that the distinction between time and space is entirely arbitrary . . . We can call the body a 'rubric' in which spatiality and temporality coexist indissolubly, in which their necessary unity is most clearly shown. When you die in time you dissolve in space."[51]

Jones is aware that to blur the boundaries between life and death—to see them as part of a continuum—upsets canonical notions of absolute difference between these states of being. Indeed, in his ongoing work he uses as an aid a technique borrowed in part from the improvisational "21." He writes: "My own process involved the intuitive combining of the survivor's gestures to make phrases, plumbing my own body's imagination, or borrowing from existing forms—capoeira and karate among them—to create expressive dance sequences."[52] Thus, the process of dance making is shown to be extremely collaborative—blurred, shared, borrowed, quoted.

One wonders in seeing the "lifelike" moving images if Jones thought about Barthes's musings on having his photograph taken—when the latter describes "that very subtle moment when, to tell the truth, I am neither subject nor object but a subject who feels he is becoming an object: I then experience a micro-version of death (of parenthesis): I am truly becoming a specter."[53] In his piece "Ghostcatching" Jones borrows from himself or rather a computer-generated simulacrum of himself so that his body's imprint has movement if not a "life" of its own. It is a figure that can be choreographed and can continue performing "as" his presence even in the absence of Jones's equally performative fleshly form. The cleavage enacted by this technological breakthrough allows us to theorize and view more clearly the "dancer" or the figure of the dance/r.

Jones seemed to anticipate such a split between sight, sound, and

meaning when, in the talkback/question-answer period after his Riverside performance of "21" he suggested, first, that he had answered questions about his philosophy of dance in the performance itself and, second, that he was listening not to the "words" spoken, but rather to the rhythm and tone-pattern that they produced. He answered a spoken question from an audience member with "purely" bodily movement—without the benefit of speech and with non-linguistic gestures. Such interactive call-and-response dialogue occurred in different forms of communication. Peggy Phelan's elegant engagement with the aesthetic surgery performance on/by the artist Orlan also suggests such mixed (media) feelings about the possibilities of translating and transforming the body. Phelan describes Orlan's performance as follows: "While it is true that the surgeon holds the knife/pen, Orlan is clearly the *auteur* of this act. Her face is 'in process,' a set of quotations, citations of 'beautiful' faces. As writing, Orlan's performances remind us that the body is not coherent; only reading practices—in their broadest performance—make them beautiful, sick, well, living, or dying."[54] Certainly, these questions of quotation and reading are at work (and play) in Jones's series of performances.

The emphasis on translation, juxtaposing dancing/words, telling stories of the body, and embodying/telling stories adds weight/wait to Toni Morrison's claim that "We die. That may be the meaning of life. But we *do* language. That may be the measure of our lives."[55] Jacques Derrida, in an interesting reading of the title of a program in which he participated, muses upon the efficacy and import of quotation. In reference to a printed poster for the program, he states that it has: "'Materiality'—in quotation marks—'Archival Intervention, Virtual Futures,' was not one I myself chose, as you might have supposed. . . . Upon receiving the poster for the colloquium, I for the first time saw unfurl before my eyes this intimidating banner that I would never have dared to wave myself: 'Materiality'—in quotation marks, and yes, I myself would certainly have wanted to add those quotation marks—'Archival Intervention, Virtual Futures.'" He continues:

> The generalization of quotation marks that then becomes necessary would in that case no longer mean in the least that one is citing an ulterior author or text; rather, and quite on the contrary, it would mean that one is performatively instituting a new concept and a new contract with the word. One is thus inaugurating another word, in sum, a homonym that must be put forward cautiously between quotation

marks. Another word-concept is thus staged whose event one causes to come about. The quotation marks signal in this case that one is citing only oneself at the moment of this invention or this convention in a gesture that is as inaugural as it is arbitrary."[56]

The essay then becomes a dialogue that continues:

> Derrida: The question of the "here-now" that you ask . . .
> Interlocuter: . . . In quotation marks? . . .
> Derrida: . . . Yes, exactly, in quotation marks. What happens when "here-now" is put in quotation marks? Or in parentheses? Or between brackets (*entre crochets*)? It/Id gets unhooked. Like hooks that unhook. Like pliers or cranes (somewhere, I think, I have compared quotation marks to cranes) that grab in order to loosen the grasp. But how is one to efface or lift the brackets once one begins **writing** [here and now] anything whatsoever?

This critical question remains alive in Jones's hyperstylized, queerly phrased dances.

Dancer from the Dance

The fungibility of the commodity makes the captive body an abstract and empty vessel vulnerable to the projection of other's feelings, ideas, desires, and values; and as property the dispossessed body of the enslaved is the surrogate for the master's body since it guarantees his disembodied universality and acts as the sign of his power and dominion. The desire to don, occupy, or possess the black body as a sentimental resource and/or locus of excess enjoyment (supplement) [makes] the Black body the vehicle of the other's enjoyment.[57]
—Saidiya Hartman, *Scenes of Subjection*

No actuality can be fully imaged, since it emerges from, projects into, and recedes into inactuality. Bodies and objects, their forms and contents, do not account for all of it. They do not catch the momentum. To look only at bodies and objects is to miss the movement.[58]
—Brian Massumi, *Parables for the Virtual*

In the final section of this chapter I look at the recent phenomenon of "motion-capture" technology or, as the actors who participate in its making are lobbying to call it: "performance." What seemed a conun-

drum if not an impossibility for William Butler Yeats at the turn of the second epoch (to employ a scheme furnished by Allucquere Roseanne Stone)—namely, how to tell the dancer from the dance—is now part of our techno-environment. Indeed, the advent of motion-capture technology, which was featured in films such as *Polar Express* (2004) and in video games such as Grand Theft Auto, makes possible in new ways the "disconnect" or disjuncture between "body" and "movement"—a split whose "surplus of signification serves to heighten its materiality."[59]

The proliferation of motion-capture (MOCAP[60]) technology in the last few years allows us to pose new questions about labor. Such technology stages a difference between body and performance as enacted by "live" actors whose movements are "captured" in this technological process. The actors wish to license the recording of their movements. They are concerned about how they will be compensated for their actions. Thus, several actors' unions are lobbying to have MOCAP provide dividends to the actors. Like other commercial work, this could yield real gains given that sales for video games that employ MOCAP, such as *Halo 2* (licensed by Microsoft), are in the tens of billions of dollars. In fact, sales for *Halo 2* reached 100 million dollars on the first day of its release. Finally, were this specific brand of performance covered by the Screen Actors Guild it could also be eligible for Academy Awards. The implications of compensating actors for such movements open up larger questions about labor, industry, and "posthuman" performances.

Here, I want to think about the effects and affect of MOCAP vis-à-vis racial, gendered, and sexualized subjects given MOCAP's increasing presence on global screens. The use of MOCAP is a direct outgrowth of video and animation technology and can be thought of in the context of the long-standing surveillance of third world peoples and people of color—and we might even say of black men in particular. Perhaps it is no coincidence that one of the first performances to be captured by the technology was that of the NBA player Shaquille O'Neal. His athletic body became the minstrel ground for such targets of opportunity, as I suggested earlier with my quotation of Saidiya Hartman's work, that allows us to understand all such movements as constrained by the legacy of slavery that made entertainment (and the bodies movement in particular) subject to subjection. Let us look more closely at how the process of MOCAP works. To begin, it requires an actor to don a "mocap" suit adorned with "retroreflective markers" applied with Velcro that "capture" the motions so

that they appear more "realistic." The technology is featured on gaming consoles such as Sony's Playstation 2, Microsoft's Xbox, and Nintendo's GameCube. It is also being used in other areas such as art, music, dance, film, biomechanics, and more. A still evolving technology, it has been defined as "measuring an object's position and orientation in physical space, then recording that information in a computer-usable form."[61]

Bits and bytes make up the body in question—simultaneously visual, visceral, and eviscerated. "The markers, which look like ping pong balls, are covered in tape that is designed to reflect directly back to the markers' original light source, which in this case was light bulbs arranged in a ring around each of 21 mocap cameras. The cameras surround the area where the action [is] to take place, called 'the live area.'"[62] This is an evacuated space of the 989 Studios in San Diego, California. 989 Studios was a division of Sony Computer America, and is now 989 Sports. The studio explains, "The cameras captured everything, storing the data in computer files to be edited later"; however, one suspects that something eluded capture or was left to return.[63] The process of editing seeks to distill the movements even further, working from the assumption that "humans are deeply programmed to recognize . . . subtleties [of motion]. If you see a person walking toward you at some distance, it's likely that your brain will form an opinion automatically whether that individual is male or female, old or young, and sometimes even passive or aggressive, based on their movement."[64] The slippage from gender to age to behavior elides the oft-cited "racial" distinctions that are too readily read in racist regimes (blacks had to cross the street when they saw a white person ahead, whites grabbed their belongings when a black was visible). The suggestion that our movements bespeak us does not give us freedom. Indeed, with the development of "smartpens" one's unique biometric identity will be captured.

Motion-capture performance, as those actors who regularly perform prefer to label their work, dissolves the body into points of light and allows for the superimposition of characters onto the movement. The entire performance saves labor by being worth "a thousand man-hours of hand animation work."[65] As such it is reminiscent of Yayoi Kusama's use of day-glo dots to obliterate her body that I discussed in chapter 1. Unlike Kusama's polka dot protests, however, motion-capture video games are used by the U.S. military (which began developing the technology in the 1970s) to practice war maneuvers.

The technology of MOCAP is not, of course, limited to military and commercial media use. Indeed, Bill T. Jones is among a handful of artists experimenting with MOCAP.[66] His collaborative piece "Ghostcatching," which has been called "a virtual-dance installation," has geometrically abstract ciphers that move in three-dimensional space. The term itself has been linked to Native American understandings of the camera. Shelley Eshkar, working as the graphic designer on the project, hand drew and then digitized the images gleaned from Jones's MOCAP "recording" sessions. In postproduction the artistic directors Paul Kaiser and Michael Girard of 3D Studio Max's Character Studio choreographed and coordinated the 3D dance animation. Isabel Valverde reads the piece as "representing a Western patriarchal conception of culture. . . . [that] conforms to *and* transgresses the norm at the same time; on the one hand, representing the conventions in a very subtle but fashionable way while, on the other hand, being perceived as the imaginary abstraction of one real person performing all these roles and in doing so challenging these same binaries."[67] In so stating, Valverde wants to read race and gender onto the "splines" that are colored—thus, she reads red as indigenous, yellow as Asian, etc. While I applaud her interest in how to read abstractions of abstractions, I am interested, perhaps more like Kaiser, in thinking about if and how "the drawn line [can] carry the rhythm, weight, and intent of physical movement . . . What kind of dance do we conceive in this ghostly place, where enclosures, entanglements and reflections vie?"[68] A look at Valverde's verbs confirms the quotation from Hartman that begins this section. The Web site explains the piece as follows:

GHOSTCATCHING / 1999

Ghostcatching is a digital art installation that fuses dance, drawing, and computer composition. Paul Kaiser and Shelley Eshkar created the visual and sound composition; Bill T. Jones created and performed the dance and vocal phrases. The movement phrases, recorded by means of optical motion-capture, became the building blocks for the virtual composition. They were edited, re-choreographed, and then staged in the 3D space of the computer, where they were also mapped onto 3D models rendered in the style of a gesture drawing. The final artwork, seven minutes long, is a meditation on the act of being captured and of breaking free.

In this live performance for the stage, three elements interact: the physical performance of Bill T. Jones, who dances while telling two

intertwined stories; the virtual music of composer Roger Reynolds; and the virtual spaces and movements of 3D projections by Downie, Eshkar, and Kaiser.

In actual performance, Jones is motion-captured in real time, allowing our imagery to respond to—and even intervene in—his story. The imagery neither "illustrates" the stories nor duplicates Jones's figure; rather it evokes odd parallel spaces and dual figures (boy and man) which inter-relate complexly with the stories and the stage space.[69]

The 3D scenes are rendered in real time, with timings, durations, and placements determined autonomously. Captured movement nevertheless emanates from a live performance that is necessarily mediated. "The discourse of visionary virtual world builders is rife with images of imaginal bodies, freed from the constraints that flesh imposes. Cyberspace developers foresee a time when they will be able to forget about the body. But it is important to remember that virtual community originates in, and must return to, the physical. No refigured virtual body, no matter how beautiful, will slow the death of a cyberpunk with AIDS. Even in the age of the technosocial subject, life is lived through bodies. Forgetting about the body is an old Cartesian trick, one that has unpleasant consequences for those upon whose labor the act of forgetting the body is founded— usually women and minorities."[70]

In her article about dance and virtual reality (VR), the longtime critic Jennifer Dunning quotes a Web site for the International Dance and Technology conference that asks, "could stages and studios soon be a thing of the past? Is virtual dance the future of dance?"[71] Some of the organizers of that conference characterized VR as an "extension" and a new art form, and they credit Merce Cunningham as a progenitor of the intersection of animation and dance, or more specifically human movement and theatrical space, with his computer composition program Life Forms. Leslie Hansen Kopp, the director of Preserve, discusses the necessity of archiving dance as follows: "Ten years ago the dance community discovered that it was losing two generations simultaneously, from age and AIDS, and also discovering that videotape doesn't last."[72] The desire to archive what is fleeing, fleeting, has been a problem in the field of performance studies.[73]

As Dunning states: "Dance, as inherently suggestive and metaphorical as it is physical, has always been a virtual art form to some extent. Extract the physical, though, and what do you have? As the written material

accompanying the "Ghostcatching" installation rather chillingly asked, 'What is human movement in the absence of the body?'"[74] Such is the queer art of quotation that marks the dissimulation and desire as well as ghosting. The labored process of making dance is collaborative. As in dance, language, and life, one's time is not one's own. It is, in the most profound and queer senses, borrowed, which is to say, quoted.

Sem;erot;cs ; Colon:zat:ons : Exclamat!ons ❗

A Dialogue

CAST OF CHARACTERS:
Xon (transmitter on)
YABA[1]
ZPupil (eye of a webcam)
BLP[2]

SETTING: "A hall where public meetings are usually held, a hall peopled with political echoes, the ghosts of banners. . . . It is an untenable structure, a performance straining the limits of the possible: a theoretical debate presented and set forth among intellectuals and for intellectuals on the sexuality of women. Between the audience and the stage, Italian footlights made of lights and wood: the too numerous audience, by convention, cannot intervene. It is on this point that the other spectacle will emerge: implicated yet meant to be mute, 'the audience,' essential character, will nevertheless intervene. It will speak and cause things to happen: with its own bodies and voices, by moving, shouting, upsetting the order of the other spectacle. It will cause and speak disorder in relation to the order of the debate."[3] The split stage contains three partially obscured focal points: (1) a blackboard, (2) one "old-fashioned" pull-down screen for a slide projector, and (3) another screen for images emanating from a PowerPoint projection. A table is downstage with a large pile of books on it, from which some of the characters quote passages as noted in the script (think Moises Kaufman's *Gross Indecency: The Three Trials of Oscar Wilde*), and a podium stands upstage left.[4] Spotlight on Xon, who

steps into view and begins to draw a large semicolon with white chalk on the blackboard—takes time, sensuously rendering the curve. Completes drawing by building the "point" with concentric circles until a dot appears. Turns from board and smiles coyly. Meanwhile, ZPupil has been fiddling with a slide projector—noisily trying to put slides in order, not upside down—makes mistakes and fixes them. YABA fiddles with the PowerPoint presentation, surreptitiously and intermittently superimposing images on both the blackboard and the screen set up for the slide projector. As the dialogue begins, the main characters—think of them as X, Y, Z—along with Blp are engaged in a heated discussion about varying values of three different and differently related ~~sexual organs~~ punctuation marks. Blp joins ZPupil, where they are marginalized, stage right; they sit together on the floor, and begin rolling a black ball back and forth.

YABA: "There are two different ways of thinking about colons and semicolons you can think of them as commas and as such they are purely servile or you can think of them as periods and then using them can make you feel adventurous."[5]

ZPUPIL: Where'd they come from? Are they made up or real?

YABA: Well, leaving aside the problematic aspect of the latter half of your question, I would say that the honor of having invented the semicolon probably belongs to the English nation; for from the Leyden edition of Pliny, 1553, it is evident that the Dutch printers were not then in the practice of using it; and if, in 1570, they were, Roger Ascham would probably have employed it; for the Dutch were the principal classical printers in his time; but we find that some English books were marked with it at that period. "The colon dates back to William Caxton of the fifteenth century, the first English printer, and its form has remained practically unchanged."[6]

BLP: YYSSW (-.-) Zzzz . . .[7]

XON: "There are a good many people who seem to regard the colon and the semi-colon as identical stops and who use them indiscriminately."[8]

BLP: *(To Zpupil)* WIAN[9]

XON: *(Continuing)* And yet, "The form of the two stops would certainly lead one to suppose that, by origin, the colon approximates more nearly to the full-stop and the semi-colon to the comma."[10] *(Draws them on board while speaking)* See . . . dot comma . . . rather like an appendage—a period with a supplement, an after thought to what was to be the final word, like Adam's rib. It's like adding a body to a head—attaching, hanging, appending.[11]

BLP: *B* {}[12]

YABA: There is, you know, a more precise way to calculate the differences. "If we exclude the two supernumeraries, the question mark and the exclamation mark [about which more later], as being primarily rhetorical and elocutionary, although with the caution that in their syntactical role they stand approximately on a level with—the exclamation mark slightly under, but the question mark dead-level with—the period; . . . we can then establish, with all the fallacious exactitude that characterizes a statistical table, the relative value of the points or stops or punctuation marks . . . To satisfy the typographical purism of the simplicists, the relative values of the unsupported stops may be set forth in the following merely approximate table, based upon a fundamental 10 for a period: *(Calculates/tabulates on PowerPoint screen—graph and/or statistical table)*

> parentheses- - - - - -1 or 2
> comma- - - - - - - - - -2 or 1
> dash- - - - - - - - - - - -3–5
> semicolon- - - - - - - -6
> colon- - - - - - - - - -8
> period- - - - - - - -10"[13]

ZPUPIL: According to your schema (or is that scheme?), "the 'exact value' of the individual points is arbitrary: there can be no single exact value, for every point varies in syntactical importance and in elocutionary duration according to the almost infinite potential variations of the contexts. But the relative importance, whether syntactical and logical, or elocutionary and rhetorical, is not arbitrary."[14]

YABA: Yes—and notice as well, however, that the semicolon is always less than the colon. Here by two, although it could be more depending . . . depending on one's equation.

BLP: IDGI _/[15]

YABA: Such measurements belong to those who study sadistics . . . NOT statistics. Personally, if I may use that dubious term, "I have always had a great affection for the semicolon; it has a certain discreet charm. On the other hand, there is just one word to describe the colon: bossy. A colon says: 'Pay attention, this next bit is really important.' If the colon is fanfare, the semicolon is more like a polite cough. It is a nasty shock to discover that it has enemies. Gertrude Stein, who might, in her time, have been considered a bit of a bossyboots herself, suggested that semicolons were simply commas with pretensions."[16]

XON: As a wearer of bossyboots myself (preferably well heeled and made of black patent leather—is the latter redundant?), I have to disagree. "A century ago the German poet Christian Morgenstern wrote a brilliant parody 'In Reich der Interpunktionen,' in which imperialistic semicolons are put to rout by an 'antisemikolonbund' of periods and commas."[17] I have grown fond of semicolons in recent years. The semicolon tells you that there is still some question about the preceding full sentence; something needs to be added; it reminds you sometimes of Greek usage.

YABA: Ah . . . yes, yes, I recall that "the semicolon is one of the most ancient marks of punctuation, dating back to the time of Aristophanes of Byzantium, *circa* 120 B.C."[18] In Greek, I believe that the semicolon acted as a question mark—again, we have the arbitrariness of the meaning of the form. It's in the doing—its function is not inherent, essential, but rather culturally constructed and performed. In Eritrean, three dots signify an ending, performing as does the period in English . . . (or, perhaps the ending of girlhood and entrance into [con]scripted signifiers of sexuality).

XON: Right. Heavy periods . . . that is an ad now . . . But to return to the semicolon, I think that "it is almost always a greater

pleasure to come across a semicolon than a period. The period tells you that that is that; if you didn't get all the meaning you wanted or expected, anyway you got all the writer intended to parcel out and now you have to move along. But with a semicolon there you get a pleasant little feeling of expectancy; there is more to come; read on; it will get clearer."[19]

BLP: *8((:[20]

ZPUPIL: "The things I like best in T. S. Eliot's poetry, especially in the *Four Quartets*, are the semicolons. You cannot hear them, but they are there, laying out the connections between the images and the ideas. Sometimes you get a glimpse of a semicolon coming, a few lines farther on, and it is like climbing a steep path through woods and seeing a wooden bench just at a bend in the road ahead, a place where you can expect to sit for a moment, catching your breath."[21]

XON: Oh! How pastoral! I prefer to herald semicolons' wily, femme ways. For example, "a semicolon that wants to dominate another semicolon in the same sentence must wait for the end of the sentence; and then it can act like a colon, trumping the rest; the last semicolon gets the last laugh."[22]

YABA: No, no . . . that never happens. "The Semicolon, [is] second in value . . . The word colon, from the Greek, means a limb or member; a phrase of a sentence. Semi, a Latin prefix, means half. Semicolon, then, means a half of a member; half of a phrase of a sentence."[23] And you know the value we place on halves—they are have-nots!

BLP: CDFM (:-([24]

XON: Ah, yes, of course I see your point, YABA—characterizing the semicolon as "half-wit" leaves it vulnerable in a culture that values wholeness. Less than and incomplete, in your view, the semicolon, like woman, is secondary and dependent. The semicolon is the most dismissed (dissed miss) of all punctuation marks. Made into an effeminate sign, often it appears as a kind of effete half-wit; the semicolon seems destined to be colonized by the colon: a more masculine, definitive mark. Given the fact

that, as some surmise, the semicolon was once a Greek question mark, its imagined ties to the feminine question and its corollary, the questionable feminine, seem plausible.[25] "I think the place where it could best be deciphered is in the gestural code of women's bodies. But, since their gestures are often paralyzed, or part of the masquerade, in effect, they are often difficult to 'read.' Except for what resists or subsists 'beyond.' In suffering, but also in women's laughter. And again: in what they 'dare'—do or say—when they are among themselves."[26] I ask you?

YABA: You need to give up on the laugh of the Medusa, Xon. It's not about women's bodies at all. "The semicolon is a hermaphrodite—it stands for nothing. Its only use is to show that you've been to college."[27]

ZPUPIL: Semicolon; it
makes you laugh
A kind of colon,
but only half.[28]

YABA: "The semicolon was a compromise; it served as a convenient mean between two extremes. At the end of the 15th century, the virgule (/) was used to signify a comma, and the two colon-like dots (:) were the full stop. There was nothing in between, and the ; was a suitable medium. . . . It became a very popular sign; today, however, many writers never use the semicolon at all."[29]

BLP: ;-)[30]

XON: That may be. "I do not intend to suggest a mere freshening-up of the worn semicolon face, but I would give the word 'semicolon' *some* significance in the mind of the young struggler-with-sentences. . . . Once the gradations from period down to comma went as follows: period, colon, semicolon, comma. The semicolon meant something then. But the semicolon [like woman] has taken over the function of the colon as a strong separator of independent clauses, while the colon has been relegated to the dowager formality of introducing series. Hence, with the big four now shrunk to the familiar three, why

shouldn't we take the mask off and reveal the semicolon's mid-position by significantly calling it 'semiperiod'?"[31]

ZPUPIL: Humph! That would be preferable to the "heavy periods" highlighted in that ad? *(Advertisement appears on-screen showing female figures groaning, bent over with the strain of holding up heavy periods—red dots)*

YABA: There's no doubt,
no ifs or buts:
The colon's got a
lot of guts.[32]

BLP: :-/[33]

ZPUPIL: *(Reads from Maurya Simon's book)*:

The semicolon is
Like a sperm forever frozen in its yearning towards an
ovum,
like a tadpole swimming upstream to rouse the moon's
dropped coin,

like an ooze of oil spilt from an inky bubble, the
semicolon
signifies both motion and stillness, an undulant pause, a
moment's
stalled momentum.

It must have arisen from some toiling mind concocting a
serpentine idea,
one thought hinged to another, a startled gasp between
exhalations;

it must have emerged like a comet's long tail from behind
the hulk of thought,
Isadora's scarf trailing her neck, before being pulled taut.

Surely it gives us pause, gathering up strength as it coils
its diamonds;
it waits for our minds to waiver and assemble, while it
rattles bright-

toothed seductions; it swells to fullness in fractions of
 important breath—
then strikes out silently, aimed at the heart of meaning,
 its venom art.[34]

These days the semicolon, one of the least loved, least under-
stood punctuation marks, barely ekes out a living between the
period and the comma. It suffers nightmares from its precari-
ous situation. [On screen is an exceprt from "A Semicolon's
Dream Journal" that reads: "I dreamed I was blind and couldn't
see if there was a conjunctive adverb. Then I had a nightmare
about tatty motel room in the middle of a brutal desert, where
'the beds are chap and occasionally feature little black periods
and semicolons that reveal themselves to be hungry bedbugs,'
just as in THE DEVIL'S HIGHWAY by Luis Alberto Urrea.
I woke up scratching. I remember now that the room didn't
have cable either."[35]]

XON: "Theodor Haecker was rightfully alarmed by the fact that the
 semicolon is dying out; this told him that no one can write
 a period, a sentence containing several balanced clauses, any
 more. Part of this incapacity is the fear of page-long para-
 graphs, a fear created by the marketplace—by the consumer
 who does not want to tax himself and to whom first editors
 and then writers accommodated for the sake of their incomes,
 until finally they invented ideologies for their own accommo-
 dation, like lucidity, objectivity, and concise precision. Lan-
 guage and subject matter cannot be kept separate in this pro-
 cess. The sacrifice of the period leaves the idea short of breath.
 Prose is reduced to the 'protocol sentence,' the darling of the
 logical positivists, to a mere recording of facts, and when syn-
 tax and punctuation relinquish the right to articulate and shape
 the facts, to critique them, language is getting ready to capitu-
 late to what merely exists, even before thought has time to
 perform this capitulation eagerly on its own for the second
 time. It starts with the loss of the semicolon; it ends with the
 ratification of imbecility by a reasonableness purged of all ad-
 mixtures."[36]

YABA: "Visually, the semicolon looks like a drooping moustache; I

am even more aware of its gamey taste."[37] (*YABA leers at Xon, licks lips loudly and then smirks*)

XON: Look, we're arguing about style, not taste.

ZPUPIL: I want to pause for a moment to discuss the semi-colon in the play *W;T* by Margaret Edson. Remember, we went to see it that spring in New York—before the HBO version. The play stages punctuation as grave matter, not merely an engraved matter. The climactic exchange explicates the drama's title—which appears on the playbill as well. The exchange occurs between the play's protagonist, Vivian Bearing, a professor of English with terminal cancer, and E. M. Ashford, her former teacher. The topic is John Donne's *Holy Sonnet Six*.

E.M.: Do you think the punctuation of the last line of this sonnet is merely an insignificant detail? . . . [The sonnet] is ultimately about overcoming the seemingly insuperable barriers separating life, death, and eternal life. In the edition you chose, this profoundly simple meaning is sacrificed to hysterical punctuation:

> And Death—*capital D*—shall be no more—*semi-colon*!
> Death—*capital D*—*comma*—thou shalt die—*exclamation point*!

[She compares another edition, noting] Gardner is a *scholar*. [Her edition] reads: "And death shall be no more, *comma*, Death thou shalt die." [As she recites this line, she makes a little gesture at the comma.] Nothing but a breath—a comma—separates life from life everlasting. It is very simple really. With the original punctuation restored, death is no longer something to act out on a stage, with exclamation points. It's a comma, pause. . . . Not insuperable barriers, not semicolons, just a comma.

VIVIAN: Life, death . . . I see. *(Standing.)* It's a metaphysical conceit. It's wit![38]

XON: *(Stepping into spotlight to deliver monologue)* Yes, I remember that moment in the play when the pupil concedes that her professor has confounded her by opening the boundaries among litera-

ture, life, art, and death. Her epiphany helps her to endure death's slow sentence, which makes each of us a period, by focusing instead on the semicolon, the "dot-comma" to borrow Mieke Bal's pun.³⁹ I really thought that it was most pedantic. I mean, what is the "authentic" version of a text anyway? Geez. Bal suggests, in a subsection called "The Sense of Not-Ending," that "the overall erotic effect of the painting [David Reed's *#275*] is enhanced here by an increased level of sensuality that is almost 'metasensuous,' enfolding the eye and holding it a bit longer so the experience of time surfaces into consciousness. One of the signs that makes this portion stand out is the small dot next to the curl that bleeds over into the lower, orange-toned band of the work. This dot looks like a comma. It seems significant that this dot-comma, ending the single, largest, densest, and thickest set of folds in the painting, is the only place where any of the waves and folds seem to have an ending; yet, this ending takes the shape of a sign that, in writing, signifies not-ending, a sign that there is more to come. And this linguistic non-ending is visually represented by the crossing of the line next to the comma. The line of colors, the line of the sentence, the line formed by the fold: the fragility of infinity is enacted here."⁴⁰

YABA: I don't get that at all. That painting has nothing to do with the great tradition of Caravaggio. The mere suggestion is preposterous.

XON: Well, my dear, that is precisely Bal's point—about space and time . . . not that you have read her work. "The *work* of art, not as object but as effect, is not to be confined to the surface or skin, nor to one person or hand, but instead, initiates an interaction that comes to full deployment in this grander fold, where the work envelopes the 'you' that constitutes it. As the end that only underscores endlessness, the dot-comma embodies the Barthesian punctum that pricks so that the viewer bleeds, leaving a stain on the subjectivity thus produced. This comma inscribes, then, yet another event in the encounter with the work, signaling narrativity in its wake."⁴¹

XON: Do you remember we read that section of *Camera Lucida* in

class—and we discussed his (mis)reading of the Van der Zee photo—he claims to have been haunted, actually "pricked" by a detail, the *punctum*. At first Barthes thinks he remembers the black patent Mary Janes, then he remembers the white pearl necklace like the one his mother had worn. . . . Later, he realizes that the *punctum* is "no longer of form but intensity is Time"; but ironically Barthes perhaps thought or knew more about Van der Zee's technical trick—his incorporation of dead images than he realized. Van der Zee portraits mixed the living and the dead, substance and shadow *(photo on screen)*. The experience of this aspect of the *punctum* may have been present (presented) to him earlier . . . though he could say or see nothing about it.

ZPUPIL: The semicolon is not an ending but rather a pause that signifies that there is more to come. Remember W;t!

XON: I'd like to move from *wit* to *Wet*—Mira Schor's book. . . . Schor writes of her book as part of a larger inquiry into language in the book's final section, "Afterword: Painting and Language/Painting Language." *(Xon holds up the book)* In this autobiographical essay, Schor explains that her purpose is "to literally embed the gap between visual and verbal languages within each other's materiality and meaning."[42] She discusses the mixed media of paint and language in which "strangely, the more [she] want[s] to only 'paint paint' the more [she is] tied to language as [her] image and [her] conceptual anchor" (213). Her oil painting *Light Flesh*, also called *Slit of Paint* (1994), serves as the cover of her book of collected essays: *Wet: On Painting, Feminism, and Art Culture* (1997). The work, thick with impasto even in its two-dimensional photographic reproduction, represents a semicolon floating in the center of what appears to be a vaginal opening. The taupe-colored semicolon contrasts with the blood-red "interior" at the heart/center/vital organ space of the image. The painting blends realism and conceptual art in a wonderfully ironic and witty way. With its cream-colored edges that mimic labia at first glance, a viewer might miss the distinct punctuation that lies at the center of the image. The thick surface of the image calls for an erotics

of touch as much as visual pleasure. This is not a smooth slick surface upon which one's eyes glide, but rather one in which the viscous goo makes one stop and think (twice) about its impact. Look, see here, when I open the front cover of the book, just after the white half-title page, bearing, on the right-hand side, the main title *WET* rendered in bold capitals (no subtitle), the second page contains yet another representation of Schor's work, this time shot in a wider angle and in black and white. In this expanded view, we see the dark edges leading to the center of enlightenment—the semicolon just to the left of the inner margins of the book's binding. (This in contrast with Foucault's reading of Magritte's painting *La trahison des images* with the phrase "Ceci n'est pas une pipe," painted as handwritten script, not print!) Indeed, Schor has commented (in response to sexist remarks about men's biological capacity for painting) that "it is in fact precisely this intersection of visuality, sexuality, and manual impulse that makes [her] a painter" (167). Why, Schor goes so far as to recommend that in order to perceive painting, the optical process must be bolstered by the sense of touch (172). Like the sonic gaze of punctuation, Schor might say, painting hails our visceral gaze by engaging our senses as sensations making analphabetic symbols such as the semicolon sensuous and sensible. The sense of touch is important perhaps because it is as yet another remove from verbal language than the merely optical (172). Here, punctuation hails not only our "sonic" gaze but our full-body response. "I would lay claim both to being polymorphously perverse, because after all why shouldn't *painting* benefit from the input of more than one sense, and also to having the very same body part, connecting my optic nerve and my hand to my sexuality, especially if sexuality is defined as not just the province of genital intercourse but as a profound life/death drive" (167).

Ultimately, Schor wants to champion the feminine "goo" that comprises the language of paint. Inspired by her mother's mezuzahs, in which the Hebrew appeared to Schor as purely visual given that she did not read Hebrew, she notes that "language takes on its deepest meaning . . . at the level of its appearance as an aesthetic image. . . . Language has been an

Figure 16. Mira Schor, *Slit of Paint*, 1994. Oil on canvas, 12″ × 16″; jacket cover for *Wet: On Painting, Feminism, and Art Culture*, Duke University Press, 1997. Reproduced with permission of the artist.

important visual and conceptual element in my own work in different ways, which repeat the graph of my writing: personal (pre-theory), polemic (political content and the visual appearance of theory language), and, most recently, language as self-referential sign (post-theory)" (210). When Schor was coeditor, with Susan Bee, of the journal *M/E/A/N/I/N/G* (1986–1996), she instituted a paradoxical policy of no illustrations (the journal was after all, a forum for art and artists). "How could a publication for artists, by artists, and about visual art function without images? The very daring oddness of the choice gave the journal a notorious novelty, but the effect was to emphasize the artists' voices and perspectives, to call attention to the materiality of different writing styles and characters. The variety of voices created the verbal 'texture' of the publication, instead

of editing each piece toward a house style or homogenized and general editorial tone."[43]

Schor comments further that language served as a still-life element for [her] paintings. "Painting text led to painting punctuation marks, especially the semicolon seen as the true G-spot: these paintings imagined a gynecological examination in which it would be discovered that there was language in there! (212). Like Carolee Schneemann's performance piece *Interior Scroll*, Schor seeks to invert and revise the Western f/phallacy of the dark continent. For those of you who know Schneemann's "scrolls" this is a similar idea—that rather than being the inscrutable dark continent, there is language in there! I here want to make a case, along with Schor, not for vagina monologues, but rather Vagina Dialogues. What interests me about this statement is the way it revises the concept of body and language, of the deep connection between gestus and punctum. In a sense, Schor returns us to older technologies of handwriting and to embodied text. As she states: "Language has been an important visual and conceptual element in my own work in different ways, which repeat the graph of my writing" (211). In *War Freize* 1991–94, "the language was no longer that of the secret diary or an obsessional love letter . . . it was public, often appropriated from the news, such as the phrase 'Area of Denial' which was a type of weapon used during the Gulf War. . . . In these paintings I used the careful cursive script in which I was taught to write at the Lycée. I chose this rather than the ubiquitous helvetica font of media culture because I had cathected to the physical and aesthetic pleasure of writing out a letter . . . putting my weight into a thicker downstroke, lifting my wrist for a delicate upstroke" (212). It resembles rendering the human form graphically as punctuation. The strokes themselves bear the mark of their human origin. This concept of personal software of her own script. We are familiar again with the stylus and abbreviations, if not the translation from manuscript to print technology, from the proliferation of the "palm pilot." As Schor further notes: "My use of language as image reflects the degree to which I was immersed in theoretical texts at the time: so many words were intercut with slashes (virgules) or parentheses in order to reveal their ideological

underpinnings. In a sense, 'the language' served as a still-life element for my paintings" (212).

ZPUPIL: The mapping of human bodies onto written marks has its origins in the anthropomorphism of the alphabet discussed by Jeff Masten. It seems that, as Adorno states, "the less punctuation marks, taken in isolation, convey meaning or expression and the more they constitute the opposite pole in language to names, the more each of them acquires a definitive physiognomic status of its own, an expression of its own, which cannot be separated from its syntactic function but is by no means exhausted by it."[44] *(Artschwager punctuation marks start to move and dance—the top of several exclamation and question marks start to swing from the rafters to which they are attached and the "ball" points begin to roll dangerously across the stage. The dots in the* Up and Across *installation become uninstalled and plop off their horizontal staging.)*

YABA: "For Heidegger, even the colon can place a call. In fact, the call is made at a point of disconnection that cites and recites itself in the cleavage between word and thing."[45]

ZPUPIL: *(Flipping pages furiously)* From Stephan George's poem "The Word,"

So I renounced and sadly see:
Where word breaks off no thing may be.

YABA: Heidegger reads the switchboard effect of the colon, which connects disconnectedly what is seen to break off. The colon, Heidegger writes, "names the call to enter into that relation between thing and word which has now been experienced."[46] "In German, the word for 'colon' is *Doppelpunkt*, the doubling structure of the hearing and saying which inhabit the call,"[47] the nature of language:

The being of language:
The language of being.

Two phrases *held apart* by a colon.

XON: The colon acts as a "hinge." It makes all the difference for complicated phrases such as lesbian: writing.

YABA: "Exclamation marks have the same difficulty [as question marks] and also quotation marks, they are unnecessary, they are ugly, they spoil the line of the writing or the printing and anyway what is the use, if you do not know that a question is a question what is the use of its being a question. . . . When I first began writing I found it simply impossible to use question marks and quotation marks and exclamation points and now anybody sees it that way. Perhaps some day they will see it some other way but now at any rate anybody can and does see it that way. So there are the uninteresting things in punctuation uninteresting in a way that is perfectly obvious, and so we do not have to go any farther into that."[48] "We have tried to convey the tone of voice, cadence and emphasis of a protest by the use of an exclamation mark and a question mark (but this is very jejune). Punctuation, italics, and word order may help, but they are rather crude."[49]

BLP: DLG ;->[50]

YABA: "So now to come to the real question of punctuation, periods, commas, colons, semi-colons and capitals and small letters. I have had a long and complicated life with these. Let us begin with these I use the least first and these are colons and semi-colons, one might add to these commas. When I first began writing, I felt that writing should go on, I still do feel that it should go on but when I first began writing I was completely possessed by the necessity that writing should go on and if writing should go on what had colons and semi-colons to do with it, what had commas to do with it, what had periods to do with it what had small letters and capitals to do with it to do with writing going on which was at that time the most profound need I had in connection with writing. What had colons and semi-colons to do with it what had commas to do with it what had periods to do with it."[51]

(All characters leave the stage. Punctuation continues to hang from the ceiling. After an uncomfortably long pause, the characters return.)

ZPUPIL: "Exclamation-mark or exclamation-point. This mark consists of a short line at the top, that tapers like a billiard-cue, and a

period directly under it. It is called, for short, an *exclam*, a *bang*, and a *screamer*. This mark is said to have been formed from the Latin *Io*, joy." He renders the mark *I* over *o* on the board.[52]

XON: "An exclamation point looks like an index finger raised in warning."[53]

BLP: BFD:-W[54]

ZPUPIL: Known in British English (which apparently is distinct from global English as well as American English) as a "screamer," this mark would seem to be a performative with illocutionary force.[55] When encountered, audiences almost invariably react—widening their eyes, raising an eyebrow, skipping a heartbeat, rushing in (to the text) to help. We see the exclamation point hopping its dance, its action and appearance are in effect one—performing in a singular gesture the "unity of the *gramme* . . . [the] attempt to recapture the unity of gesture and speech, of body and language [given that its body is its language]."

XON: The exclamation point certainly solicits a reaction from an addressee. It can be an element of surprise, pain, fear, or anger (all affective states). "Aura tells its name: it tells us to shut up and listen. To the exclamation point."[56] It is, however, resolutely emotional. The exclamation point is an amplifier; it pumps up the (visceral) volume. This helps to explain the following sentence: "The hydrogen bomb is history's exclamation point. It ends an age-long sentence of manifest violence."[57]

ZPUPIL: I'm glad to see that you do not shy away from explosive material! Ironically, flying back from Nagasaki I once met a woman from a Seattle firm named Axiom Architecture—their logo is an exclamation point.

YABA: My high school in Washington state, Richland to be exact—used a mushroom cloud and exclamation mark as our mascot—"the bombers." My dad and his cronies came up with that one when they were doing the Manhattan Project up at the Hanford Nuclear Reservation to help in the war effort. Most of the teams have that mushroom cloud as the logo—but not football, baseball, or track.[58] She explained to me that "just as

there are nuances to the spoken word which cannot be captured simply in the letters which make it up, there are nuances to the experience of buildings as environments. [Their] approach to architectural design focuses on experiential meaning. Just as a sequence of letters and words on a page can fire the imagination with ideas and images, so too can the sequence of architectural spaces and forms build one upon the other to convey a unique experience. The lady claimed that they shouted out from the rooftops, "every Axiom design is punctuated by an architectural exclamation point: to let you know that we mean it!"

YABA: For me, the saying, "Less is more" rings true in the case of exclamation marks. One will suffice for almost any occasion, and forming a small army of exclamation marks to attack your reader with excruciating force is entirely unnecessary. Another appropriate analogy would be the boy who cried exclamation mark. If you use it all the time then people will begin to realize that you really don't have anything to exclaim. They will probably assume you have become addicted to their use and can't stop. One of the worst cases I have ever seen of exclamation excess was in the greeting from a personal ad. Every single sentence ended with an exclamation mark. One would think that generally, people want to make a good impression, but shouldn't that be even more true in a personal ad? What kind of person has so much exuberance bubbling from them that everything they say is an exclamation? Perhaps I am overly sensitive to our friend the exclamation mark. Perhaps he really likes to be with his friends. Perhaps exclamation marks get scared of being all alone amidst all the letters since most offenders don't bother to end sentences with any punctuation at all if they're not using an exclamation mark. If this is the case, I must advise you that the exclamation mark is a sick and twisted creature indeed. As a final remark about this serious problem rampant in our society today, I have provided an example of an e-mail, followed by a version revised to be less exclamatory. The red text is incorrect. Green text is what I revised [shown on screen].

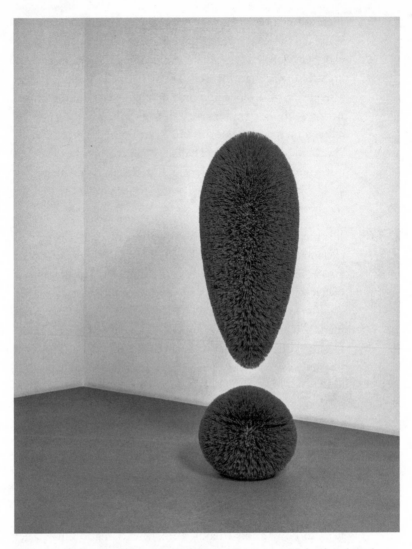

Figure 17. Richard Artschwager, *Exclamation Point*, 1995. Nylon bristle and wood, 122 × 45.5 × 45.5 cm. Private collection, Xavier Hufkens Gallery, Brussels.

ZPUPIL: Use an **exclamation point** [!] at the end of an emphatic dec-
laration, **interjection**, or command.

> "No!" he yelled. "Do it now!"

An exclamation mark may be used to close questions that are
meant to convey extreme emotion, as in

> "What on earth are you doing! Stop!"

XON: An exclamation mark will often accompany mimetically pro-
duced sounds, as in

> "All night long, the dogs *woof*! in my neighbor's yard."

BLP: -!-!-! __!⁵⁹

XON: I've noticed that in academic prose, an exclamation point is
used rarely, if at all, and in newspaper writing the exclama-
tion point is virtually nonexistent. It's too showy. I'll have to
look again at what Seth Leher says about how the seriousness
of academic prose developed. Maybe the punctuation mark
"un point d'ironie" that was proposed by the writer Alcanter
de Brahm (1868–1942) would be useful in academic prose, or
the mark serving the same purpose and called an "interabang"
that was introduced by the American Type Founders Com-
pany could supercede the use of italics and/or quotations.⁶⁰

YABA: "Exclamation points, gestures of authority with which the
writer tries to impose an emphasis external to the matter itself,
have become intolerable, which the *sforzato*, the musical coun-
terpart of the exclamation point, is as indispensable today as
it was in Beethoven's time, when it marked the incursion of
the subjective will into the musical fabric. Exclamation points,
however, have degenerated into usurpers of authority, asser-
tions of importance. It was exclamation points, incidentally,
that gave German Expressionism its graphic form. Their pro-
liferation was both a protest against convention and a symp-
tom of the inability to alter the structure of language from
within; language was attacked from outside instead. Exclama-
tion points survive as tokens of the disjunction between idea
and realization in that period, and their impotent evocation re-
deems them in memory: a desperate written gesture that yearns

in vain to transcend language. Expressionism was consumed in the flames of that gesture; it used exclamation points to vouch for its effect, and it went up in smoke along with them. Seen in German Expressionist texts today, they look like the multiple zeros on the banknotes printed during German inflation."[61]

ZPUPIL: "In every punctuation mark thoughtfully avoided, writing pays homage to the sound it suppresses."[62]

YABA: Did you see the United Church of Christ's new campaign slogan? It features a slogan that—believe it or not—is from Gracie Allen. *(On-screen is seen)* "Never place a period where God has placed a comma. God is still speaking." That's their Web site, stillspeaking.com. The banner only costs $124 or maybe $99 for the smaller version.

ZPUPIL: That reminds me of a poem by Nancy Lee Couto, "The Punctuation of the Creation as Seen from the Ellipsis." I remember one stanza that goes something like,

> In the beginning was the sentence
> harsh
> unappealable
> aimed at the abruptness
> of the ultimate halting period
> softened by semicolons
> colons and commas
> but aimed
> always aimed
> at the period[63]

XON: Yes. "Even the good old comma continues to evolve: it was flipped upside down and turned into the quotation mark circa 1714, and a woman I knew in college punctuated her letters with home-made comma-shapes made out of photographs of side-flopping male genitals that she had cut out of *Playgirl*"[64] like Yayoi Kusama!

YABA: "Punctuation marks are like signals given by football referees. Everyone in the stadium cannot hear the referee call 'offside,' but they can see the signal. We cannot hear the writer, but we can see that the comma means that he wants us to pause. Just

as the referees cannot make up their own signals, so the writer must use the 'standard' signals of punctuation if he is to be understood."[65] That's what I tell my students: a good clean analogy they can follow.

XON: Leave it to you to get us to God . . . and football.

BLP: GGN2DWI[66]

(In a sudden flash of light accompanied by a loud noise, like a computer being unplugged, characters vanish from the stage. Moments later, we see remnants of an explosion. ZPupil begins sweeping up. A broken computer screen flashes the following symbols: X-(.[67])

Post \ Script: Cyberpunktuations?

Digitalization is just the most recent step in the abridging tactic of language. So language survives digitalization easily because it has already traveled most of the way there.

—David Bergsland, *Printing in a Digital World*

Smileys are global travelers.

—David Sanderson, *Smileys*

The character Blp featured in chapter 5 serves as a prompt for thinking about the profound impact that the combinations of punctuation marks known as "smileys" or "emoticons" have had on our culture and thought. No doubt there is some irony in the fact that the new languages of "smileys" and text messaging have created a market for printed dictionaries and pocket books on the topic, in conjunction with the proliferation of Web site indexes and "keys" to their usage. Here, I point out that we still rely upon the culture of the book to guide us in the navigation of new technologies.

Smileys are figures at once hieroglyphic, pictographic, and resolutely—often in high resolution—visual. They too are part of the "image-text" that is again predominate in our era.[1] They call on us to be cyber literate—to learn to read codes conveyed electronically, digitally, and in a new way. Specifically, smileys require that those of us who are habituated to reading horizontally from left to right, or in Hebrew from right to left, or even vertically, must reorient ourselves so that we can read "sideways" or even backwards. Smileys supplement our reading habits and open up new possibilities for perceiving signs. These new habits of mind and body (did you tilt your head, or merely change your mind in order to read them?) bespeak new movements—literally and philosophically (and

here I am thinking of Susan Foster's recent work aligning points of view and questions of colonial sympathy in her comparison of seventeenth-century narratives about the Lisbon earthquake).[2] Such figures require different bodily orientations—they have material effect and, of course, affect, given that they represent intonation and are meant to mimic moving forms of affect. It becomes increasingly difficult but not impossible to discern when punctuation functions in its primary role when it is used simultaneously with smileys (which have punctuation performing another "secondary" role). Smileys or emoticons efface and effect (as in perform) facial features and hand gestures. :-) A new generation of smileys has appeared on the scene and NetLingo is fast trying to track them down. We consider these "straight-on smileys" as another form of ASCII art: those in which you do not tilt your head but rather look at it straight on, such as @(*o*)@ for a koala. The layouts used by sites that feature emoticons are modeled on magazines and/or graphic symbols for printers—such as those of generic stereotyped slaves that Marcus Wood discusses in his book, *Blind Memory*.[3]

Combining punctuation on a keyboard, one can render nuns, priests, frowns, policeman, concepts, insults—the list is virtually endless (pun intended). These emotive types might be read as direct descendents of Darwin's early study on emotion as well as Lavater's "types" or, later, Lombroso's criminal profiles. Indeed, several of the books that show different smileys categorize and display them as examples of different "faces." A question that we might ask about how to read these new forms is how do we use punctuation marks qua punctuation with smileys that are made of punctuation? Because smileys often appear at the conclusion of sentences (like German verbs) they seem to be distinct from punctuation that is retrospectively "proper." We have unwittingly become skilled at understanding the difference between the syntactical uses of punctuation and the iconic use of smileys to represent ideas visually. Thus the "same" marks perform variously in our new modes of writing and reading. We will need more research to figure out exactly in what ways such a new code has caught on—taken hold—and transformed our understanding of punctuation. Certainly, however, the rapid incorporation of these new ways of reading can be seen in the ongoing work of our screen culture and increasingly digital, virtual environments.

David Sanderson's 1993 book of over 650 emoticons was billed by the *Wall Street Journal* as the "Noah Webster of Smileys." The book defines a smiley as "a sequence of ordinary characters you can find on your com-

puter keyboard. . . . If you don't see that it represents a smiling face, tip your head to the left and look at it again. The colon represents the eyes, the dash represents the nose, and the right parenthesis represents the (smiling) mouth. . . . Another term for smileys is 'emoticons,' which presumably means icons representing emotions. . . . The smiley usually follows after the punctuation mark at the end of a sentence. . . . A smiley tells someone what you really mean when you make an offhand remark."[4] As I noted in the introduction, punctuation marks have borne the affect and emotion in much of Western print culture. Sanderson's definition again makes the link between punctuation and embodiment explicit. Note, in particular, how he describes the need to imaginatively/mentally turn your head sideways in order to read smileys. This movement is culturally if not linguistically determined.

In contrast, smileys in Japan are read vertically. This is a significant shift in value from previous uses of punctuation as grammar. A Web site of smileys hails its readers by stating: "If you want to use them in your e-mail, simply copy and paste them!" Such offers further signal the desire and opportunity for the global circulation of these emotive characters and for the unauthored, unauthorized borrowing that promotes current compositions.[5]

When I type a colon, a dash, and a parenthesis it renders these marks as a "smiley." This trademark icon has been programmed to appear as a face rather than as a sequence of punctuation marks. In a mock attempt to query the value of the entire enterprise, the back-cover copy of Sanderson's book questions, "Are smileys the creative expression of a high-tech culture? Or are they an aberration that reduces human writing to soulless shorthand of silly symbols? Who really cares? ;-)." Why, cultural critics and linguists, of course! I am fascinated by the phenomenon, the cultural practice of the new rendering/rendition of punctuation marks. How do they convey information? How are our feelings inscribed in them? How can we characterize our relation(s) in computer-mediated communication (CMC)?

In the October 2002 issue of the journal *PMLA*, John Mowitt asks "what is a text today?" in his essay by the same title. His critical commentary questions the object status of the text as the "latest rage of the teen age," a practice some call "texting"—a new global, mobile technological means that telegraphically and instantly sends "cryptic" signs over cellular phones. Indeed, there is a new market in selling language guides or "dictionaries" (not style or rule books) of this new language/speech. "Since

much of what is texted involves intercourse (meetings, dates, quickies, deals, etc.)—in effect, the marking of matter by drive—the link between the Talkabout T900 and Freud's mystic writing pad becomes virtually irresistible. Significantly, the structure of a texted message is radically plural: everything from the digitally organized display to the chip-operated mechanism to the bounced trajectory of the signal to the urban distribution of senders and receivers, whose bodies are fully subject to prosthetic enhancement and fetishization."[6] The ubiquity of the cell phone, long preferred in "third world" countries for its relatively reliable reception and ease of "installation," moves many a contemporary plot forward. The incorporation of txt and smileys has crossed over into filmic and photographic representations. Thus, punctuation continues to perform and reform our understanding of (post)modernity, subjectivity, and to signify the styled. As such, punctuation marks are ineluctably, and I would add increasingly, part of our everyday lived environment. This book suggests that, as in the past, the matter of punctuation will continue to effect our affect.

Punctuation plays a key role in Miranda July's smart and lyrical film *Me and You and Everyone We Know* (2005).[7] Two characters from the ensemble cast are the Swersey brothers—Peter is a teenager and Robby is a young child. It is Peter who utters the film's title as he explains to his younger sibling that the pattern of punctuation he has printed out from their computer is "me and you and everyone we know." This scene, which occurs toward the end of the film, recalls an earlier one from the opening sequence in which Peter and Robby together use a program to make a representation of a black-and-white tiger on their screen by using different punctuation marks. In the opening scene, as the boys are shown sitting at the computer together, Robby supplements the movement of his brother's hands with spoken words: he says "space space dash" as Peter keys in the directions to make the picture. The boys' father asks "Is that a tiger?" They answer nonchalantly, saying "I guess so."

In both scenes, the camera zooms in to give the film audience an extreme close-up of a page full of periods, semicolons, commas, and dashes. At one point in the second scene, Peter points to a comma and explains to Robby that the comma represents a person lying down, that the semicolons are people walking, the periods are people "seen from above, from the sky," and he indicates with his index finger two seemingly random dots that become, as he states "me, you and everyone we know." These punctuation marks gesture toward a recalibration of our perspective on

embodiment. So, too, it is in keeping with what could be misread as a vaguely humanist impulse to see punctuation personified.

As an artist in/of the digital age, July is more careful to juxtapose what are images of inscription and embodiment; the film knowingly patterns the glowing "afterlife" of life's death. Connecting the dots, Peter underscores an ethic of the film: relationship by any means necessary (is it an updated, online version of *Howard's End* "Only connect"?). Although the marks are machine made they are domestic and local, produced in the boys' bedroom of the family's ramshackle rental. Restoring order, momentarily, to their chaotic and changed life (they live with their white father who is separating from their black mother) the sheet is a mark of their resourcefulness, creativity, technological savvy, and their will to order as well as existence. The Kusama-esque mode (specifically that of her film *Self-Obliteration*, discussed in chapter 1) of lingering on various orbs—a glowing orange-red sun speckling a car windshield—helps the audience read the film's aesthetic universe that treats such "natural" and "technological" forms as equivalents. A department store comes up on the cell phone as "M + F STORE"—the cell phone screen is one of many screens featured in the feature. Others include store windows, car windshields, windowpanes, TV sets, and movie projector screens.

No longer caught in the binary between the natural and unnatural, July's film reveals instead a world of surface and sensuality, frame and flesh, desire and proximity, or perhaps of surfaced sensuality, framed flesh, and desired proximity. Her erotic subjects revel in queer acts. For example, little Sylvie who prematurely stocks her "hope chest, *trousseau* in French," is a closet fetishist prone to sniffing brand-new pink plastic shower curtains and fondling "classic" kitchen items such as a hand-held blender (all purchased with her own money). The father's colleague, also a neighbor, flirts with a character named Heather and other teenage girls who enjoy flirting back—an aura not of exploitation but rather exploration as the girls solicit him first and feel very much "in control" of the rules and the discourse. An air of innocence pervades all the sexual scenes in what appears to be contradistinction to the labels mentioned in the script: child killer, pedophile, pervert—these terms no less than those also mentioned, such as "citizen" and person, seem inept and inaccurate. July offers a new, queer take on ideas of sexual citizenship exemplified in legal discourse by concepts such as the age of consent.

In one of the most original and funny episodes in the film (which like

Figure 18. Still from Miranda July, *Me and You and Everyone We Know*, 2005.

the coeval film *Crash* connects or collects a disparate people into a multi-culti mixed community in Los Angeles), the brothers are online in a real-time chat room writing under the "NightWarrior" mantle/handle. The "real time" "TALK" (as the program is called) dialogue begins typically for such esx: "How's your bosom?" Peter types. He must define the word for Robby, and then he explains that "it's probably a man." Aware of their own masquerade, he adds "we have to sound like a man." The users here, while presumed to be (white) men, are mixed children and woman—so the premise of performance and/as mimicry is enacted in the exchange, simulating and emulating codes of manliness, the boys improvise a response.

Peter tells Robby that "everyone just pretends." Robby retorts, sure of his hermeneutic skill: "I think it's a woman—I can tell." In this scene, the audience is positioned as voyeur—placed behind (even though in front of the screen) the characters, surveying their discourse (as the Internet itself is a site for oversight by Homeland Security and other agencies). Then, the younger brother contributes the following: spoken and then typed on screen by Peter, his amanuensis.

Robby: "You poop into my butt hole and I poop into your butt hole . . . back and forth . . . forever."

Robby: "Ask her if she likes baloney." [This is a hilarious comment in part because baloney is a synonym for "fakery."] "I want to poop into your butt hole and then you pass it back, the same poop back and forth. Forever."

There is a long pause as the boys wait for the response from "untitled." Peter worries that the correspondent will think that they are "a crazy perverted person." Finally, the response comes (pun intended). "You are making me very hot." Such a heated reception to Robby's scatological improvisation suggests that it is not nonsense after all (as Peter feared it would be), or that if it is at least it produced the desired effect.

Later, Robby, who has increasingly come to be a privileged figure in the film, sits at a computer in a public library. Unmonitored at the monitor, he is engaged in an online dialogue with Untitled.

> Untitled: Are you touching yourself?
> NightWarrior: [The camera pans from Robby's point of view as he looks down at fingertips that are touching on edge of table. He types in his answer] Yes.

Robby's writing betrays the labor it takes for him to compose his messages. Cleverly, he cuts and pastes text such as the multisyllabic word "remember" into his responses. It is a reference to the "poop" in their previous encounter. Robby picks up a pencil that is on the table and begins to draw an illustration of the "butts and poop" on a yellow legal style notepad. The handdrawn text is an abstract line drawing—two curves that look like a human (ungendered?) bottom and an enormous oblong-shaped "poop." He then renders/translates the drawing into punctuation marks:))<>((. Untitled does not read his meaning, and types, "Huh?" Then Robby, as his avatar name "NightWarrior," translates again: "back and forth." Untitled proposes that they meet offline in the park the next day; it is Nancy Harrington, the curator at the Center for Contemporary Art who writes under the mantle/handle/avatar? "Untitled," who finally meets Robby in person on a bench at Laurelhearst Park.

The typographical rendition))<>((of the two "butts"—actively passing poop back and forth. Forever.—becomes the cyber-graphic emblazoned on a banner for a major museum exhibit entitled "Digital Technology." This exhibit replaces the "Shock and Awe: Images of War, 1996–2005," which is curated by Nancy, who, as noted above, turns out to be the correspondent of the young boy. In a scene in which Nancy and her assistant view slides for a potential show on digital communication, the curator seeks submissions that are explicitly "now"; or rather, as she states as their standard of value, "What does it tell us about digital culture? What is contemporary about the graphic—What shows us that it could only have been produced in the digital age?" Robby's logo is readily

Figures 19 and 20. Stills from Miranda July, *Me and You and Everyone We Know*, 2005.

anthropomorphized as a sexualized and political sign—as a visual image that tells a story in its own right/write.

The unacknowledged appropriation follows a repeating pattern of (white) American appropriation—an ongoing narrative of co-opting black creativity (the brothers, as noted, are "black" while Harrington is white, and therefore the scenario replicates the long history of black art becoming the uncredited basis for mainstream popular and high culture—think of the Nicholas Brothers and Fred Astaire among many many others). Nancy is "untitled"—a term with much resonance: she is entitled, but "untitled" to the production of (black/child) labor. The class narrative—culture comes from below—is made into Art in the space of the museum context.

The audience of museum goers sees Robby's uncredited icon move from the more privatized screen to the enormous public banner on the side of the museum. When the two characters meet offline ("in person" seems outdated) as arranged online, their moment is tender and touching. With the two seated on a park bench (vestiges again of the nineteenth-century reordering of sacred space—the public park and the museum sought to redefine noble activity, even as the park after dark became a central space of trysting), the scene is rife with touching . . . erotic desire—Robby's small brown fingers gently touch Nancy's silky straight brown hair, moving her hair behind her ear (an update on an oft-repeated scenario). In (re)turn, she leans over awkwardly to kiss him, just barely missing his lips and he hers—in the liminal crease between the beginning of his cheek and end of his smile. That space that one day, with age, will become a laugh line—those parentheses that frame the mouth (~). After kissing him, she collects her bag and walks off into the background in a medium shot. In the foreground, Robby's back faces us as he kneels, all of us watching Nancy walk into the distance/future.[8]

The queer erotics of the scene are poignant rather than perverse. The scene receives one of the film's biggest laughs—that laugh of recognition (as) surprise. The event is at once absurd and profound. What they share is most intimate—something akin to "forever" or the "always" that passes between Toni Morrison's characters Shadrack and Sula (who represent yet another disparate, desperate "couple"). One could read the scene in many ways: perhaps, for example, Robby misses a maternal presence (he has asked his older brother Peter in the middle of their first exchange with untitled/Nancy: Where's Mom?).

As the film narrative moves forward to its ending, Robby's sleep is

interrupted repeatedly. In the twilight he hears a constant, steady tapping. When he inquires, his mother tells him: "It's the lights coming on. They are run by a giant computer." During the film's denouement, Robby wanders out of the house, following the sound, and ends up on the corner of his street where a commuter, a man dressed in a suit and tie, waits for the early morning bus. As he does so, he rhythmically taps a coin against the metal pole of the street corner sign. When Robby asks him, plaintively, "What are you doing?" the man answers, "Just passing the time." This phrase demonstrates how time is socially constructed and culturally marked by/with a beat, a gesture, the rhythm of punctuation. The bus rolls onto the screen and just before he boards, the man turns and gives Robby the coin. The reddish glow of the morning sun burnishes the young boy's exquisite, cherubic face. He begins to tap the coin in a rapid even beat—a consistent or rather insistent machine—like motion and sound. The metal post rings in this penultimate shot. Cut to the radiant orange sun. Music rises from the beat. Blackout. Credits. The final shot showing the rising sun is ambiguous—dawn, like dusk, makes things unclear.

Black-and-white mesh on-screen pixels. The punctuation provides texture and a "hook" in the visual and thematic (not to mention technological) sense. The punctuation marks in the film transmogrify before our eyes into "you, me and everyone we know." It is significant that it is Peter who provides a perspective on the page: he says that it is all of us as "seen from above," and thus again he invokes a truly global perspective that changes scale, like Kusama's view of all of us as polka dots. The pixilated personas materialized by Peter's perspicacious perspective are not proper pronouns: they appear and then disintegrate at the interactive interface of punctuation's art, politics, and play.

<p style="text-align:center">))<>((</p>

One need only look around to realize that they are everywhere: they are in the sky; they are scrawled in spray paint on city walls; they are found in the empty center of fruit-filled cookies; they are woven in fabric; we handle them as we enter a converted loft building; we sit on question mark benches as we ponder our thoughts; we type them on screens and encounter them in galleries; we wear them on earlobes, fingers, and necks; we pencil them in margins; we color them in books. . . . At times, they appear as a series of bright white headlights speeding toward us along an otherwise pitch-black freeway. At other times and places, they

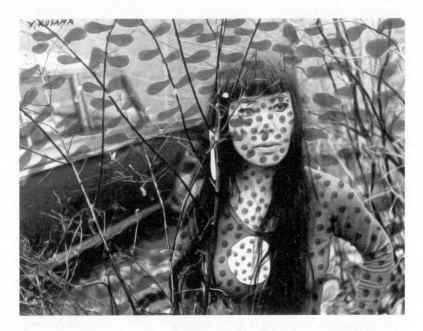

Figure 21. Yayoi Kusama, *Self Obliteration*, 1967. Black-and-white photograph with ink, 19 × 24 cm. Kusama Studio.

Figure 22. Chao & Eero Jewel, *Exclamation Ring*, 2004. Photograph by Chao-Hsien Kuo.

Figure 23. Richard Artschwager, *Untitled (Quotation Marks)*, 2002. Rubberized horsehair. Collection of the artist.

dance and jangle as if on a movie screen of our memory (depending on who we are and where we may have been—perhaps in the crow's nest of a 1930s segregated theater, where they guide our eyes to sing along, part of the horizontal scroll of text), or perhaps we remember them lined up momentarily like dangled prisms of sunlight making blind spots on an otherwise clear window.

Let's experiment one last time. Close your eyes and gently, gently press your hands to your eyelids for a moment. Did they appear, like a mystery, before your very eyes? The DOTS? Certain forms touch us, and we touch them. We may learn to recognize the core/corps relationship of such elements that we too often take for granted. Dots, like punctuation marks, are one such integral part of our quotidian experience, and increasingly so as we read pixels as they are screened on our phones and in our habitats, as they proliferate and transform environments, politically performing "me, you, and everyone. . . ."

Notes

For(e)thought

1 For the descriptivist versus prescriptivist debate I have relied upon Deborah Cameron's book *Verbal Hygiene* (see pp. 5–8 in particular). "Truss" refers to Lynne Truss who wrote the best-seller *Eats, Shoots and Leaves: The Zero Tolerance Approach to Punctuation*.

2 This language comes from Anna Scott's call for a conference at the University of California, Riverside. See also Elkins, *Visual Studies*.

3 Richard Artschwager, personal correspondence with the author, August 19, 2004.

4 Harold Herd, *Everybody's Guide to Punctuation* (1925), quoted in Partridge, *You Have a Point There*, 5.

5 Quoted in Spivak, *A Critique of Postcolonial Reason*, 428.

6 Benjamin, *Illuminations*, 10.

7 I italicize this term as it is meant to evoke Eve Sedgwick's book of the same name.

8 See Greene, *The Trouble with Ownership*. See also Jeff Masten's work, *Textual Intercourse: Collaboration, Authorship and Sexualities in Renaissance Drama*.

9 Cappon, *Guide to Punctuation*, 1.

10 Truman Capote, *The Paris Review Interviews*, vol. 1, 39.

11 See Mercer, "Black Hair/Style Politics."

12 See Graf, "Gestures and Conventions."

13 Bremmer and Roodenburg, *A Cultural History of Gesture*, 6. My work has been informed as well by Elin Diamond's explication of Brechtian *gestus* in her *Unmaking Mimesis*, 52–55; more specifically, her formulation of the "not . . . but" made (as in much of Derrida's work) with punctuation as a key figure to the concept. We can see then how punctuation is performative—how it is constitutive of and "does" and "makes" material figurations. Quintilian extends Cicero's work. See Quintilian's *Institutio Oratoria*, trans. H. E. Butler. Loeb Classic Library. Cambridge: Harvard University Press, 1984.

14 Ronell, *The Telephone Book*, 8.

15 Goldberg, *Writing Matter*, 311.

16 Ronell, *The Telephone Book*, 184.

17 "Up and across" refers to the title of a piece by Richard Artschwager.

18 Goldberg, *Writing Matter*, 313.

19 Victor Borge had a routine in which he performed sounds as punctuation marks.

20 See Garber, " " " (Quotation Marks)," 13.

21 Pollock, "Performing Writing," 83.

22 Partridge, *You Have a Point There*, 93.

23 Coleridge, *The Complete Poems*, 422. I am grateful to Reginald Gibbons for bringing this essay to my attention. For more on Coleridge's lectures during this period, see Holmes, *Coleridge*.

24 In addition to Gates, see Judy, *(Dis)Forming the American Canon*.

25 For more on economics and slavery, see Baucom's *Specters of the Atlantic*, especially his discussion of the sublime on pp. 253–58.

26 On the talking book and "speakerly text," see Gates, *The Signifying Monkey*.

27 Truss, *Eats, Shoots and Leaves*.

28 Crystal, *The Cambridge Encyclopedia of Language*, 169. The cover of this text shows two sets of quotation marks as purely graphic forms.

29 We might read/think of punctuation as a kind of "secret agency," a term I cite from Tom Cohen's discussion of Hitchcock's *Secret Agent* (1936) in which he argues, "the title . . . is a kind of mnemonic trace, neither living nor dead, void of semantic content yet that on which all switchboard relays or translation or even visibility (reading) seem to rest" (Cohen, *Material Events*, 116).

30 *Chronicle of Higher Education*, August 17, 2001, A12.

31 Ross, *Oreo*, 12.

32 Kushner, *Homebody/Kabul*, 12–13.

33 Bringhurst, *The Elements of Typographic Style*, 89.

34 Nanette Twine's essay "The Adoption of Punctuation in Japanese Script," which addresses the adoption of Western-style punctuation in the late-nineteenth-century Japanese script kanji, reasons that the modernist novelists of the Meiji era viewed punctuation as marks of modernization if not (Western) modernity that were both democratic and timely, thus conscripting modern Japanese script to be up to date.

35 Bringhurst, *The Elements of Typographic Style*, 84.

36 Edwards, "Louis Armstrong and the Syntax of Scat," 645.

37 See Auerbach, *Ellen Terry*.

38 *The Chicago Manual of Style*, 14th ed., 158.

39 North, *The Dialect of Modernism*, 14.

40 Cha, *Dictee*, 1.

41 See Bhabha, "Colonial Mimicry."

42 Cheng, *The Melancholy of Race*, 140.

43 Speaking of facilitating corrections, one of several letters written to me from

the State Corrections facility in Huntington, Pennsylvania, about my use of the ellipsis in Ellison's *Invisible Man* (see chapter 2) stated: "I am curious [about] your interpretation of what was unspoken, spoken, inferred, laid out, assumed. Curious to find if and or how you might relate the concept of invisibility to the ellipsis." The article was well received. Indeed, my correspondent's "reaction" included a page of an advertisement for Kenneth Cole's cologne, named "Reaction," that was defaced with handwriting and punctuation that read: "Reaction? ---very impressive!" The ad itself is a black box on a gray background. Personal correspondence to the author from inmate EP0065, February 17, 2006, and April 7, 2006.

44 Derrida, "Ellipsis," 294 and M. B. Parkes, *Pause and Effect*.

45 This may be yet another example of the way in which my "prose is straining to become iconic." See Bolter, "Ekphrasis, Virtual Reality, and the Future of Writing," 259.

46 Exhibited at the spring 2002 exhibit, "Richard Artschwager: The Hydraulic Door Check. Sculpture, Painting, Drawing," at MAK in Vienna.

47 In 1994 the critic Arthur Danto noted that this work, "fabricated, like brushes, of metal bristles, raises a question in the very shape of the question mark. For the bristles render vague the boundaries of the forms they constitute, and so the work, which is a question, raises questions about itself" (quoted in Noever, *Richard Artschwager*, 175).

48 Kliege, "Challenge to Looking," 62.

49 Richard Artschwager notebook, quoted in *Up and Across*, 67.

50 Artschwager quoted in Corrin, "Artschwager's Way," 64. This is now easier given that one can design one's own fonts!

51 Artschwager quoted in Kliege, "Challenge to Looking," 64.

52 Corrin, Lisa G., "Artschwager's Way," 11.

53 Ibid., 11.

54 See Jean, *Writing the Story of Alphabets and Scripts*.

55 Baron, *From Alphabet to Email*, 167. I concur with much of Baron's argument, particularly her sense that "punctuation has become increasingly rhetorical in character, though the nature of this rhetorical function differs . . . from its earlier role in orally re-presenting written texts" (167).

56 Judy, *(Dis)Forming the American Canon*, 266

57 For more on the early uses of the typewriter, see Kittler, *Gramophone, Film, Typewriter*.

58 Monette, "3275."

1. Smutty Daubings

1 Miller, *Dimensional Typography*, 7.

2 Here I am riffing on the title of the AIDS activist group ACT-UP (AIDS Coalition to Unleash Power).

3 Fleming, *Graffiti and the Writing Arts of Early Modern England*, 134.

4 The archive on work by and about Kusama continues to expand. Popular in the United States since she first arrived in New York in the late 1950s, she had her heyday in the following decade as a coeval of Andy Warhol, and a fellow traveler in various international schools of artists such as the Dutch NUL. Following her return to Japan in the early 1970s there has been a pronounced resurgence of interest in her work, not only in Japan and the United States but throughout the world. This interest was marked by a major retrospective of her oeuvre, entitled "Love Forever," mounted in New York and Los Angeles in 1998 (see the catalogue for this show: *Love Forever: Yayoi Kusama, 1958–1968*). Kusama was one of the first performance artists as well. (On Warhol, see Doyle, Flatley, and Muñoz, *Pop Out*.)

5 Kusama's temporary work is closer to graffiti in its transgression and temporary temporality. She was pointedly not a tattoo artist interested in permanence.

6 Gombrich, *Art and Illusion*, 259. Also see Crary's *Techniques of the Observer*.

7 Hooke's name remains somewhat obscure, perhaps because he had a major row with his colleague Isaac Newton. "Yet Hooke was perhaps the single greatest experimental scientist of the seventeenth century. His interests knew no bounds, ranging from physics and astronomy, to chemistry, biology, and geology, to architecture and naval technology; he collaborated or corresponded with scientists as diverse as Christian Huygens, Christopher Wren, Robert Boyle, and Isaac Newton. Among other accomplishments, he invented the universal joint, the iris diaphragm, and an early prototype of the respirator; invented the anchor escapement and the balance spring, which made more accurate clocks possible; served as Chief Surveyor and helped rebuild London after the Great Fire of 1666; worked out the correct theory of combustion; devised an equation describing elasticity that is still used today ('Hooke's Law'); assisted Robert Boyle in studying the physics of gases; invented or improved meteorological instruments such as the barometer, anemometer, and hygrometer; and so on. He was the type of scientist that was then called a *virtuoso*— able to contribute findings of major importance in any field of science. It is not surprising that he made important contributions to biology and to paleontology" (Jardine, *The Curious Life of Robert Hooke*, 174). Hooke's ingenuity and capacious intellect seems congruent with Kusama's multitude of talents and range of interests. For more on Hooke, see Fournier, *The Fabric of Life*.

8 Recent biographies of Hooke include Inwood, *The Man Who Knew Too Much*; Jardine, *The Curious Life of Robert Hooke*; and Jardine et al., eds., *London's Leonardo*.

9 See Johns, *The Nature of the Book*, 428, 429.

10 Hooke quoted in Johns, 431.

11 Bringhurst, *The Elements of Typographical Style*, 23.

12 Johns, *The Nature of the Book*, 430.

13 Ibid., 430–31.

14 Hooke quoted in Johns, 431. See also Elizabeth Spiller, *Science, Reading and Renaissance Literature*.

15 Fournier, *The Fabric of Life*, 188.

16 Kusama even claimed that Warhol copied her after viewing one of her accumulation exhibits in the early 1960s. She appeared on New York's Channel 13 in December 1965 with Warhol, Lichtenstein, Bontecou, Segal, and Marisol. For a good overview of the era, one that includes Kusama (albeit in a section on artists in Japan), see the exhibition catalogue *Out of Actions: Between Performance and the Object, 1949–1979*. For more on happenings see Michael Kirby, *Happenings: An Illustrated Anthology*. London: Sidgwick and Jackson, 1965 and Allan Kaprow, *Essays on the Blurring of Art and Life*. Berkeley: University of California Press, 1993.

17 Kusama's official Web site is www.yayoi-kusama.jp and can be accessed in both Japanese and English. My reading of Kusama's work, which will not discuss her poetry or fiction (some of which has been translated into English), is limited by the fact that I do not know her "native tongue." Kusama's use of English, her adopted tongue, is clear from her deft puns and cagey answers to questions. Listen to an interview with Robert Murdock from December 22, 1966 at http://collections.walkerart.org/item/archive/14. For more on the 1960s scene, see Banes, *Greenwich Village 1963*. Baz Kershaw also writes well of the period; see his *The Politics of Performance: Radical Theatre as Cultural Intervention*.

18 Miller, *Dimensional Typography*, 7.

19 Jack S. Blanton Museum of Art Archive, University of Texas, Austin.

20 April 24, 1969 interview regarding the opening of Kusama's fashion boutique at 404 Sixth Avenue. Jack S. Blanton Museum of Art Archive, University of Texas, Austin. Many of the sources in the Blanton Archive are reproduced in Kusama, *Yayoi Kusama*, 2002.

21 For more on the art scene in this period, see Banes, *Greenwich Village 1963*; Crow, *The Rise of the Sixties*; Fried and Greenberg, "Avant-Garde and Kitsch."

22 Kusama, "Struggles and Wandering of My Soul," 2.

23 See Brooks Adams and Alexandra Muroe, "Proliferating Obsessions," 228–33 in *Art in America*; Laura Hoptman et al., *Yayoi Kusama*; and Takemi Kuresawa, "An Unwritten Biography," *Art Asia Pacific*, 68–76.

24 Van Starrex, "Kusama and Her Naked Happenings," *Mr.* August 1968, 41.

25 See Snead, "Repetition as a Figure of Black Culture"; see also Moten, *In the Break*.

26 Sedgwick, *Touching Feeling*, 16.

27 Judd quoted in Solomon, "Dot dot dot: Yayoi Kusama," *Artforum*, February 1997, 71.

28 Halberstam, *In a Queer Time and Place*, 120.

29 Cheng, *In Other Los Angeleses*, 80.

30 Kusama is writing in the era when revolutionary political groups such as the

Black Panthers and the Weather Underground were active, although she is a pacifist who advocated "love not war." Such flyers also redo the earlier DADA Feminist Manifesto by Mina Loy and others. See Martin Puchner, *Poetry of the Revolution*.

31 The August 1969 Naked Orgy Performance in the Garden of the Museum of Modern Art exemplifies Kusama's philosophy of the body. This "Grand Orgy to Awaken the Dead at the MOMA" claimed that

> At the museum you can take off your clothes in good company:
> RENOIR
> MAILLOL
> GIACOMETTI
> PICASSO
> I positively guarantee that these characters will all be present and that all will be in the nude.*
> *Sociological note: The nude has become socially acceptable among the more permanent residents of the garden of the museum. Phalli are also *a la mode*, particularly the harder varieties in granite, basalt, and bronze.

32 See Mercer, "1968: Periodizing Politics and Identity," 287–308.

33 Kusama's work prefigures the work discussed by Richard Meyer, who has done so much to remember gay and lesbian art. In particular, see his recent essay "Gay Power circa 1970: Visual Strategies for Sexual Revolution." In the visual images accompanying this article, excessive exclamation points, multiple nude bodies, and feminized "curlique" fonts abound.

34 Van Starrex, "Kusama and Her Naked Happenings," *Mr*. August 1968, 41.

35 Kusama, "Struggles and Wandering of My Soul," 2.

36 *Self-Obliteration* (1967 [16mm, optical sound, 23 minutes]) won the Fourth International Experimental Film Competition held in Belgium in 1968. It also won second prize at the 1968 Ann Arbor Film Festival and was selected for the New American Filmmakers Series at the Whitney Museum of American Art, among other awards.

37 Press comments collected by Jud Yalkut. Private communication sent in 2003.

38 Schneemann quoted in Schneider, *The Explicit Body in Performance*, 34.

39 I acknowledge Fred Moten's reevaluation of this era and area that critiques accounts of "white hipsterism" (see Moten, "'Round the Five Spot," in *In the Break*, 149).

40 Dixon, "Performativity in the 1960s American Experimental Cinema," 48.

41 Richards quoted in "An Accumulation of Things Happening: An Interview with Charles Rowell," 1003–4.

42 Kusama, "Struggles and Wandering of My Soul," 3.

43 Howard Junker, "Theater of the Nude," 104.

44 The troupe staged a happening, "Bored with the Board" to protest the 1968

elections. Held at the Board of Elections on November 3, Kusama sought to spread the "naked truth" about the candidates by asking, "How do Nixon, Humphrey and Wallace look with their pants down?" Typewritten communiqué dated November 1968. Jack S. Blanton Museum of Art Archive.

45 See Schneider, *The Explicit Body in Performance*.

46 John Gruen, "Vogue's Spotlight: The Underground Anatomic Explosions. Polka Dots for Love," *Vogue*, October 1968, 17.

47 J. Roach, *IT*, 127.

48 Miller, *Dimensional Typography*, 3–7.

49 Van Starrex, "Kusama and Her Naked Happenings," *Mr.*, August 1968, 39.

50 There is an interesting paper to be written comparing Ono's "Cut Piece" where she let an audience cut clothes from her body and Kusama's happenings and fashion designs. Ono was an admirer of Kusama's work.

51 Meyer, "Gay Power circa 1970," 454.

52 Artschwager had his first one-man show in February 1965, after having participated the previous year in a group show that included Andy Warhol and Frank Stella among others. For more on Artschwager's relationship to the 1960s arts scene, see Stein, "Art's Wager." Artschwager's "Authochronology" reveals, in the third person, a sense of his art, times, and his values. It should be noted that this is a living piece that continues to transform.

53 Artschwager quoted in dialogue with Claes Oldenburg, first published in *Craft Horizon*, September/October 1965, 28–30.

54 Donald Judd, "Specific Objects" (1965), quoted in Stiles and Peter, eds. *Theories and Documents of Contemporary Art*, 114.

55 Noever, *Richard Artschwager*, 14.

56 The term comes from a French journalist who reviewed Seurat's work. See Herbert, *Seurat and the Making of La Grande Jatte*.

57 Kusama, "Struggles and Wandering of My Soul," 6.

58 Bryson, "Cultural Studies and Dance History," 68.

59 Solomon, "Dot dot dot: Yayoi Kusama," 71.

60 Her performances from this vantage point seem "avant-garde" and prescient. For more on the topic of homosexual marriage, see Freeman, *The Wedding Complex*; Lisa Duggan's Web site "Beyond Marriage" (http://www.beyondmarriage.org); and Chauncey, *Why Marriage?*, 2004.

61 "Open Letter To My Hero, Richard Nixon," Jack S. Blanton Museum of Art Archive, University of Texas, Austin.

62 Digable Planets, *Rebirth of Slick (I'm Cool Like That), Reachin': A New Refutation of Time and Space*, Warner Records, 1992.

63 Hollander and Weber, *Words for Images*, 80.

64 See Morrison, *Playing in the Dark*.

65 Anonymous typescript memo, dated October 1968. Jack S. Blanton Museum of Art Archive, University of Texas, Austin.

66 Tyler, "Death Masks," 122.

67 Gibson, "www.periodchallengeshyphen.com." A1.

68 Harvey, *Spaces of Capital*. See also work by Saskia Sassen, Deborah Massey, and Gayatri Spivak.

69 See Spivak, *A Critique of Postcolonial Reason: Toward a History of the Vanishing Present*.

70 Miller, *Dimensional Typography*, 1.

71 We remember as well that the "period" is a metonym for menstruation, which is marked in cycles.

72 Herrnstein-Smith, *Poetic Closure*, 2.

73 See ibid.

74 This question is at the heart of the right-to-die movement as well.

2. Belaboring the Point . . .

1 See, for example, Hammond, "The Noisy Comma."

2 Kushner, *Homebody/Kabul*, 5. Significantly, the Homebody's monologue that takes place during act 1 is all about reading and speaking. Not only does the play open with this character reading from a guidebook, but later she self-consciously proclaims: "I speak . . . I can't help myself. Elliptically. Discursively. I've read too many books, and that's not boasting, for I haven't read *many* books, but I've read too many. . . . So my diction, my syntax, well, it's so *irritating*, I apologize, I do, it's very hard, I know. To listen. I blame it on the books, how else to explain it?" (12–13). While the generically named Homebody theorizes her idiosyncratic way of speaking as one that has been influenced by printed matter, Ralph Ellison's Invisible Man has a different problem: he struggles to articulate in writing the influence of music and vernacular speech. One final note, although Kushner lays out the rules for reading his text, he deviates from them immediately.

3 McLuhan and Fiore, *The Medium Is the Massage*, 117.

4 See Taylor, *The Archive and the Repetoire*, especially 16–29.

5 Bullins, *The Theme Is Blackness*, 84.

6 Moten, *In the Break*, 74.

7 I take much of my understanding of typography from Johanna Drucker. In *The Visible Word* she writes: "Typography renders apparent the relative, rather than the absolute, value of symbolic systems. No easy closure on signification is available in typographically experimental work. . . . Material specificity enters into the final sum of semantic and symbolic value which collapses the planes of *imago* and *logos* in an uncomfortable and disturbing blend of presentational and referential modes which displace the fictive categories of presence and absence" (245–46). See also Bringhurst, *The Elements of Typographic Style*; and Peters, *Theatre of the Book, 1480–1880*.

8 Indeed, a similar idea occurs in Miranda July's lovely film *Me and You and Everyone We Know* (2005). For it is the "biracial" black brothers who recog-

nize themselves in the computer printout—black punctuation marks on a white page—and voice the title of the film as I discuss in the postscript to this book.

9 Here I follow Alex Weheliye who, in his *Phonographies: Grooves in Sonic Afro-Modernity*, points out that too many critics of Ellison's work read the blues as opposed to its technological transfer. A search of "Ellison and theater" yields few results: instead, the voluminous (and often luminous) scholarship on Ellison's life and published works looks to related genres such as folklore, ritual, myth, history, and music—especially the blues and jazz. How, then, might we approach this conjunction? To begin, we can turn to the continually shifting biographical record where we learn that as a young man growing up in Oklahoma, Ellison knew Ida Clark, the personal assistant of the established theatrical grande dame, Emma Bunting. As was customary during the decades of Jim Crow segregation, traveling black workers roomed with black families. "During the late 1920s, the Ellisons were privileged to host an unusual houseguest. A black woman from England named Clark would come and stay at the Ellison household during the theater runs of Emma Bunting's company. . . . As Bunting's personal maid, Miss Clark had access to the exciting world of professional theater. . . . Clark introduced an unfamiliar accent and speech pattern into the house and delighted Ralph with her own rendition of high society theatrics. . . . She showed him how blacks might fit into the world of Shakespeare and Big Ben, places that Ralph might have been inclined to imagine himself excluded from" (Jackson, *Ralph Ellison*, 69).

10 Ellison, *Invisible Man*, 7. Subsequent citations to *Invisible Man* are given parenthetically in the text.

11 Rebecca Schneider, "Archives Performance Remains," 106.

12 Jones, "Jazz Prosodies," 71.

13 Blount, "The Preacherly Text," 583.

14 Yukins, "An 'Artful Juxtaposition on the Page,'" 1248.

15 Irwin, "A Bugler of Words," 110.

16 Ellison to Albert Murray, January 24, 1950, in Ellison, *Trading Twelves*, 8.

17 O'Meally, *The Craft of Ralph Ellison*, 7.

18 *American Masters Series: Ralph Ellison: An American Journey*, directed by Aaron Kirkland, PBS, 2002.

19 Although the PBS documentary was the first to dramatize scenes from his magnum opus *Invisible Man*, regrettably the director chose to render the scenes in a hyperrealist style that flattens Ellison's dramatic text.

20 Birdoff, *The World's Greatest Hit*.

21 See Mackey, "Other: From Noun to Verb."

22 Ellison quoted by O'Meally, introduction to *New Essays on Invisible Man*, 11.

23 Crystal, *The Cambridge Encyclopedia of Language*, 70.

24 Cubilié, *Women Witnessing Terror*, 172.

25 See Moten, *In the Break*, 71.

26 Richards, "The Halle Berry One Two," 1013.

27 Richards, "'An Accumulation of Things Happening,'" 1008.

28 Ibid., 1005.

29 Rowell, "'Words Don't Go There,'" 965.

30 We recall from the introduction that Avital Ronell in *The Telephone Book* suggests that "punctuation hails our sonic gaze"—a phrase that perfectly captures Ellison's problematic as theorized in *Invisible Man*.

31 See, for example, Amiri Baraka/LeRoi Jones, *Blues People*; Robert Ferris Thompson, *Flash of the Spirit*; Houston H. Baker Jr., *Blues Ideology and African American Culture*; John Callahan, *In the African American Grain*; Aldon Nielson, *Black Chant*; and Fred Moten, *In the Break*. For a reading of queerness in Ellison's text, see Ferguson, *Aberrations of Blackness*.

32 Bal, *Quoting Carravaggio*, 197.

33 Julien, "Black Is, Black Ain't," 255.

34 Bal, *Quoting Carravaggio*, 202.

35 Here we might also think of Hortense Spillers's "Mama's Baby, Papa's Maybe: An American Grammar Book."

36 Blount, "The Preacherly Text."

37 Benston, *Performing Blackness*, 9.

38 There is a joke that changes the yoke of racist humor. The not/joke is a retort and goes as follows: "What is black and white and red and floating down the river? "A white man telling nigger jokes."

39 Edwards, "Louis Armstrong and the Syntax of Scat," 647.

40 Edwards, "Louis Armstrong and the Syntax of Scat," 648–49.

41 Merchant, *The Syntax of Silence*, 64.

42 Weheliye, *Phonographies*, 2005, 27.

43 Here we might think of Peter Stallybrass's work in *The Cultural Studies Reader* on Renaissance conceptualizations of the term "individual," which was once synonymous with the term "indivisible." See Stallybrass, *The Cultural Studies Reader*.

44 The term "complete multiple" is the title of a 1991 catalogue of Richard Artschwager's work.

45 Ellison, "The Little Man at Chechaw Station," 503.

46 Partridge, *You Have a Point There*, 9.

47 The writer Machado de Assis provides examples of two different types of elliptical performance in his prescient nineteenth-century novel *The Posthumous Memoirs of Bras Cubas*, 90–91. The author was a typesetter, a self-taught man-of-letters, and a translator.

48 Merchant, *The Syntax of Silence*, 1.

49 Eric Partridge's parsing of the term is a means of opening up what will be my more detailed discussion of Ellison. Partridge defines "dots" (to use his British locution for ellipsis) in a section tellingly entitled "'Twopence Coloured': Compound Points or Multiple Punctuation; Plurality of Dots." The twopence

coloured refers to hand-colored prints sold from the Punch and Judy theaters, thus connecting the term not only to commodity culture, but also more significantly to the coterminus nineteeth-century practice of blackface minstrelsy, which is the quintessential form that figures the mimicked relation of performing blackness. See also Robert Louis Stevenson's essay "Penny Plain and Two-Pence Coloured." The archive of work on minstrelsy includes Robert Toll, *Blacking Up*; Eric Lott, *Love and Theft*; Saidiya Hartman, *Scenes of Subjection*; and Hatch, McNamara, and Bean, *Inside the Minstrel Mask*.

50 Paul Klee redacted in Phelan, "Warhol: Performances of Death in America," 225.

51 Roach, *Cities of the Dead*, 6.

52 DuBois, *The Souls of Black Folk*, xli.

53 Hill, *After Whiteness*, 26.

54 Ibid., 67.

55 See Elam and Alexander, *Colored Contradictions*. The title comes from the last line of George C. Wolfe's play *The Colored Museum*.

56 Johnson, *Appropriating Blackness*, 42.

57 See Charles Mills's discussion in *Blackness Visible*. Mills's work is described by the *Library Journal* as "a take-off on Ralph Ellison's *Invisible Man*, in which Ellison graphically portrayed the American black person as systematically obliterated from society's consciousness." Other essays appear in the special summer 2003 issue of *boundary 2*, edited by Ronald Judy, titled "Ralph Ellison: The Next Fifty Years."

58 Partridge, *You Have a Point There*, 84.

59 Moten, *In the Break*, 68.

60 Partridge, *You Have a Point There*, 85.

61 Cheng, *The Melancholy of Race*, 132.

62 See Masten, Vickers, and Stallybrass's *Language Machines: Technologies of Literary and Cultural Production*.

63 Tempo was also a kind of coin currency in nineteenth-century Japan. In the *O.E.D.* the term tempo resides among related terms such as temper, tempera, temperamental, temperature, temperance, tempest, and temple. All seem to have a role to play in Ellison's elucidation of the blackness of blackness. The main root, however, is attributed to a Latin source, "tempus," meaning time. The first if rare definition listed is "the timing of an attack in fencing so that one's opponent is within reach." Second, tempo is a musical term signifying "relative speed or rate of movement; pace, time; the speed at which music for a dance is or should be played." Thus, I think it is felicitous (pace Austin) that Ellison's preface to the preaching mentions "flamenco." Finally, tempo can refer to "the rate of motion or activity (of someone or something)." The temporal, unlike the sacred, is secular time. Temporal: "Belonging or relating to a particular time or period; of passing interest, ephemeral." Metaphysically speaking, what is temporary is "occurring or existing in time, not from eternity."

64 Strunk and White, *The Elements of Style*, 82.

65 See Snead, "Repetition as a Figure of Black Culture."

66 It should come as no surprise, then, that Strunk and White's *Elements of Style*, which was written in the same era as *Invisible Man*, deems subcultural style (pace Dick Hebdige) dangerous, primitive, native, and by extension "black." They write:

> The young writer will be drawn at every turn toward eccentricities in language. He will hear the beat of new vocabularies, the exciting rhythms of special segments of his society, each speaking a language of its own. All of us come under the spell of these unsettling drums; the problem for the beginner is to listen to them, learn the words, feel the vibrations, and not be carried away.
>
> Youth invariably speaks to youth in a tongue of his own devising: *he renovates the language with a wild vigor, as he would a basement apartment.* [emphasis added] By the time this paragraph sees print, *uptight, ripoff, rap, dude, vibes, copout*, and *funky* will be the words of yesteryear. . . . more appropriate to conversation than composition." (81–82)

Importantly, Ellison's entire opus belies the impossibility of this prediction. Moreover, Strunk and White unwittingly prove Ellison's understanding of the profound influences of blackness on American race relations. It is precisely the blackness in whiteness that composes American culture. For more on Sancho, see *Ignatius Sancho: An African Man of Letters*, in King, et al., 1997, 45–73.

3. Hyphen-Nations

1 See *Tillotsons Style Book for Type Composition*, 2nd ed. (1949).

2 For more on postnational discussions of American identity, see Pease and Wiegman, *The Futures of American Studies*.

3 Partridge, *You Have a Point There*, 134.

4 In this it may share something with the hymen as discussed by Jacques Derrida in "The Double Session." In French, the hyphen is called a *tiret* or *trait d'union*—both terms together express the hyphen's contradictory function. See Finch-Crisp, *The Printers' Universal Book of Reference and Every-Hour Office Companion*, 28.

5 See the use of the hyphen on the first page of Rudyard Kipling's *Kim* and throughout Salman Rushdie's *The Satanic Verses*, both of which I discuss in my book *Impossible Purities*.

6 Partridge, *You Have a Point There*, 14.

7 Ibid., 138.

8 Sassen, "Spatialities and Temporalities of the Global," 264, 265.

9 It should come as little surprise that *The Satanic Verses* glories in hyphenations of this sort.

10 See DeVinne, *The Practice of Typography, Correct Composition*, 244.

11 Theodore Roosevelt quoted in *Immigration and Americanization*, 29.

12 Strunk and White, *The Elements of Style*, 35. In 1959 when E. B. White revised William Strunk's text, White became the nation's expert on grammar. White won a Pulitzer Prize and a Presidential Medal of Freedom for his contributions to American literary culture.

13 Hyphens are not the only punctuation marks destined to disappear. Sometimes apostrophes do as well. For example, two venerable British institutions, namely Harrod's department store and Lloyd's bank, became, at the turn of the last century, Harrods and Lloyds, respectively. Around the same time, in 1891, the U.S. Board of Geographic Names called for an end to possessive place names.

14 Here we might recall Bakhtin's distinction between "closed" and "open" bodies.

15 Lang, "Strunk, White, and Grammar as Morality," 15.

16 Cameron, *Verbal Hygiene*, 68.

17 Lauren Berlant might call this an example of "hygienic governmentality" (Berlant, "The Face of America and the State of Emergency," 175).

18 United States Government Printing Office Board, *United States Government Printing Office Style Manual*, 73.

19 Much nationalistic discourse focuses on the need to strengthen "traditional" family forms in which women are subordinate and revered only as bearers of future generations.

20 Mackey, *Discrepant Engagement*, 98.

21 Sollors, *Beyond Ethnicity*, 151.

22 Many African American children and arguably other disenfranchised groups creatively deform the pledge; rather than repeating the proper closing, "With liberty and justice for all," these everyday subverters (my mother among them), utter, "With liberty and justice for *some*." The challenge to delete the un-original (pun intended) phrase "one nation under God" (which was added to the pledge in the 1950s) went before the Ninth Circuit court in 2004.

23 Spivak, "More on Power/Knowledge," 35.

24 Schlesinger, *The Disuniting of America*, 138.

25 See Spillers, "Notes on an Alternative Model: Neither/Nor," 183. Jack Forbes might modify Spillers's phrase to read: (native)Americans becoming Africans in the new world (see Forbes's excellent volume *Black Africans and Native Americans*).

26 See *Time* 142, no. 21, fall 1993.

27 Boorstin quoted in Tad Szulc, "The Greatest Danger We Face," *Parade Magazine*, July 25, 1993, 4. According to the *OED*, the term "un-American" entered the language in 1818 in a protest against the importation of "foreign" Italian marble. Thus, from its early usage, the phrase un-American has been directed against the importation of "others." Other key uses include the infamous Mc-

Carthy hearings on Un-American activities, and in the wake of the Patriot Act the term has seen a resurgence.

28 Boorstin, "A Conscience-Wracked Nation," 24.

29 Quoted September 10, 2002, on *ABC News with Peter Jennings*.

30 Boorstin, "A Conscience-Wracked Nation," 5.

31 See Woodward, *A History of the South. Volume 9: Origins of the New South: 1877–1913*, 334–35.

32 For more on the paradoxes of slave maternity, see Spillers, "Mama's Baby, Papa's Maybe."

33 Boorstin, "A Conscience-Wracked Nation," 24. At a 1987 press conference, Jesse Jackson announced his preference for this moniker. See Martin, "From Negro to Black to African American; Stuckey, *Slave Culture*; and Benston, "I Yam What I Am." It should not be presumed that only Boorstin is critical of this nomenclature. Indeed, many so-called African Americans use other signifiers or alternate among identificatory terms. Ronald A.T. Judy understands the Negro "as a trope . . . [marking a shift] from complex matrices of power to comprehensible categories of 'natural' difference. The overbearing motif of this occultation is the exclusion of the African from the space of Western history and the marginal inclusion of the Negro as negativity" (Judy, *(Dis)Forming the American Canon: African-Arabic Slave Narratives and the Vernacular*, 94).

34 Roach, "Mardi Gras Indians and Others," 467–68.

35 I refer here to the 1967 Supreme Court case that decriminalized marriage between whites and blacks (miscegenation) in the United States.

36 "The Nation; An Appeal Beyond Race," *New York Times*, August 2004, 2.

37 Other metaphors include mosaic, salad, and gumbo.

38 San Juan, *Racial Formations/Critical Transformations*, 131.

39 In a discussion of white supremacy and anti-abortion activism, Peggy Phelan notes that "the visibly pregnant woman embodies the literal swelling of [the] proliferating hyphen. This is why she is . . . an unresolved figure which Law continually recalculates. . . . Is she a double subject or a half-subject? (Who controls the other half?)" (*Unmarked*, 171). Deborah Grayson in *Mediating Intimacy* complicates this division in her intriguing reading of surrogate mothers and the law in which the labor is divided between carriers and conceivers.

40 Boorstin, "A Conscience-Wracked Nation," 24.

41 Safire, "On Language," *New York Times Magazine*, June 21, 1992, 12.

42 We should not lose the analogy with that other global merger phenomenon— namely, multinational corporations. Both merger practices reflect the survivors' need to become one, and consistently to drop ungainly/unprofitable parts that threaten the whole. Daimler-Chrysler is a good example.

43 Freeman, *The Wedding Complex*, xv-vi.

44 Barrett, "McGreevey Nationality Invalid," www.nationalist.org (13 August 2004).

45 McQuain, "Blending In," *New York Times Magazine*, August 1992, 11. In keeping with the conventional, many of these blended terms enter the standard language from the world of advertising, which is starved for new products or just the "new."

46 Ibid. I am sure that students at my alma mater, Vassar College, will be sorry to hear this given that they have established a "bi-racial support group" called "Blend."

47 Anemona Hartocollis, "Zero Identity: The End of Ethnicity," *New York Newsday*, December 12, 1991, 69. I thank Ellen Gruber Garvey for sending me this article.

48 Ibid. Colo's catalogue includes the category "black" along with other ethnic/national groups, some of whose citizens are black. This elision between race and nation helps to expose the sociological, cultural, and not "biological" construction of "race" as well as the paradigmatic paradox that continues to confuse race and national origin. For more on this subject, see Parati, "Strangers in Paradise"; and Forbes, *Black Africans and Native Americans*.

49 See Phelan, *Unmarked*.

50 Barbara Ehrenreich, *New York Times Magazine*, April 14, 1992, 16.

51 For more on scientific definitions of race, see Zuckerman, "Some Dubious Premises in Research and Theory on Racial Differences." See also Zuberi, "*Thicker than Blood*"; the MIT Web site on race; and Balibar and Goldberg, *Racist Culture*.

52 Hill, *After Whiteness*, 11.

53 Kathy Dobie, "Long Day's Journey into White," *Village Voice*, April 28, 1992, 29.

54 Hill, *After Whiteness*, 9.

55 Strunk and White, *The Elements of Style*, 35.

56 In Derrida's lecture published as a monograph entitled *On Monolingualism*, he expounds upon the significance of the term "Franco-Magrebian."

57 Morrison, *Playing in the Dark*, 47.

58 Brooks, *Children Coming Home*, 5.

59 See Piper, "Passing for White, Passing for Black."

60 Senna, *Caucasia*, 1.

61 Indeed, the interest in racial memories is a global issue in multiple senses of the term.

62 Mowitt, *Percussion*, 69. This quotation comes from Mowitt's striking chapter on Rodney King and the "lactification" of Rock-and-Roll.

63 Judy, *(Dis)Forming the American Canon*, 296.

64 See Fanon, *Black Skin, White Masks*.

65 Case, "Toward a Butch-Femme Aesthetic," 283.

66 *The Terror of Wedding* (1987) is an unpublished play by Amy Robinson that juxtaposes Florence Nightingale's decision not to marry with discussions about

the Intifada. For more on the complexity of such "weddings," see Freeman, *The Wedding Complex*.

67 Simon, *A Brief History of Punctuation*. Another "hyphens" poem, by Rebecca Forrest, appeared on the punctuation listserv.

> A hyphen is a slippery thing.
> A slender snip of em dash string.
> It lops syllabs at column wall
> With just a thread for -ble recall.
>
> But then, unscalpel-like, it deigns
> To link two-part descriptor chains
> (When they're preposed and when the first
> Describes the next and both headfirst
>
> Bump up against the noun described).
> And, too, it thwarts mixups ascribed
> To orthographic obfuscation
> That re-creates for recreation.
>
> And finally it joins the parts
> Of compound words--like doting hearts--
> At least until the data based
> On usage shows them interlaced.
>
> (Such facts, of course, should all be parked
> In a database.) This little mark
> Has many skills and yet it's not
> All-powerful. It just cannot
>
> Supplant a dash or other signs
> Except a minus; there it shines.
> The hyphen's gift is (now restating)
> Exclusively for hyphenating.

68 Gifford-Gonzalez, "We are Not Amused," 703. I am grateful to Jeff Tobin for bringing this article to my attention.

69 Deborah Sontag, "Immigrants Forgoing Citizenship While Pursuing American Dream," *New York Times*, July 25, 1993, 1.

70 Heide Seward, "Census Reveals Fewer Hyphenated Americans," *New York Times*, May 31, 2002.

71 Called "Stars and Stripes Forever," this show was performed at the 2004 Women and Theatre Conference in New York City. I am grateful to Professor Farah for sharing her script with me.

72 Mukherjee, *Jasmine*, 198.

73 See Chu, *Assimilating Asians*, 128–38, for a discussion of the novel's critical reception and its controversial portrayal of the problem of assimilation.

74 See Gunew and Spivak, "Questions of Multiculturalism," 158.

75 David Palumbo-Liu, *Asian/American*, 1.

76 Bhabha, "How Newness Enters the World," 219 (emphasis in original).

77 Phelan, *Unmarked*, 160.

4. *"Queer" Quotation Marks*

1 Baron, *From Alphabet to Email*, 55.

2 Here I am indebted to the work of so many dance scholars, including but not limited to Susan Foster, Jane Desmond, Anna Scott, and Tommy deFrantz, as well as my colleagues Carrie Lambert and Susan Manning—all of whom argue for the importance of choreography in the study of cultural movements broadly conceived. See especially, Foster, *Reading Dancing*; and Desmond, *Meaning and Motion*.

3 Halberstam, *In a Queer Time and Place*, 1.

4 For more on the "live," see Auslander, *Liveness*.

5 Edward Said quoted in Garber, *Quotation Marks*, 10.

6 See Morrison, *Beloved*.

7 Roach, *Cities of the Dead*, 34.

8 Artschwager, *Complete Multiples*, 23.

9 See Muñoz, *Disidentifications*.

10 Banes, *Terpsichore in Sneakers*, 84.

11 Sontag, "Notes on 'Camp,'" 280.

12 See Benjamin, *Illuminations*; and Hebdige, *Subculture*.

13 Sontag, "Notes on 'Camp,'" 280.

14 Cleto, "Introduction: Queering the Camp," 29. See also Meyer, ed. *The Politics and Poetics of Camp*, 1994.

15 See work by Pamela Robertson, E. Patrick Johnson, and Carole-Anne Tyler.

16 Derrida, "Typewriter Ribbon," 280.

17 Marjorie Garber, " " " (Quotation Marks)," 659.

18 See Snead, "Repetition as a Figure of Black Culture."

19 One wonders as well if in this later film of Goldberg's, *The Associate*, there is not a commentary on the scene in *Ghost* when her character, in transgendered white male drag, has a near kiss with a white woman (played by Bebe Neuwirth) who does not yet know that a black woman's body lies beneath Goldberg's vaguely eighteenth-century costume.

20 For more on appropriation, see Johnson, *Appropriating Blackness*; and Fusco, *English Is Broken Here*.

21 Jones, "'Presence' in Absentia," 12.

22 Bal, *Quoting Carravaggio*, 8.

23 Garber also has a chapter, "Sequels," in her book *Quotation Marks*, 73–82.

24 Boyarin, "SpaceTime and the Politics of Memory," 7.

25 Stein, "Orta or One Dancing," 296–97.

26 Foster, *Reading Dancing*, 95.

27 Phelan, "Thirteen Ways of Looking at *Choreographing Writing*," 205.

28 Halberstam, *In a Queer Time and Space*, 103.

29 Diamond, *Unmaking Mimesis*, 143.

30 Halberstam, *In a Queer Time and Space*, and Ahmed, *Queer Phenomenology*.

31 Here I quote from the autobiographical text *The Motion of Light in Water* by Samuel R. Delany, who writes about the drag show The Jewel Box Review, in which the female impersonators presented "a masculinity thrust into quotation marks" (34).

32 See Anderson, *Imagined Communities*.

33 As Amelia Jones, in *Body Art*, reminds us: "Body art is *not* 'inherently' critical, as many have claimed, nor (as . . . others have argued) inherently reactionary, but rather—in its opening up of the interpretive relation and its active solicitation of spectatorial desire—provides the *possibility* for radical engagements that can transform the way we think about meaning and subjectivity (both the artist's and our own). In its activation of intersubjectivity, body art, in fact, demonstrates that meaning is an exchange and points to the impossibility of any practice being 'inherently' positive or negative" (14).

34 Diamond, *Unmaking Mimesis*, 142–43. A section titled, "The Quotable Gesture," in Benjamin's essay "What Is Epic Theater?" reads: "Making gestures quotable is one of the substantial achievements of the epic theater. An actor must be able to space his gestures the way a typesetter produces spaced type. . . . Epic theater is by definition a gestic theater, for the more we interrupt someone in the act of acting, the more gestures result." *Illuminations*, 151.

35 Foster, *Reading Dancing*, 90.

36 Bill T. Jones, discussion held after his performance of "21" at the University of California, Riverside, February 1996.

37 Jones, *Last Night on Earth*, 262–63.

38 Sedgwick, *Tendencies*, xii.

39 For a reading of Croce's fear of both blackness and death, see the epilogue to Holland, *Raising the Dead*; see also Román, *Acts of Intervention*.

40 Roach, *Cities of the Dead*, 286.

41 See Foster, *Reading Dancing*, 76–88.

42 Phelan, *Unmarked*, 178.

43 Jones, post-performance discussion, UC-Riverside.

44 See Banes, *Terpsichore in Sneakers*.

45 Roach, *Cities of the Dead*, 32.

46 See Lorde, *Zami, A New Spelling of My Name*; and Holquist, "From Body-Talk to Biography."

47 This intersection of modern dance and photography has been explored in Carrie Lambert's work on the choreographer Yvonne Rainer. In an essay entitled "Moving Still," Lambert explains Rainer's desire to work against choreograph-

ing dance for "the photographic moment." Lambert concludes, however, that the moving and the still are interdependent.

48 See work by David Román, Elizabeth Alexander, Douglas Crimp, Richard Meyer, Gregg Bordowitz, Paul Monette, José Muñoz, Alex Juhasz, and others.

49 See Gere, *How to Make Dances in an Epidemic."*

50 Jones, *Last Night On Earth*, 253.

51 Boyarin, *Remapping Memory*, 21.

52 Jones, *Last Night On Earth*, 258.

53 Barthes, *Camera Lucida*, 14.

54 Phelan, "Introduction: The Ends of Performance," 16.

55 Morrison, *Nobel Laureate Acceptance Speech*, 22.

56 Derrida, "Typewriter Ribbon," 280, 281.

57 Hartman, *Scenes of Subjection*, 21.

58 Massumi, *Parables of the Virtual*, 136

59 Weheliye, *Phonographies*, 7–8.

60 This acronym sounds like a Starbuck's drink—I like to think of it as short not for motion-capture, but rather for more capitalist exploitation.

61 Furniss, "Motion Capture."

62 Grumet, "Motion Capture Technology," 430.

63 Ibid.

64 Ibid.

65 Armstrong, "Hollywood's Cutting Edge Is Old Hat to Video Gamers," *Globe and Mail* (Toronto), November 11, 2004.

66 Ralph Lemon has worked with VR to create a CD-ROM, *Mirrors & Smoke: A Non-Linear Performance in Virtual Space.*

67 Valverde, "Catching Ghosts in *Ghostcatching*," 25. See also De Spain, "Dance and Technology"; and Kozzel, "*Ghostcatching*."

68 Kaiser quoted in Valverde, "Catching Ghosts," 26.

69 See www.cooper.edu/art/ghostcatching/.

70 Stone, "Will the Real Body Please Stand Up?" 94.

71 Jennifer Dunning, "How to Tell the Computer from the Dance," *New York Times*, February 23, 1999, E1.

72 Kopp quoted in ibid.

73 See Derrida, *Archive Fever*; Taylor, *The Archive and the Repertoire*; and essays by Rebecca Schneider.

74 Dunning, "How to Tell the Computer from the Dance," E1.

5. *Sem;erot;cs ; Colon:zat:ons : Exclamat!ons !*

1 This is an acronym for "Yet Another Bloody Acronym" (John and Blake, *The Total TxtMSg Dictionary*, 287).

2 I take this term from Richard Artschwager, for whom it is a dimensional figure

or rather an oval SHAPE that appears in its various guises (e.g., in paint on buildings and smokestacks in the built environment, as well as in textured material in gallery corners). One early description of the blp is "titled" "when attitude becomes form." See Shaffner, "A Revised Short History of the Blp," 77–80.

3 Catherine Clément quoted as the epigraph to Hart, *Making a Spectacle*.

4 I am grateful to E. Patrick Johnson for bringing to my attention, after this chapter was written, the wonderful essay by D. Soyini Madison, "Performing Theory/Embodied Writing."

5 Stein, "Poetry and Grammar," in *Lectures in America*, 218.

6 Lasky, *Proofreading and Copy-Preparation*, 30.

7 Blp "speaks" British-style txtmsg and emoticon—the translations for which, taken from John and Blake's *The Total TxtMSg Dictionary*, appear in the endnotes. Blp's comment here translates as "Yeah, Yeah, Sure, Sure, Whatever, I'm bored" (290).

8 Allardyce, *Stops*, 43.

9 What's in a name? 277.

10 Allardyce, *Stops*, 43.

11 See González, "The Appended Subject."

12 Blink, 294. No comment, 302.

13 Partridge, *You Have a Point There*, 91–92.

14 Ibid., 93.

15 I don't get it, 147. My glass is empty, 302.

16 Oliver Pritchett, "Pay Attention: It's Important!" November 24, 2003, Telegraph.co.uk, http://www.telegraph.co.uk/arts/main.jhtml?xml=/arts/2003/11/23/botru23.xml.

17 Robinson, "The Philosophy of Punctuation," 29.

18 Lundmark, *Quirky QWERTY*, 19.

19 Thomas, "Notes on Punctuation," 126.

20 Strange, 299.

21 Thomas, "Notes on Punctuation," 129.

22 Sarah Boxer, "If Not Strong, at Least Tricky: The Middleweight of Punctuation Politics," *New York Times*, March 6, 1999, B11.

23 Fletcher, *A Simple Guide to the Art of Punctuation*, 10.

24 Castrated dog at a fucking match. Frowning. This is a folk saying from my grandmother, Maude De Vere White Bright.

25 Lundmark, *Quirky QWERTY*, 134.

26 Irigaray, *The Sex Which Is Not One*, 134.

27 Kurt Vonnegut, interview on National Public Radio, March 3, 2000.

28 Lundmark, *Quirky QWERTY*, 134.

29 Ibid.

30 Wink.

31 Bonner, "Farewell Semicolon?" 447–48.

32 Lundmark, *Quirky QWERTY*, 133.

33 I am skeptical, 297.

34 Simon, "X. The Semicolon: A Totem," in *A Brief History of Punctuation*.

35 Conley, "A Semicolon's Dream Journal," April 1, 2006. http://www.oneletter words.com/weblog/?c=Semicolon.

36 Adorno, "Punctuation Marks," 95.

37 Ibid., 91.

38 Edson, *W;T*, 14–15.

39 Bal, *Quoting Carravaggio*, 195–96.

40 Ibid.

41 Ibid., 196–97.

42 Schor, *Wet*, 213. Subsequent references to this work are cited in parentheses in the text.

43 Joanna Drucker, "M/E/A/N/I/N/G: Feminism, Theory, and Art Practice," xviii. Here the editors also explain their choice of the title for their successful venture. They write that the title "announced an ethical and philosophical dimension. But the slashes (technically virgules) that separate the M from E from A from N from I from N from G not only graphically indicate our connection to the influential contemporary poetry journal *L=A=N=G=U=A=G=E*, they also break up the possibilities of an uninflected metaphysical belief in *meaning*. We put the concept of meaning back on the table of contemporary art discourse, but with a postmodern twist" (Bee and Schor, *M/E/A/N/I/N/G: An Anthology of Artists' Writings, Theory, and Criticism*, 1–2).

44 Adorno, "Punctuation Marks," 91.

45 Ronell, *The Telephone Book*, 167.

46 Heidegger quoted in ibid.

47 Ronell, *The Telephone Book*, 167.

48 Stein, "Poetry and Grammar," 215.

49 Austin, *How to Do Things with Words*, 74.

50 Devilish little grin, 94. Devilish wink, 302.

51 Stein, "Poetry and Grammar," 216.

52 Lasky, *Proofreading and Copy-Preparation*, 30.

53 Adorno, "Punctuation Marks," 91.

54 Big fucking deal, 52. Speaking with forked tongue, 301.

55 See Austin, *How to Do Things with Words*.

56 Artschwager, personal correspondence, August 19, 2004.

57 McLuhan and Fiore, *The Medium Is the Massage*, 138.

58 For more, see Joshua Dale, "An Unconscious Burden of Guilt: The Battle Over the Mushroom Cloud in Richland, Washington," unpublished manuscript.

59 No! No! No!, 292. Enough for now, from Sanderson, *Smileys*, 84.

60 See Drucker, *The Visible Word*, 35.

61 Adorno, "Punctuation Marks, 92–93.

62 Ibid., 97.

63 Couto, "The Punctuation of the Creation as Seen from the Ellipsis," 457.

64 Baker, "Survival of the Fittest," 17.

65 Backscheider, "Punctuation for the Reader," 874.

66 God's got nothing to do with it, 125.

67 Dead, 303.

Post\Script

1 Mitchell, *Picture Theory*, 83.

2 See Foster, "The Kinesthetics of Calamity," 2006.

3 In the film *Forrest Gump* (1994) the eponymous fictive hero invents the smiley face.

4 Sanderson, *Smileys*, 1–3.

5 An excellent volume on these issues is Geoffrey Nunberg's *The Future of the Book*.

6 Mowitt, "What Is a Text Today?" 1219.

7 Miranda July, *Me and You and Everyone We Know*, IFC and Film Four/Sony Pictures, 2005.

8 There are several scenes in the film that transmogrify space into time. One of the most charming occurs when the boys' father, the newly separated shoe salesman, and the lonely solo artist Christine (played by July) walk down a street together to their respective parked cars. As they move toward their destination, walking together, they see a sign that reads, "Ice Land." They surmise and then debate that this stroll could be mapped as a lifelong relationship. One month, six months, a lifetime. As space becomes time, like a microcosm (film works this way as it is unrolled/scrolled), the scene represents a major aspect of our postmodern condition and life and death more generally. Each step forward leads to an inevitable parting. This is a wonderful demonstration of the time/space dimension that provides a metacommentary on the medium of film.

Bibliography

Adorno, Theodor W. "Punctuation Marks." In *Notes to Literature*. Vol. 1. Edited by Rolf Tiedemann. Translated by Shierry Weber Nicholsen. New York: Columbia University Press, 1991 [1958].

Ahmed, Sara. *Queer Phenomenology: Orientations, Objects, Others*. Durham, N.C.: Duke University Press, 2006.

Allardyce, Paul. *Stops, or How to Punctuate: A Practical Handbook for Writers and Students 3rd Edition* London: T. F. Unwin, 1884.

Anderson, Benedict. *Imagined Communities: Reflections on the Origins and Spread of Nationalism*. London: Verso Books, 1991.

Artschwager, Richard. *Complete Multiples*. New York: Brooke Alexander Editions, 1991.

———. *Up and Across*. Nürnberg: Neues Museum Press, 2000.

Auerbach, Nina. *Ellen Terry: A Player in Her Time*. Philadelphia: University of Pennsylvania Press, 1997.

Auslander, Phillip. *Liveness*. London: Routledge, 1999.

Austin, J. L. *How to Do Things with Words*. Oxford: Oxford University Press, 1962.

Backscheider, Paula. "Punctuation for the Reader—A Teaching Approach." *English Journal* 61, no. 6 (September 1972): 874–77.

Baker, Nicholson. "Survival of the Fittest: A Review of *Pause and Effect.*" *New York Review of Books*, November 4, 1993: 17–21.

Bal, Mieke. *Quoting Carravaggio: Contemporary Art, Preposterous History*. Chicago: University of Chicago Press, 1999.

Balibar, Etienne, and David Goldberg. *Racist Culture: Philosophy and the Politics of Meaning*. Cambridge, Mass.: Blackwell, 1993.

Banes, Sally. *Greenwich Village 1963: Avant-Garde Performance and the Effervescent Body*. Durham, N.C.: Duke University Press, 1993.

———. *Terpsichore in Sneakers: Post-Modern Dance*. Middletown, Conn.: Wesleyan University Press, 1987.

Baron, Naomi S. *From Alphabet to Email: How Written English Evolved and Where It's Heading*. London: Routledge, 2000.

Barrett, Richard. "McGreevey Nationality Invalid," www.nationalist.org, 13 August 2004.

Baucom, Ian. *Specters of the Atlantic: Finance Capital, Slavery and the Philosophy of History*. Durham, N.C.: Duke University Press, 2005.

Bee, Susan, and Mira Schor, eds. *M/E/A/N/I/N/G: An Anthology of Artists' Writings, Theory, and Criticism*. Durham, N.C.: Duke University Press, 2000.

Benjamin, Walter. *Illuminations*. Edited by Hannah Arendt. Translated by Harry Zohn. New York: Schocken Books, 1968.

Benstock, Shari. "Ellipses: Figuring Feminisms in *Three Guineas*." In *Textualizing the Feminine: On the Limits of Genre*. Norman: University of Oklahoma Press, 1991.

Benston, Kimberly W. "I Yam What I Am: The Topos of (Un)naming in Afro-American Literature." In *Black Literature and Literary Theory*, edited by Henry Louis Gates Jr. New York: Methuen Press, 1984.

———. *Performing Blackness: Enactments of African-American Modernism*. New York: Routledge, 2000.

Berlant, Lauren. "The Face of America and the State of Emergency." In *The Queen of America Goes to Washington City: Essays on Sex and Citizenship*. Durham, N.C.: Duke University Press, 1997.

Bhabha, Homi K. *Nation and Narration*. New York: Routledge, 1990.

———. "Of Mimicry and Man: The Ambivalence of Colonial Discourse." In *The Location of Culture*. London: Routledge, 1994.

Birdoff, Harry. *The World's Greatest Hit: Uncle Tom's Cabin*. New York: Vanni Press, 1947.

Blount, Marcellus. "The Preacherly Text: African American Poetry and Vernacular Performance." In "Special Issue on Performance," edited by Kimberly Benston. *PMLA* 107, No. 3 (May 1992): 582–93.

Bolter, Jay David. "Ekphrasis, Virtual Reality, and the Future of Writing." In *The Future of the Book*, edited by Geoffrey Nunberg. Berkeley, Calif.: University of California Press, 1996.

Bonner, Willard Hallam. "Farewell Semicolon?" *College English* 5, no. 8 (May 1944): 447–48.

Boone, Joseph. *Libidinal Currents: Sexuality and the Shaping of Modernism*. Chicago: University of Chicago Press, 1998.

Boorstin, Daniel J. "A Conscience-Wracked Nation." *The Economist*, September 11–17, 1993.

Boyarin, Jonathan. "Space, Time and the Politics of Memory." In *ReMapping Memory: The Politics of TimeSpace*, edited by Jonathan Boyarin. Minneapolis, Minn.: University of Minnesota Press, 1994.

Bremmer, Jan, and Herman Roodenburg, eds. *A Cultural History of Gesture*. Ithaca, N.Y.: Cornell University Press, 1992.

Bringhurst, Robert. *The Elements of Typographic Style*. Point Roberts, Wash.: Hartley and Marks, 1992.

Brody, Jennifer DeVere. *Impossible Purities: Blackness, Femininity, and Victorian Culture*. Durham, N.C.: Duke University Press, 1998.

Brooks, Gwendolyn. *Children Coming Home*. Chicago: David Company, 1991.

Bryson, Norman. "Cultural Studies and Dance History." In *Meaning in Motion: New Cultural Studies of Dance*, edited by Jane Desmond. Durham, N.C.: Duke University Press, 1997.

Bullins, Ed. *The Theme Is Blackness: "The Corner" and Other Plays*. New York: William Morrow, 1973.

Butler, Judith. *Bodies That Matter*. New York: Routledge, 1993.

———. "Performative Acts and Gender Constitution: An Essay in Phenomenology and Feminist Theory." *Theatre Journal* 40 (1988): 519–31.

Cameron, Deborah. *Verbal Hygiene*. New York: Routledge, 1995.

Cappon, Rene J. *The Associated Press Guide to Punctuation*. Cambridge, Mass.: Perseus, 2003.

Carey, G. V. *(M.I,N'D*-T:H;E!?S.T^O"P) A Brief Guide to Punctuation*. London: Penguin Books, 1976 [1939].

———. *Punctuation*. Cambridge: Cambridge University Press, 1957.

Case, Sue-Ellen. "Toward a Butch-Femme Aesthetic." In *Making a Spectacle: Feminist Essays on Contemporary Women's Theatre*, edited by Lynda Hart. Ann Arbor: University of Michigan Press, 1989.

Cha, Theresa Hak Kyung. *Dictee*. Berkeley: University of California Press, 2001 [1982].

Chauncey, George. *Why Marriage? The History Shaping Today's Debate over Gay Equality*. New York: Basic Books, 2004.

Cheng, Anne Anlin. *The Melancholy of Race: Psychoanalysis, Assimilation, and Hidden Grief*. New York: Oxford University Press, 2001.

Cheng, Meiling. *In Other Los Angeleses: Multicentric Performance Art*. Berkeley: University of California Press, 2002.

Chicago Manual of Style, The. 14th ed. Chicago: University of Chicago Press, 1982.

Chu, Patricia. *Assimilating Asians: Gendered Strategies of Authorship in Asian America*. Durham, N.C.: Duke University Press, 2000.

Cleto, Fabio. "Introduction: Queering the Camp." In *Camp: Queer Aesthetics and the Performing Subject*. Edinburgh: Edinburgh University Press, 1999.

Cocker, W. J. *Hand-Book of Punctuation, with Instructions for Capitalization, Letter-Writing, and Proof-Reading*. New York: A. S. Barnes and Co., 1878.

Cohen, Tom. "Political Thrillers: Hitchcock, de Man, and Secret Agency in the 'Aesthetic State.'" In *Material Events: Paul de Man and the Afterlife of Theory*, edited by Tom Cohen, Barbara Cohen, J. Hillis Miller, and Andrzej Warminski. Minneapolis: University of Minnesota Press, 2001.

Coleridge, Samuel Taylor. *The Complete Poems*. Edited by William Keach. London: Penguin Books, 1997.

Conley, Craig. "A Semicolon's Dream Journal." April 1, 2006. http://www.one letterwords.com/weblog/?c=Semicolon.

Corrin, Lisa G. "Artschwager's Way: An Introduction to the Notebooks of Richard Artschwager." In *Up and Across*. Nürnberg: Neues Museum Press, 2000.

Couto, Nancy Lee. "The Punctuation of the Creation as Seen from the Ellipsis." *College English* 28, no. 6 (March 1967): 457.

Crary, Jonathan. *Techniques of the Observer*. Cambridge, Mass.: MIT Press, 1992.

Crow, Thomas. *The Rise of the Sixties: American and European Art in the Era of Dissent, 1955–69*. London: Everyman Art Library, 1996.

Crystal, David, ed. *The Cambridge Encyclopedia of Language*. Cambridge: Cambridge University Press, 1987.

Cubilié, Anne. *Women Witnessing Terror: Testimony and the Cultural Politics of Human Rights*. New York: Fordham University Press, 2005.

Daniels, Peter, and William Bright, eds. *The World's Writing Systems*. New York: Oxford University Press, 1996.

Davidson, Cathy. *Revolution and the Word: The Rise of the Novel in America*, expanded edition. New York: Oxford University Press, 2004.

Davies, Phillip, ed. *Immigration and Americanization*. Boston: Ginn and Co., 1920.

Day, William. *Punctuation Reduced to a System*, 3rd ed. London, 1847.

De Assis, Joaquim Maria Machado. *The Posthumous Memoirs of Brás Cubas*. Translated by Gregory Rabassa. New York: Oxford University Press, 1997.

Delaney, Samuel R. *The Motion of Light in Water: Sex and Science Fiction Writing in the East Villiage*. Minneapolis: University of Minnesota Press, 2004.

Derrida, Jacques. "The Double Session." In *Dissemination*. Translated by Barbara Johnson. Chicago: University of Chicago Press, 1981.

———. "Ellipsis." In *Writing and Difference*. Translated by Alan Bass. Chicago: University of Chicago Press, 1978.

———. *Monolingualism of the Other, or the Prosthesis of Origin*. Translated by Patrick Mersah. Stanford, Calif.: Stanford University Press, 1998.

———. "Typewriter Ribbon: Limited Ink (2) ('within such limits')." In *Material Events: Paul de Man and the Afterlife of Theory*, edited by Tom Cohen, Barbara Cohen, J. Hillis Miller, and Andrzej Warminski. Minneapolis: University of Minnesota Press, 2001.

Desmond, Jane, ed. *Meaning and Motion*. Durham, N.C.: Duke University Press, 1999.

De Spain, Kent. "Dance and Technology: A Pas-de-Deux for Post-humans." *Dance Research Journal* 32, no. 1 (summer 2000): 2–17.

DeVinne, Theodore Low. *The Practice of Typography: Correct Composition. A Treatise on Spelling, Abbreviations, the Compounding and Division of Words, the Proper Use of Figures and Numerals, Italic and Capital Letters, Notes, etc. with Observations on Punctuation and Proof-Reading*. New York: Century Co., 1901.

Diamond, Elin. *Unmaking Mimesis: Essays on Feminism and Theater*. London: Routledge, 1997.

Dixon, Wheeler Winston. "Performativity in the 1960s American Experimental Cinema: The Body as Site of Ritual and Display." *Film Criticism* 23, no. 1 (spring 1998): 44–56.

Dobie, Kathy. "Long Day's Journey into White." *Village Voice*, April 28, 1992.

Dolan, Jill. "Geographies of Learning: Theatre Studies, Performance and the Performative." *Theatre Journal* 45, no. 4 (1993): 417–42.

Doyle, Jennifer, Jonathan Flatley, and José Esteban Muñoz. *Pop Out: Queer Warhol*. Durham N.C.: Duke University Press, 1996.

Drucker, Johanna. *The Alphabetic Labyrinth: The Letters in History and Imagination*. London: Thames and Hudson, 1995.

———. "M/E/A/N/I/N/G: Feminism, Theory, and Art Practice." In *M/E/A/N/I/N/G: An Anthology of Artists' Writings, Theory, and Criticism*, edited by Susan Bee and Mira Schor. Durham, N.C.: Duke University Press, 2000.

———. *The Visible Word: Experimental Typography and Modern Art, 1909–1923*. Chicago: University of Chicago Press, 1994.

DuBois, W. E. B. *The Souls of Black Folk*. New York: Random House, 2003.

Dunning, Jennifer. "How to Tell the Computer from the Dance." *New York Times*, February 23, 1999, E3.

Edson, Margaret. *W;T*. New York: Faber and Faber, 1999.

Edwards, Brent Hayes. "Louis Armstrong and the Syntax of Scat." *Critical Inquiry* 28 (spring 2002): 618–49.

Ehrenreich, Barbara. "Cultural Baggage." *New York Times Magazine*. April 14, 1992, 16–18.

Elam, Harry J. Jr., and Robert Alexander, eds. *Colored Contradictions: An Anthology of Contemporary African-American Plays*. New York: Plume Books/Penguin, 1996.

Elkins, Stanley. *Visual Studies: A Skeptical Introduction*. New York: Routledge, 1999.

Ellison, Ralph. *Invisible Man*. New York: Vintage, 1981.

———. "The Little Man at Chechaw Station." In *The Collected Essays of Ralph Ellison*. Edited by John F. Callahan. New York: Random House, 1995.

———. *Trading Twelves: The Selected Letters of Ralph Ellison and Albert Murray*, edited by Albert Murray and John F. Callahan. New York: Random House, 2000.

Fabb, Nigel, Derek Attridge, Alan Durant, and Colin McCabe, eds. *The Linguistics of Writing*. Manchester: Manchester University Press, 1987.

Fanon, Frantz. *Black Skin, White Masks*. Translated by Charles Lam Markmann. New York: Grove Press, 1967.

Ferguson, Roderick. *Aberrations of Blackness*. University of Minnesota Press, 2004.

Finch-Crisp, William. *The Printers' Universal Book of Reference and Every-Hour Office Companion*. London: J. Haddon and Co., 1875.

Fleming, Juliet. *Graffiti and the Writing Arts of Early Modern England*. Philadelphia: University of Pennsylvania Press, 2001.

Fletcher, W. C. *A Simple Guide to the Art of Punctuation: For Authors and Printers*. Oxford: George Bryan and Co., 1899.

Forbes, Jack. *Black Africans and Native Americans: The Language of Race and the Evolution of the Red-Black Peoples*. Chicago: University of Illinois Press, 1993.

Foster, Susan Leigh. "Choreographies of Gender." *Signs* 24 no. 1 (fall 1998): 1–33.

———. *Reading Dancing: Bodies and Subjects in Contemporary American Desire*. Berkeley: University of California Press, 1986.

———. "The Kinesthetics of Calamity." Paper presented at Considering Calamity: An Interdisciplinary Conference on Methods for Performance Research. Northwestern University, October 1, 2006.

Fournier, Henri. *Traité de la Typographie*. Westmead, U.K.: Gregg International Publishers, 1971 [1825].

Fournier, Marian. *The Fabric of Life: Microscopy in the Seventeenth Century*. Baltimore, Md.: Johns Hopkins University Press, 1996.

Fowler, H. W., and F. G. Fowler. *The Concise Oxford Dictionary of Current English*. Oxford: Clarendon Press, 1921.

Freeman, Elizabeth. *The Wedding Complex: Forms of Belonging in Modern American Culture*. Durham, N.C.: Duke University Press, 2002.

Frey, A. Manuals-Roret. *Nouveau Manuel Complet de Typographie*. Paris: Chez Leonce Laget, 1857.

Fried, Michael, and Clement Greenberg. "Avant-Garde and Kitsch" (1939). In *Pollock and After: The Critical Debate*, edited by F. Fascina. London: Routledge, 2000.

Furniss, Maureen. "Motion Capture" MIT Communications Forum. http://web .mit.edu/comm-forum/papers/furniss.html.

Fusco, Coco. *English Is Broken Here: Notes on Cultural Fusion in the Americas*. New York: Routledge, 1997.

Garber, Marjorie. " " " (Quotation Marks)." *Critical Inquiry* 25 (summer 1999): 653–79.

———. *Quotation Marks*. New York: Routledge, 2003.

Gates, Henry Louis Jr., ed. *Race, Writing, and Difference*. Chicago: University of Chicago Press, 1986.

———. "The Body Politic: Choreographer Bill T. Jones." *The New Yorker* 70, no. 39 (November 28, 1994): 112–24.

———. *The Signifying Monkey: A Theory of African-American Literary Criticism*. New York: Oxford University Press, 1988.

Gere, David. *How to Make Dances in an Epidemic: Tracking Choreography in the Age of AIDS*. Madison: University of Wisconsin Press, 2004.

Gibson, Richard. "www.periodchallengeshyphen.com." *The Press-Enterprise*, July 13, 1998: A1, 9H 1.

Gifford-Gonzalez, Diane. "We Are Not Amused." *American Anthropologist* 94, no. 3 (September 1992): 703.

Goldberg, Jonathan. *Writing Matter*. Stanford, Calif.: Stanford University Press, 1990.

Gombrich, E. H., ed. *Art and Illusion: A Study in the Psychology of Pictorial Representation*. Princeton, N.J.: Princeton University Press, 1969.

Gonzalez, Jennifer. "The Appended Subject: Race and Identity as Digital Assemblage." In *The Feminism and Visual Culture Reader*, ed. Amelia Jones. New York: Routledge, 2003.

Gourevitch, Philip, ed. *The Paris Review Interviews. Vol. I*. New York: Picador Press, 2006.

Graf, Fritz. "Gestures and Conventions: The Gestures of Roman Actors and Orators." In *A Cultural History of Gesture*, edited by Jan Bremmer and Herman Roodenburg. Ithaca, N.Y.: Cornell University Press, 1992.

Grayson, Deborah. *Mediating Intimacy: Black Mothers and the Law*. Chicago: University of Chicago Press, 2000.

Greene, Jody. *The Trouble with Ownership: Literary Property and Authorial Liability in England, 1600–1730*. Philadelphia: University of Pennsylvania Press, 2005.

Grumet, Tobey. "Motion Picture Capture Technology." *Popular Mechanics*, November 2001: 43–45.

Gunew, Sneja, and Gayatri Chakravorty Spivak. "Questions of Multiculturalism." In *Women's Writing in Exile*, edited by Mary Lynn Broe and Angela Ingram. Chapel Hill: University of North Carolina Press, 1989.

Halberstam, Judith. *In a Queer Time and Place: Transgendered Bodies, Subcultural Lives*. New York: New York University Press, 2005.

Hall, Stuart. "New Ethnicities." In *Black British Studies*, edited by Houston Baker Jr. Chicago: University of Chicago Press, 1996.

Hammond, Anthony. "The Noisy Comma: Searching for the Signal in Renaissance Dramatic Texts." In *Crisis in Editing: Texts of the English Renaissance*, edited by Randall McLeod. New York: AMS Press, 1994.

Hart, Lynda, ed. *Making a Spectacle: Feminist Essays on Contemporary Women's Theatre*. Ann Arbor: University of Michigan Press, 1992.

Hartman, Saidiya. *Scenes of Subjection*. New York: Oxford University Press, 1996.

Hartocollis, Anemona. "Zero Identity: The End of Ethnicity." *New York Newsday*, December 12, 1991, 68–69, 88.

Harvey, David. *Spaces of Capital: Towards a Critical Geography*. New York: Routledge, 2001.

Hatch, James, Brooks McNamara, and Ann Marie Bean, eds. *Inside the Minstrel Mask: Readings in Nineteenth-Century Blackface Minstrelsy*. Hanover, N.H.: Wesleyan University Press, 1997.

Hebdige, Dick. *Subculture: The Meaning of Style*. London: Methuen, 1979.

Herbert, Robert L. *Seurat and the Making of "La Grande Jatte."* Chicago: Art Institute of Chicago; Berkeley: University of California Press, 2004.

Herd, Harold. *Everybody's Guide to Punctuation*. London: Allen and Unwin, 1925.

Herrnstein-Smith, Barbara. *Poetic Closure: A Study of How Poems End*. Chicago: University of Chicago Press, 1968.

Hill, Mike. *After Whiteness: Unmaking an American Majority*. New York: New York University Press, 2004.

Holland, Sharon. *Raising the Dead: Readings of Death and (Black) Subjectivity*. Durham, N.C.: Duke University Press, 2000.

Hollander, John, and Joanna Weber, eds. *Words for Images: A Gallery of Poems*. New Haven, Conn.: Yale University Art Gallery, 2001.

Holmes, Richard. *Coleridge: Darker Reflections, 1804–1834*. New York: Pantheon Press, 1998.

Holquist, Michael. "From Body-Talk to Biography: The Chronobiological Bases of Narrative." *Yale Journal of Criticism* 3 (1989): 1–35.

Hooke, Robert. *Micrographia: or Some Physiological Descriptions of Minute Bodies Made by Magnifying Glasses. With Observations and Inquires thereupon*. London: John Bowles, 1665.

Hoptman, Laura, ed. *Yayoi Kusama*. London: Phaidon Books, 2000.

Huling, J. B. *Suggestions in Punctuation and Capitalization*. Chicago, 1887.

Humphries, Henry Noel. *The Origin and Progress of Writing*. London, 1853.

Inwood, Stephen. *The Man Who Knew Too Much*. London: Pan Books, 2002.

Irigaray, Luce. *The Sex Which Is Not One*, trans. Catherine Porter (Ithaca, NY: Cornell University Press, 1985).

Irwin, Scott. "A Bugler of Words: Ellison's Musicality and the Jazz/Blues Tradition in *Invisible Man*." *Oakland Journal* (winter 2004): 108–16.

Jack S. Blanton Museum of Art Archive, University of Texas, Austin.

Jackson, Lawrence. *Ralph Ellison: Emergence of Genius*. New York: Wiley Press, 2002.

Jardine, Lisa. *The Curious Life of Robert Hooke: The Man Who Measured London*. London: HarperCollins, 2003.

Jardine, Lisa, et al., eds. *London's Leonardo: The Life and Works of Robert Hooke*. Oxford: Oxford University Press, 2003.

Jean, Georges. *Writing: The Story of Alphabets and Scripts*. London: Thames and Hudson, 2000.

Jefferson, Thomas. "On Manners." In *Notes on the State of Virginia*, edited by William Peden. Chapel Hill: University of North Carolina Press, 1995.

John, Andrew, and Stephen Blake, eds. *The Total TxtMSg Dictionary: Over 6,300 of the Most Important E-Acronyms, E-Abbreviations and Definitions for Mobiles, E-MAIL & PDAs*. London: Michael O'Mara Books Ltd., 2001.

Johns, Adrian. *The Nature of the Book: Printing and Knowledge in the Making*. Chicago: University of Chicago Press, 1998.

Johnson, E. Patrick. *Appropriating Blackness: Performance and the Politics of Authenticity*. Durham, N.C.: Duke University Press, 2002.

Jones, Amelia. *Body Art: Performing the Subject*. Minneapolis: University of Minnesota Press, 1998.

———. "'Presence' in Absentia: Experience Performance as Documentation." *Art Journal* 56, no. 4 (winter 1997): 11–18.

Jones, Bill T. *Last Night on Earth*. New York: Pantheon Books, 1995.

Jones, Meta Du Ewa. "Jazz Prosodies: Orality and Textuality." *Callaloo* 25, no. 1 (2002): 71.

Judd, Donald. "Specific Objects" (1965). In *Theories and Documents of Contemporary Art*, ed. Kristine Stiles and Peter Selz. Berkeley: University of California Press, 1996.

Judy, Ronald A. T. *(Dis)Forming the American Canon: African-Arabic Slave Narratives and the Vernacular*. Minneapolis: University of Minnesota Press, 1993.

———. "Ralph Ellison: The Next Fifty Years." *boundary 2* (summer 2003): 221–23.

Julien, Isaac. "Black Is, Black Ain't: Notes on De-Essentializing Black Identities." In *Black Popular Culture*, edited by Gina Dent. New York: Dia Press, 1992.

Junker, Howard. "Theater of the Nude." *Playboy* 15 no. 11 (November 1968): 99–104.

Kaprow, Allan. *Essays on the Blurring of Art and Life*. Berkeley: University of California Press, 1993.

Kaufman, Moises. *Gross Indecency: The Three Trials of Oscar Wilde*. New York: Vintage, 1998.

Kershaw, Baz. *The Politics of Performance: Radical Theatre as Cultural Intervention*. London: Routledge, 1992.

King, Reyahn, et al., eds. *Ignatius Sancho: An African Man of Letters*. London: National Portrait Gallery, 1997.

Kirby, Michael. *Happenings: An Illustrated Anthology*. London: Sidgwick and Jackson, 1965.

Kittler, Freidrich. *Gramophone, Film, Typewriter*. Translated by Geoffrey Winthrop Young and Michael Wutz. Stanford: Stanford University Press, 1999.

Kliege, Melitta. "Challenge to Looking: The Paintings and Sculptures of Richard Artschwager." In *Up and Across*. Nürnberg: Neues Museum Press, 2000.

Kozel, Susan. "*Ghostcatching*: More Perspectives on Captured Motion." *Dance Theatre Journal* 15, no. 2 (1999): 13–15.

Kuramitsu, Kristine C. "Yayoi Kusama's Body of Art." In *De-Composition: Post-Disciplinary Performance*, edited by Phillip Brett, Sue Case, and Susan Foster. Bloomington: University of Indiana Press, 2000.

Kusama, Yayoi. *Love Forever: Yayoi Kusama, 1958–1968*. Los Angeles: Los Angeles County Museum of Art, 1998.

———. "Struggles and Wanderings of My Soul." Typescript, 1975. Jack S. Blanton Museum of Art Archive, University of Texas, Austin.

———. *Yayoi Kusama*. Italy: EBS, 2002.

Kushner, Tony. *Homebody/Kabul*. London: Nick Hern Books, 2002.

Lambert, Carrie. "Moving Still: Mediating Yvonne Rainer's *Trio A*." *October* 89 (summer 1999): 87–112.

Lane, Jill, and Peggy Phelan, eds. *The Ends of Performance*. New York: Routledge, 1998.

Lang, Berel. "Strunk, White, and Grammar as Morality." In *Writing and the Moral Self*. New York: Routledge, 1991.

Lasky, Joseph. *Proofreading and Copy-Preparation: A Textbook for the Graphic Arts Industry*. New York: Mentor Press, 1941.

Lippard, Lucy. *From the Center: Feminist Essays on Women's Art*. New York: E. P. Dutton, 1976.

Lorde, Audre. *Zami: A New Spelling of My Name*. Watertown, Mass.: Persephone Press, 1982.

Lott, Eric. *Love and Theft: Blackface Minstrelsy and the American Working Class*. New York: Oxford University Press, 1995.

Lundmark, Torbjörn. *Quirky QWERTY: A Biography of the Typewriter and Its Many Characters*. New York: Penguin Books, 2003.

Lupton, Ellen. *Thinking With Type: A Critical Guide*. New York: Princeton Architectural Press, 2004.

Mackey, Nathaniel. *Discrepant Engagement: Dissonance, Cross-Culturality, and Experimental Writing*. Birmingham: University of Alabama Press, 1993.

Madison, D. Soyini. "Performing Theory/Embodied Writing." *TPQ: Text & Performance Quarterly* 19, no. 2 (April 1999): 107–24.

Malcomson, Scott L. "The Nation; An Appeal Beyond Race." *New York Times* August 1, 1994, D5.

Martin, Ben L. "From Negro to Black to African American: The Power of Names and Naming." *Political Science Quarterly* 106, no. 1 (1991): 83–107.

Massumi, Brian. *Parables of the Virtual: Movement, Affect, Sensation*. Durham, N.C.: Duke University Press, 2002.

Masten, Jeffrey. "On Q." Unpublished manuscript, 2001.

———. *Textual Intercourse: Collaboration, Authorship, and Sexualities in Renaissance Drama*. Cambridge: Cambridge University Press, 1997.

Masten, Jeffrey, Nancy Vickers, and Peter Stallybrass, eds. *Language Machines: Technologies of Literary and Cultural Production*. New York: Routledge, 1997.

McGann, Jerome. *Radiant Textuality: Literature after the World Wide Web*. New York: Palgrave Press, 2001.

McLuhan, Marshall. *The Gutenberg Galaxy: The Making of Typographic Man*. Toronto: University of Toronto Press, 1962.

McLuhan, Marshall, and Quentin Fiore. *The Medium Is the Massage: An Inventory of Effects*. New York: Ginko Press, 1967.

McQuain, Jeffrey. "Sweet Talk." *New York Times Magazine*, August 1992, 10–12.

Mercer, Kobena. "1968: Periodizing Politics and Identity." In *Welcome to the Jungle: New Positions in Black Cultural Studies*. New York: Routledge, 1994.

———. "Black Hair/Style Politics." In *Welcome to the Jungle: New Positions in Black Cultural Studies*. New York: Routledge, 1994.

Merchant, Jason. *The Syntax of Silence: Sluicing, Islands, and the Theory of Ellipses*. New York: Oxford University Press, 2001.

Meyer, Mo, ed. *The Politics and Poetics of Camp*. New York: Routledge, 1994.

Meyer, Richard. "Gay Power circa 1970: Visual Strategies for Sexual Revolution." *GLQ* 12, no. 3 (2005): 421–64.

Miller, J. Abbott. *Dimensional Typography: Case Studies on the Shape of Letters in Virtual Environments*. Princeton, N.J.: Princeton Architectural Press, 1996.

Mills, Charles. *Blackness Visible: Essays on Philosophy and Race*. Ithaca, N.Y.: Cornell University Press, 1998.

Mitchell, W. T. J. *Picture Theory*. Chicago: University of Chicago Press, 1994.

Monaghan, Peter. "With Sex and Sensibility, Scholars Redefine Jane Austen." *Chronicle of Higher Education* 47, no. 49 (August 17, 2001): A10–A12.

Monette, Paul. "3275." In *Last Watch of the Night: Essays Too Personal and Otherwise*. New York: Harcourt Brace, 1994.

Morrison, Toni. *Beloved*. New York: Knopf, 1987.

———. *Playing in the Dark: Whiteness and the Literary Imagination*. Cambridge, Mass.: Harvard University Press, 1992.

———. *Nobel Laureate Acceptance Speech*. New York: Knopf, 1994.

———. *Sula*. New York: Plume Books, 1974.

———. "Unspeakable Things Unspoken: The Afro-American Presence in Literature." *Michigan Quarterly* 28, no. 1 (winter 1989): 1–34.

Moten, Fred. *In the Break: The Aesthetics of the Black Radical Tradition*. Minneapolis: University of Minnesota Press, 2003.

Mowitt, John. *Percussion: Drumming, Beating, Striking*. Durham, N.C.: Duke University Press, 2002.

———. "What Is a Text Today?" *PMLA* 117, no. 5 (October 2002): 1217–1221.

Moxon, Joseph. *Mechanick Exercises on the Whole Art of Printing*. Oxford: Oxford University Press, 1958 [1683–84].

Mukherjee, Bharati. *Jasmine*. New York: Ballantine Books, 1989.

Mullen, Harryette. Foreword to *Oreo* by Fran Ross. Boston: Northeastern University Press, 2000.

———. "Optic White: Blackness and the Production of Whiteness." *Diacritics* 24, nos. 2–3 (1994): 71–89.

———. *Sleeping with the Dictionary*. Berkeley: University of California Press, 2002.

Muñoz, José Esteban. *Disidentifications: Queers of Color and the Performance of Politics*. Minneapolis: University of Minnesota Press, 1999.

Murray, Thomas E. "The Overlooked and Understudied Onomastic Hyphen." *Names: A Journal of Onomastics* 50, no. 3 (September 2002): 19–27.

Neill and Co., Printers. *Memoranda Regarding Style, Punctuation, Spelling, Word-Division, &c. for the Use of Compositors and Readers in the Employment of Neill & Co., Printers, Established 1749*. Edinburgh, 1895.

Nelson, Thomas, and Sons. *House Style: Rules for Compositors and Readers*. Edinburgh: Thomas Nelson and Sons, Limited, 1948.

Noever, Peter. *Richard Artschwager: The Hydraulic Door Check*. Vienna: MAK, 2002.

North, Michael. *The Dialect of Modernism: Race, Language, and Twentieth-Century Literature*. New York: Oxford University Press, 1994.

Nunberg, Geoffrey. *The Future of the Book*. Berkeley, Calif.: University of California Press, 1996.

O'Meally, Robert G. *The Craft of Ralph Ellison*. Cambridge, Mass.: Harvard University Press, 1980.

———, ed. *The Jazz Cadence of American Culture*. New York: Columbia University Press, 1998.

Palumbo-Liu, David. *Asian/American: Historical Crossings of a Racial Frontier*. Stanford, Calif.: Stanford University Press, 1999.

Parati, Graziella. "Strangers in Paradise: Foreigners and Shadows in Italian Literature." Unpublished manuscript, 1999.

Parkes, M. B. *Pause and Effect: An Introduction to the History of Punctuation in the West*. Berkeley: University of California Press, 1993.

Partridge, Eric. *You Have a Point There: A Guide to Punctuation and Its Allies*. London: Routledge, 1953.

Pease, Donald, and Robyn Wiegman, eds. *The Futures of American Studies*. Durham, N.C.: Duke University Press, 2002.

Peters, Julie Stone. *Theatre of the Book, 1480–1880: Print, Text, and Performance in Europe*. Oxford: Oxford University Press, 2000.

Phelan, Peggy. "Introduction: The Ends of Performance." In *The Ends of Performance*, edited by Jill Lane and Peggy Phelan. New York: New York University Press, 1998.

———. "'Warhol: Performances of Death in America.'" In *Performing the Body/Performing the Text*, edited by Amelia Jones and Andrew Stephenson. New York: Routledge, 1999.

———. "Thirteen Ways of Looking at Choreographing Writing." In *Choreographing History*, ed. Susan Leigh Foster. Bloomington: Indiana University Press, 1995.

———. *Unmarked: The Politics of Performance*. New York: Routledge, 1993.

Piper, Adrian. "Passing for White, Passing for Black." *Transition* 58 (1992): 4–32.

Pollock, Andrew. "Happy in the East (—) or Smiling :) in the West." *New York Times* Late Edition (August 12, 1996): 5.

Pollock, Della. "Performing Writing." In *The Ends of Performance*, edited by Peggy Phelan and Jill Lane. New York: New York University Press, 1998.

Puchner, Martin. *Poetry of the Revolution: Marx, Manifestos, and the Avant-Gardes*. Princeton, N.J.: Princeton University Press, 2006.

Richards, Deborah. "An Accumulation of Things Happening: An Interview with Charles Rowell." *Callaloo* 27, no. 4 (2004): 998–1008.

———. "The Halle Berry One Two." *Callaloo* 27, no. 4 (autumn 2004): 1013.

Roach, Joseph. *Cities of the Dead: Circum-Atlantic Performance*. New York: Columbia University Press, 1996.

———. *IT*. Ann Arbor: University of Michigan Press, 2007.

———. "Mardi Gras Indians and Others: Genealogies of American Performance." *Theatre Journal* 44 (1992): 467–68.

Robertson, Joseph, *An Essay on Punctuation*. 2nd ed. London, 1886.

Robinson, Amy. "The Terror of Wedding." Unpublished manuscript, 1987.

Robinson, Paul. "The Philosophy of Punctuation." *New Republic* (April 26, 1980): 18–30.

Rodowick, D. N. *Reading the Figural, or, Philosophy after the New Media*. Durham, N.C.: Duke University Press, 2001.

Román, David. *Acts of Intervention*. Urbana: University of Illinois Press, 2005.

Ronell, Avital. *The Telephone Book: Technology, Schizophrenia, Electric Speech*. Lincoln: University of Nebraska Press, 1989.

Rowell, Charles H. "'Words Don't Go There': An Interview with Fred Moten." *Callaloo* 27, no. 4 (2004): 965.

Rushdie, Salman. *The Satanic Verses*. London: Verso, 1992.

Safire, William. "On Language." *New York Times Magazine*, June 21, 1992, 12.

Sanderson, David. *Smileys*. Sebastopol, Calif.: O'Reilly and Associates, 1993.

San Juan, E. Jr. *Racial Formations/Critical Transformations: Articulations of Power in Ethnic and Racial Studies in the United States*. Atlantic Highlands, N.J.: Humanities Press, 1992.

Sassen, Saskia. "Spatialities and Temporalities of the Global: Elements for Theorization." In *Globalization*, edited by Arjun Appadurai. Durham, N.C.: Duke University Press, 2001.

Schimmel, Paul. *Out of Actions: Between Performance and the Object, 1949–1979*. London: Thames and Hudson, 1999.

Schlesinger, Arthur M. Jr. *The Disuniting of America*. Knoxville, Tenn.: Whittle Direct, 1991.

Schneider, Rebecca. "Archives Performance Remains," *Performance Research International* 6, no. 2 (2001): 100–108.

———. *The Explicit Body in Performance*. New York: Routledge, 1997.

———. "Solo, Solo, Solo." In *After Criticism: New Responses to Art and Performance*, edited by Gavin Butt. Malden, Mass.: Blackwell, 2005.

Schor, Mira. *Wet: On Painting, Feminism, and Art Culture*. Durham, N.C.: Duke University Press, 1997.

Sedgwick, Eve. *Tendencies*. Durham, N.C.: Duke University Press, 1993.

————. *Touching Feeling: Affect, Pedagogy, Performativity*. Durham, N.C.: Duke University Press, 2003.

Senna, Danzy. *Caucasia*. New York: Riverhead Books, 1998.

Sewer, Heide. "Census Reveals Fewer Hyphenated Americans." *New York Times*, May 31, 2002.

Shaffner, Ingrid. "A Revised Short History of the Blp." In *Up and Across*, by Richard Artschwager. London: Serpentine Gallery, 77–80.

Simon, Maurya. *A Brief History of Punctuation*. Winona, Minn.: Sutton Hoo Press, 2002.

Skelton, R. A. *Punctuation in a Nutshell*. London: Sir Isaac Pitman and Sons, 1949.

Smith, John. *The Printer's Grammar*. London, 1755.

Snead, James. "Repetition as a Figure of Black Culture." In *Out There: Marginalization and Contemporary Cultures*, edited by Russell Ferguson, Martha Gever, Trinh T. Minh-ha, and Cornel West. Cambridge, Mass.: MIT Press, 1990.

Sollors, Werner. *Beyond Ethnicity: Consent and Descent in American Culture*. New York: Oxford University Press, 1986.

Solomon, Andrew. "Dot dot dot: Yayoi Kusama." *Artforum* 35, no. 6 (February 1997): 66–73, 100, 104, 109.

Sontag, Deborah. "Immigrants Forgoing Citizenship While Pursuing American Dream." *New York Times*, July 25, 1993, A1.

Sontag, Susan. "Notes on 'Camp.'" In *Against Interpretation and Other Essays*. New York: Dell, 1966.

Spiller, Elizabeth. *Science, Reading and Renaissance Literature: The Art of Making Knowledge 1580–1670*. Cambridge: Cambridge University Press, 2004.

Spillers, Hortense J. "Mama's Baby, Papa's Maybe: An American Grammar Book." In *Black, White, and in Color: Essays on American Literature and Culture*. Chicago: University of Chicago Press, 2003.

————. "Notes on an Alternative Model: Neither/Nor." In *The Difference Within: Feminism and Critical Theory*, edited by Elizabeth Meese and Alice Parker. Philadelphia: John Benjamins, 1989.

Spivak, Gayatri Chakravorty. *A Critique of Postcolonial Reason: Toward a History of the Vanishing Present*. Cambridge, Mass.: Harvard University Press, 1999.

————. "More on Power/Knowledge." In *Outside in the Teaching Machine*. New York: Routledge, 1993.

Stackhouse, Thomas. *A New Essay on Punctuation*. London, 1800.

Stallybrass, Peter. *The Cultural Studies Reader*. New York: Routledge, 1991.

Stange, John. "Kookie Kusama: Fun City's New Goddess of Free Love." *Ace* 11, no. 5 (March 1969): 20–22, 89–90.

Stein, Gertrude. *Lectures in America*. New York: Vintage Books, 1975.

————. "Orta or One Dancing." In *Gertrude Stein, Writings 1903–1932*. New York: Library of America, 1998.

Stein, Judith. "Art's Wager: Richard Artschwager and the New York Art World in the Sixties." In *Up and Across*. Nürnberg: Neues Museum Press, 2000.

Stevenson, Robert Louis. "Penny Plain and Two-Pence Coloured." London, 1884.

Stiles, Kristine, and Peter Selz, eds. *Theories and Documents of Contemporary Art*. Berkeley: University of California Press, 1996.

Stone, Allucquere Rosanne. "Will the Real Body Please Stand Up? Boundary Stories About Virtual Cultures." In *Cyberspace: First Steps*, edited by Michael L. Benedikt. Cambridge, Mass.: MIT Press, 1992.

Strunk, William Jr., and E. B. White. *The Elements of Style*, 3rd ed. New York: Macmillan, 1979.

Stuckey, Sterling. *Slave Culture: Nationalist Theory and the Foundations of Black America*. New York: Oxford University Press, 1987.

Taylor, Diana. *The Archive and the Repertoire: Performing Cultural Memory in the Americas*. Durham, N.C.: Duke University Press, 2003.

Thomas, Lewis. "Notes on Punctuation." *The Medusa and the Snail: More Notes of a Biology Watcher*. New York: Viking Press, 1979.

Tillotsons Style Book for Type Composition, 2nd ed. London: Tillotsons (Bolton) Ltd., February 1949.

Timperley, Charles H. *The Printer's Manual*. London: Gregg Press Ltd., 1965 [1838].

Toll, Robert. *Blacking Up: The Minstrel Show in Nineteenth Century America*. New York: Oxford University Press, 1974.

Tomkins, Calvin. "On the Edge: A Doyenne of Disturbance Returns to New York." *New Yorker* (October 7, 1996): 100–103.

Truss, Lynne. *Eats, Shoots and Leaves: The Zero Tolerance Approach to Punctuation*. London: Profile Books, 2003.

Twine, Nanette. "The Adoption of Punctuation in Japanese Script." *Visible Language* 18, no. 3 (summer 1984): 229–37.

Tyler, Carole-Anne. "Death Masks." In *Gender and Photography*, edited by Jennifer Blessing. New York: Guggenheim Press, 1999.

United States Government Printing Office Board. *United States Government Printing Office Style Manual*. Washington, D.C.: Government Printing Office, 1967.

Valverde, Isabel C. "Catching Ghosts in *Ghostcatching*: Choreographing Gender and Race in Riverbed/Bill T. Jones' Virtual Dance." In *Extensions: The Online Journal of Embodied Technology*. Vol. 2, *Mediated Bodies: Locating Coporeality in a Pixilated World*. 2005.

Van Starrex, Al. "Kusama and her Naked Happenings." *Mr. Magazine* 12, no. 9 (August 1968): 38–61.

Weheliye, Alex. *Phonographies: Grooves in Sonic Afro-Modernity*. Durham, N.C.: Duke University Press, 2005.

Wood, Marcus. *Blind Memory: Visual Representations of Slavery 1780–1865*. Manchester, UK: Manchester University Press, 2000.

Woodward, C. Vann. *A History of the South*. Vol. 9: *Origins of the New South, 1877–1913*. Baton Rouge: Louisiana State University Press, 1971.

Yukins, Elizabeth. "An 'Artful Juxtaposition on the Page': Memory, Perception, and Cubist Technique in Ralph Ellison's *Juneteenth*." *PMLA* 119, no. 5 (October 2004): 1247–63.

Zuberi, Tukufu. *Thicker Than Blood: How Racial Statistics Lie*. Minneapolis: University of Minnesota Press, 2001.

Zuckerman, Marvin. "Some Dubious Premises in Research and Theory on Racial Differences: Scientific, Social, and Ethical Issues." *American Psychologist* (December 1990): 1297–1303.

Index

demic prose, 153–54; in Artschwager's *Exclamation Point*, 152; in British English, 150; in Chao and Eero Jewel's *Exclamation Ring*, 166; in close questions, 153; correlates in speech, 13; dot in, 57; excessive use of, 151, 153; in newspaper writing, 153; as performative, 150–51; as primarily rhetorical and elocutionary, 136; Stein on, 137; as ugly, 149; as unnecessary, 151; visual form of, 150

Exclamation Point (Artschwager), 152

Exclamation Ring (Chao and Eero Jewel), 166

Experimental film: Kusama and Yalkut's *Self-Obliteration*, 43–45, 174 n.36; transition in 1960s, 45

Expressionism, German, 153–54

Facial expression, punctuation acting like, 7

Family Reunion (Eliot), 69, 80, 81

Fanon, Frantz, 102

Farah, Leila, 106

Film: *Me and You and Everyone We Know*, 159–65, 161, 163, 176 n.8, 190 n.8; *Self-Obliteration*, 43–45, 160, 174 n.36. *See also* Experimental film

Fleming, Juliet, 28–29

Fluxus, 33, 44

Fonts: display, of 1960s and 1970s, 33–34; ethnocentricity and racism in, 14; helvetica, 147; prosodic significance of, 65

Footnoted quotations, 114

Forbes, Jack, 181 n.25

Fordism, 15

Forrest, Rebecca, 184 n.67

Foster, Susan, 117, 119, 157

Foucault, Michel, 145

Four Quartets (Eliot), 138

Freeman, Elizabeth, 95–96

Full stops. *See* Periods

Garber, Marjorie, 8, 113–14

Gay Liberation Front (GLF), 48

Gay men. *See* Homosexuality

Gender: and being taken seriously in art world, 44; and feminism in Kusama's work, 33, 39, 42, 45, 53, 54; in *Ghost*, 114; polka dots as feminized, 28, 55; punctuation as feminized, 3, 4; semicolons as feminized, 138, 139

George, Stephan, 148

Gere, David, 125

German Expressionism, 153–54

Gestures: Benjamin on quotable, 186 n.34; quotation marks as, 108, 113–14; reading punctuation as and through, 7–8; time as culturally marked with, 165; typography as gestural, 75–77

Ghost (film), 114

"Ghostcatching" (Jones): mathematical equations and game structures in, 117; motion capture technology in, 126, 131–32

Gifford-Gonzales, Diane, 104

Girard, Michael, 131

Global English, 58

Globalization: and American identity, 93; hyphens and, 87

Goldberg, Jonathan, 7, 29

Goldberg, Whoopi, 114, 185 n.19

Gombrich, E. H., 108

Gomez-Pena, Guillermo, 107

Gordimer, Nadine, 5

Graffiti, 28–29, 172 n.5

Grande Jatte, La (Seurat), 53

Grand Theft Auto (video game), 129

Grayson, Deborah, 182 n.39

Ground Zero, 56

Gutenberg Galaxy, The (McLuhan), 22

Haecker, Theodor, 141

"Hair" (musical), 47

binary sutured by, 70–71; typography of, 64, 68, 69, 70, 74, 77
Isidore de Seville, 17
Islands Number Four to Islands No. 4 (Martin), 55–56
Italics, 62, 64, 65, 69, 74

Jackson, Jesse, 182 n.33
Jackson, Michael, 115, 118, 121
Jameson, Fredric, 119
Janus III (Elevator) (Artschwager), 111, 112
Jardine, Lisa, 172 n.7
Jasmine (Mukherjee), 106
Jefferies, Leonard, 97
Johns, Adrian, 31
Johnson, E. Patrick, 79
Jones, Amelia, 115, 186 n.33
Jones, Bill T.: answers spoken question with bodily movement, 127; on being out of time, 125; as black HIV-positive gay male dancer, 119, 123; on distinction between life and death, 125–26; fluid transitions in movement of, 124; Haring's use of, as canvas, 36; influences on, 111; interplay of movement and stasis in work of, 111; on memory, 115; on no direction in art, 115; punctuation as embodied gesture in work of, 26; queer quotation of, 109, 113; *Still/Here*, 122, 125; Survival Workshop of, 125–26; "21 Supported Positions," 116; "Untitled," 125. *See also* "Ghostcatching" (Jones); "21" (Jones)
Jones, Boots, 116, 117, 119, 121, 123
Jones, Meta, 65
Joyce, James, 5, 96
Judd, Donald, 33, 39, 50–51
Judson Dancers, 33
Judy, Ronald A. T., 23, 171 n.56, 182 n.33

Julien, Isaac, 73
July, Miranda: embodied gesture in work of, 26, 176 n.8; *Me and You and Everyone We Know*, 159–65, 161, 163, 176 n.8, 190 n.8
Juneteenth (Ellison), 66, 67

Kaiser, Paul, 131, 132
Kennedy, Adrienne, 119
Klee, Paul, 78
Kliege, Melitta, 18
Kopp, Leslie Hansen, 132
Kusama, Yayoi, 33–57; accumulation as concern of, 45–46; *Accumulation of Nets (No. 7)*, 37; *Accumulation of Spaces (No. BT)*, 35; "Aggregation: One Thousand Boats Show," 43, 48; "The Anatomic Explosion," 47, 56; anti-racism of work of, 39, 45; Artschwager compared with, 48–49, 51–52; Brata Gallery show of 1959, 39; brush strokes of, 53–54; capitalism criticized by, 42, 56; closed versus open structures in work of, 48; comic sense of play in work of, 39; dance troupe of, 47, 55, 174 n.44; on depersonalization, 36, 38; *Dots Obsession*, 47; dream of obliteration of, 36, 65; Ellison compared with, 64–65; "endless" as keyword in work of, 43; fashion design of, 46–47; feminism and, 33, 39, 42, 45, 53, 54; first homosexual wedding staged by, 42, 47; as graffiti artist, 29, 172 n.5; in happenings, 34, 47, 49, 56, 174 n.44; "Infinity Mirror Room—Phalli's Field," 38; *Infinity Net*, 40; *Interminable Net*, 47; "Kusama Peep Show," 38; loopholes as focus of work of, 42–43; "Love Forever" exhibition, 39, 172 n.4; *Naked Demonstration at Wall Street*, 56, 57; naked demonstrations of, 48, 56; "naked" fashions

Quotation marks (*continued*)
dialogue, 5; as excessive, 108; as gestures, 108, 113–14; Jones's queer quotation, 109, 113; and pastiche and recycling, 114–15; performative aspect of, 110; as queer, 108, 109, 112; as simultaneously suturing and separating, 109
" " " (Quotation Marks)" (Garber), 113–14
Quotations, footnoted, 114

Race: American identity and, 92; Asian Americans, 106–7; in *Ghost*, 114; and Jones's "21," 124; Kusama's anti-racism, 39, 45; Kusama's racial designation, 44; and miscegenation, 78, 90, 114, 182 n.35; movements seen as bespeaking, 130; and nation, 183 n.48; Native Americans, 92, 93, 97, 101, 102, 131; of none, 97–102; racial memories, 101, 183 n.61; typographic racism, 14; whiteness, 98–99, 101. *See also* African Americans; Color line
Rainer, Yvonne, 111, 186 n.47
Reading: cultural study of punctuation and, 23; priorities of, 22; silent, 17, 75; smileys reorienting, 156–57
Reynolds, Roger, 132
Rhizome (Williams), 59
Richards, Deborah, 45, 46, 71
Riggs, Marlon, 79
Roach, Joseph, 48, 68, 78, 94, 110, 114, 123–24
Robinson, Amy, 183 n.66
Roman texts, 6–7
Ronell, Avital, 8, 14, 178 n.30
Roosevelt, Theodore, 88, 89, 92, 104
Ross, Fran, 13
Rudner, Sara, 111

Safire, William, 95
Said, Edward, 110, 113
Sancho, Ignatius, 83
Sanderson, David, 156–58
San Juan, E., 94
Sassen, Saskia, 87
Scat, 14, 76
Schlesinger, Arthur M., Jr., 92
Schnecner, Richard, 47
Schneemann, Carolee, 33, 44, 147
Schneider, Rebecca, 47, 65
Schor, Mira, 144–48; Kusama compared with, 54; *Light Flesh (Slit of Paint)*, 144, 146; as *M/E/A/N/I/N/G* editor, 146, 189 n.43; *War Frieze*, 147; *Wet: On Painting, Feminism, and Art Culture*, 144–46
Scott, Anna, 169 n.2
Scriptio continua, 4, 64
Scripts of plays, 62
Sculpture: Artschwager's blps, 51; Artschwager's S-Ps, 22; soft sculptures, 34, 47, 54
Sedgwick, Eve, 38–39, 123, 169 n.7
Self-Obliteration (film), 43–45, 160, 174 n.36
Self-Obliteration (photograph), 166
Semicolons, 135–48; antiquity of, 137; as commas with pretensions, 137; as compromise, 139; as "dot-comma," 143; dot in, 57, 135; as dying out, 141; in Edson's *W;t*, 142–43; in Eliot's *Four Quartets*, 138; as feminine, 138–39; as half, 138; invention of, 135; in July's *Me and You and Everyone We Know*, 159; as less than colons, 137, 138; mid-position of, 139–40, 141; as most dismissed of all punctuation, 138, 141; as pause signifying more, 144; periods contrasted with, 138; as polite cough, 137; as question marks in Greek, 137,

139; relative value of, 136; in Schor's *Wet*, 144–46; Simon on, 140–41; Stein on, 137; as strong separator of independent clauses, 139; as true G-spot, 147; in txt messaging, 26; visual appearance of, 141–42

Jennifer DeVere Brody is an associate professor
of English, African American Studies, and
Performance Studies at Northwestern University.
She is the author of *Impossible Purities: Blackness,
Femininity, and Victorian Culture*.

Library of Congress Cataloging-in-Publication Data
Brody, Jennifer DeVere.
Punctuation : art, politics, and play / Jennifer
DeVere Brody.
p. cm.
Includes bibliographical references and index.
ISBN-13: 978-0-8223-4218-2 (cloth : alk. paper)
ISBN-13: 978-0-8223-4235-9 (pbk. : alk. paper)
1. English language—Punctuation. I. Title.
PE1450.B724 2008
428.2—dc22
2007043972